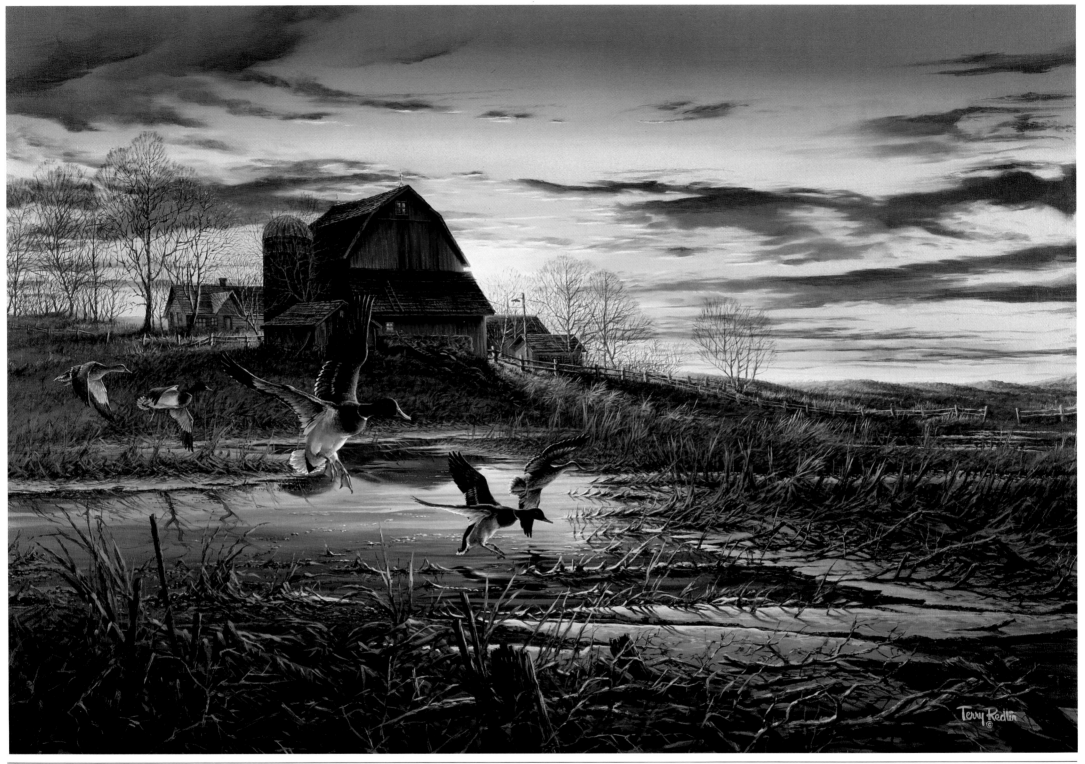

In this classic painting the artist has stopped time for one crystal clear moment. The early morning air is crisp and clean. Hints of the coming winter have formed icy edges around the marsh. As the sun emerges from behind the barn a light in the window indicates that the farmer, as well as the mallards, are up and busy at the start of a new day. This image was selected for the cover of The Farmer in 1979, and gave the artist's work its first wide exposure.

Morning Chores

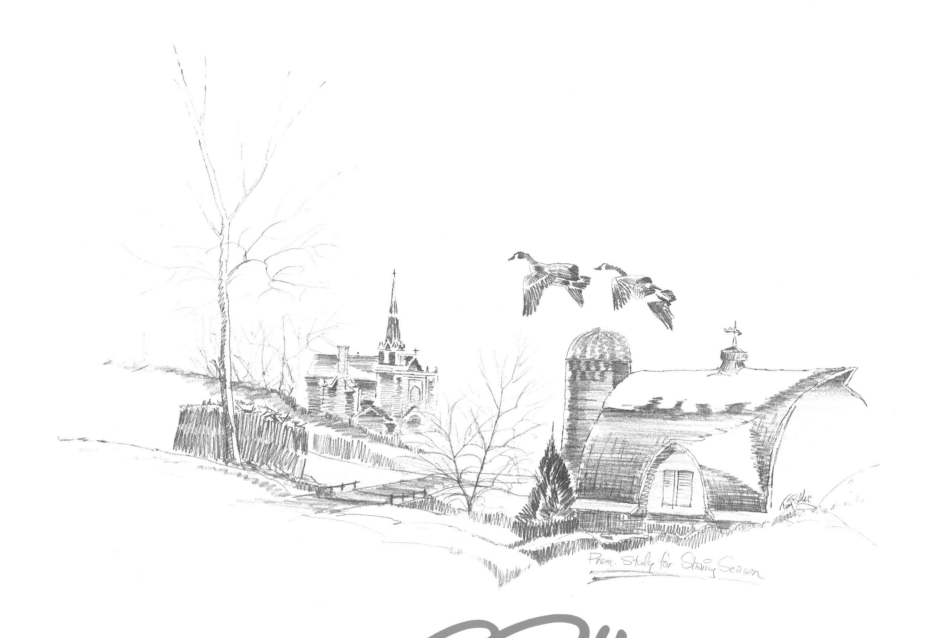

Prem. Study for Sharing Season

The Art of *Terry Redlin*

Opening Windows to the Wild

Dedication

Text: Keith G. Olson
Design: Bill E. Moeger
Separations and Printing: Watt/Peterson, Inc.
Bindery: Nicholstone Book Bindery

Text and compilation
© 1987 by The Hadley Companies.
All Rights Reserved.

ISBN 0-9618978-0-5, Clothbound, First Edition
0-9618978-1-3, Leatherbound, First Edition
Library of Congress Catalog Card Number
87-081872
Printed and Bound in the United States of America.
Published by: Hadley House, A Division of The Hadley Companies, Inc.
14200 23rd Avenue North
Plymouth, Minnesota 55441

In many ways this book has been a cooperative effort, and there is no question in my mind to whom it should be dedicated.

Over the years I have been fortunate to be married to a woman who worked to support me through art school and, after raising our three children, is able to double as secretary, art critic, business manager and overseer of my spending habits!

She has one of the most frustrating positions that I can imagine, which is being totally involved in my work, but having little control over the creative process. So many times I have heard her say, "If only I could use a brush and show you what I mean."

So she does the next best thing and keeps everything running smoothly. After 32 years together, thank you, Helene.

Terry Redlin
Lake Minnetonka, 1987

Contents

Preliminary Study for Evening Chores

5

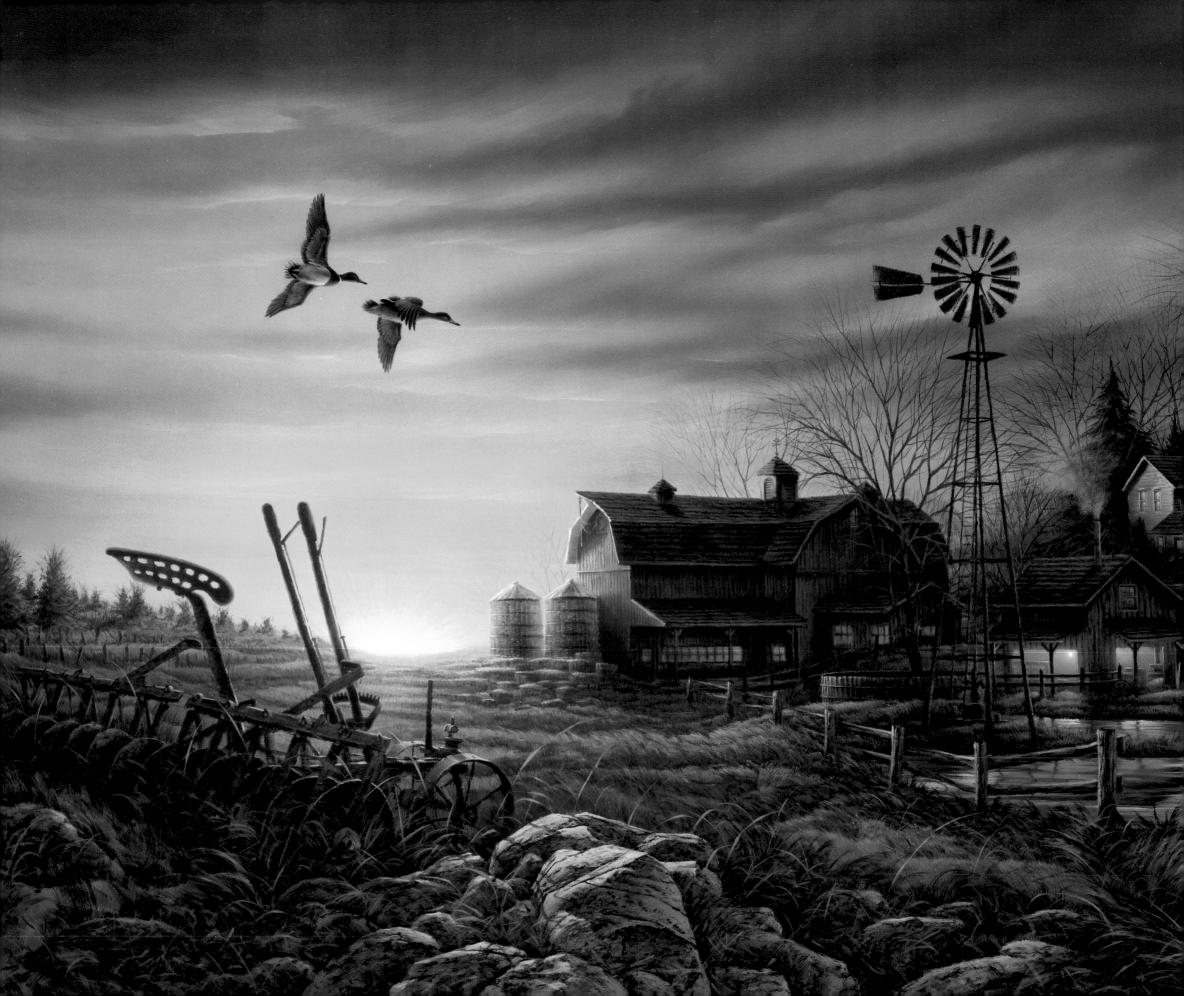

W have only to lightly scratch emotional surfaces to recognize that an important aspect of our being is connected with the land.

Although we are now primarily a nation of urban dwellers, much of our collective heritage retreats in subtle strands to the rural experience.

For many, of course, any intimate relationship ceased long ago. For others it may never have existed. But the truths inherent in this tradition remain.

As Americans we feel the constant tug of its unique values, and the image presented here invites us to, once again, touch these basic chords.

Evening Chores

The harvest is in and a hard day's work almost finished. The setting sun highlights overflowing corn bins and stacked hay bales. Lights in the barn and house tell us milking is underway and that supper will soon be ready. From the foreground rise, however, the old hand-operated disc reminds us of a more primitive era. And the mallards, with their own set of priorities, head for a well earned rest in the barnyard pond.

Terry Redlin
The Art of Sharing Memories

The Terry Redlin you meet for the first time will be the same person you will come to know the following week, month or years later. There is no guile, no hidden agenda. His friendly style hints at a small town heritage. His openness is a mark of a lifelong encounter with the outdoors.

These same traits are abundantly evident when we meet Terry Redlin's art. Like his personality, his paintings convey a sense of reality, of being at peace with themselves.

In this body of work we find no clever abstractions, no pseudo sophistication, no evidence of arty trends, no attempt to please the critics.

As Terry Redlin has come to share his memories through painting, he has touched a responsive chord in a broad spectrum of the American people. Hundreds of thousands of his prints are dramatic testimony to the fact that what he loves to paint, the public loves to display in their homes and offices.

The trail to Terry Redlin's present position at the pinnacle of the wildlife art genre seems in hindsight natural enough, perhaps even predestined. But it was not an easy path, and like the honesty portrayed in his art this story has a certain democratic ring.

Born in 1937 on a farm near Watertown, South Dakota at the end of the Depression, Terry Redlin's early years can be drawn with stark simplicity. One image from this period is vividly etched in the artist's mind. Each room in their modest house had a single electric light. It was used only when someone was in the room, then conscientiously turned off when that person left. The painting "Lights of Home", which appears on pages 126/127, is a remembrance from this time in the artist's life when the "big house on the hill" represented a strangely different and wonderful world.

But regardless of the family's sparse economic situation, there were advantages for an active young boy growing up on the edge of the great plains. Its hills, woods, lakes and prairie, and the rich variety of its wildlife, would permanently mold his character. He responded with enthusiasm to the call of the great outdoors, often at the expense of school work.

Both his parents and teachers remember young Terry as an incurable daydreamer. However, as might be expected, he excelled in the school's art courses.

During these formative years he roamed the nearby countryside hunting cottontail rabbits by moonlight, bow hunting deer in the fall, fishing the many lakes during the long summers and, of course, eagerly waiting for the great waterfowl migration which flowed via the central flyway through the area.

As wintertime recreation, in addition to his growing compulsion to draw, he remembers carving and painting his own fishing lures and repairing old rifles. At this period of his life he could easily have become a taxidermist, a gunsmith or a forest ranger. There was only one interest of overriding importance in his young life—the freedom and excitement of the outdoors.

Then, tragically, one event changed the course of his life. A motorcycle accident in 1953 resulted in the loss of a leg. No longer would he be able to participate so actively in the outdoor life that had consumed his energies. At age fifteen his world seemed shattered.

It was an emotionally traumatic time for the young man. But he quickly came to realize that he must go forward and work with what remained. And that was his native talent and interest in drawing. Art became both a spiritual therapy and a practical way to stay in touch with nature.

The young Terry Redlin began to recover, and he returned to the outdoors with a new set of priorities. His life was redirected from an emphasis on the excitement of the moment, to the challenge of capturing his experiences through a new medium of line, form and color.

A career had been born out of the inscrutable circumstances of life and without a conscious understanding of what had transpired.

Terry Redlin's next 35 years were a time of career experimentation and a slowly growing realization of what was truly basic and important in his life.

Terry and Helene, his wife of 32 years, graduated together from Watertown High School in 1955. A year later they were married and moved to Forest Lake, Minnesota where Terry attended the School of Associated Arts in St. Paul.

Nature and her creatures are the main subjects of Terry Redlin's art, and he does extensive field research for ideas that are later used in a variety of settings. This backwoods "sugar shack" became a key element in the painting on page 28.

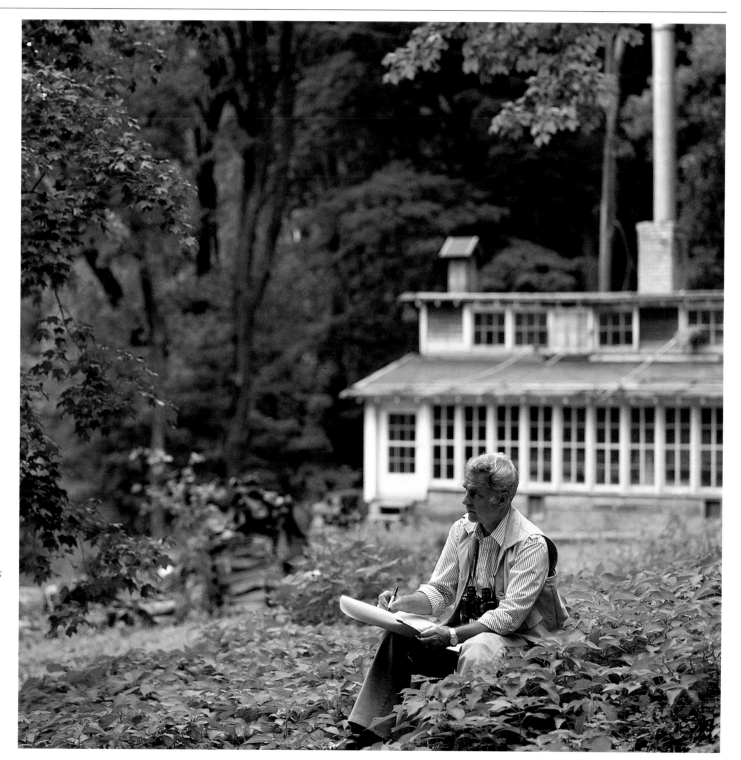

His first job was as a playing card designer for Brown and Bigelow, where he discovered the original paintings of such artists as Norman Rockwell in the company storage room. He remembers often spending noon hours there studying the composition and brush work of the many artists in the company's collection.

The open spaces of South Dakota and its lovely Lake Kampeska tempted Terry back to Watertown in 1960. There he worked for six years as an architectural illustrator, honing his drawing techniques and confronting the laws of perspective.

But new career opportunities again lured him to the Twin Cities as an illustrator for Webb Publishing, where he began to climb the corporate ladder. Eventually he became a magazine art director and found himself on the administrative rung, no longer "at the board" doing what he loved to do best.

Now living in Hastings, Minnesota, this was a period of intense and sometimes agonizng re-examination of career and life goals. The tug of art was Terry's constant companion, and many evenings, weekends and vacations were spent in the outdoors studying wildlife and in his basement studio drawing, painting and dreaming.

In 1977 Terry Redlin published his first open edition print, "Apple River Mallards" illustrated on page 25, which found a ready and brisk market. This success forced him and Helene to make a difficult but increasingly necessary choice. In 1978 he resigned his position at Webb Publishing to test the practicality of a decision of the heart. Could this initial success be sustained? Was it possible to create a living in the world of wildlife art?

The answer came immediately, and the result was unprecedented. What Terry Redlin now refers to as his "romantic realism" found a wide audience and his print editions became sell outs. Today, on the tenth anniversary of his full time commitment to art, the demand for this unique vision of wildlife and nature continues unabated.

Terry Redlin lives just west of Minneapolis on Lake Minnetonka, in the middle of an old duck hunting pass. Here, close to the sources of his inspiration, he continues to paint daily and to reflect on the place of wildlife art in his life and the culture around him.

What he sees, of course, is a ground swell of popular acceptance. But along with the excitement of growth has come an uneasy feeling about wildlife art, both in the manner of its creation and in its business practices.

One concern is addressed when aspiring young artists ask him for advice, how to get started in what appears to be a ready market for wildlife subject matter.

His response touches the very core of any artistic endeavor. The only true and lasting success, he says, is achieved out of the originality that is basic to each individual's talent and vision. The temptation to copy someone else's work is doomed to failure, not because the duplication will necessarily be detected, but because plagiarism only stunts the creative growth of the violator.

Terry Redlin's advice for attaining artistic integrity in wildlife art is simple and direct, "Get out into the field and into your own mind."

A second concern extends to the business side of wildlife art, especially to the area of publishing limited edition prints.

To Terry Redlin "limited edition" means just that, a predetermined and stated quantity – and with a guarantee that no second editions, special editions, poster editions, decorator prints or calender art of the same image will appear later. Only by adhering to his "strict limited edition" policy, he feels, can his credibility and the trust of the public be maintained.

But the thrust of Terry Redlin's life remains internal, intuitively focused on his own creative direction. He is little concerned with the petty problems of the moment. His art continues to boldly embrace both the real and the romantic, and to share beautiful images from his memory. As such, it reaches out with a universal spirit. Let the paintings speak for themselves.

Although a lifelong student of wildlife, Terry Redlin's art is far more than an academic presentation of anatomical details. The "romantic realism" of his work is beautifully evident, both in the studio and in the finished painting on page 29.

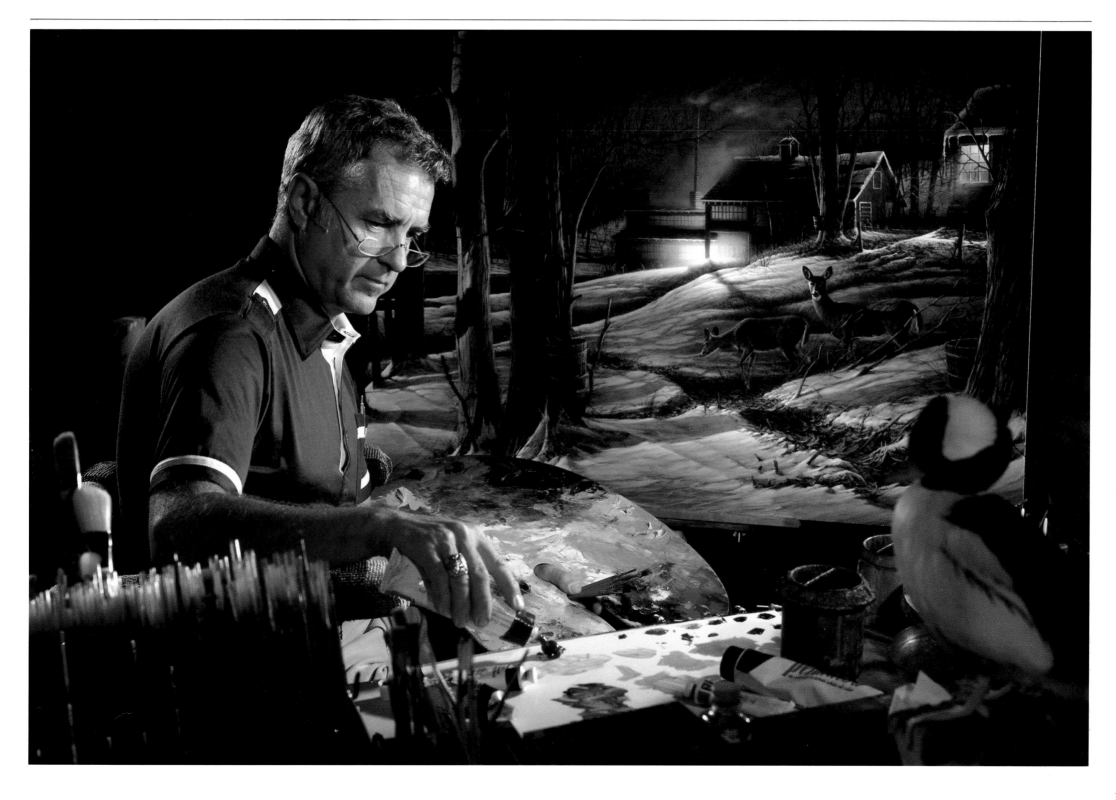

Heading South

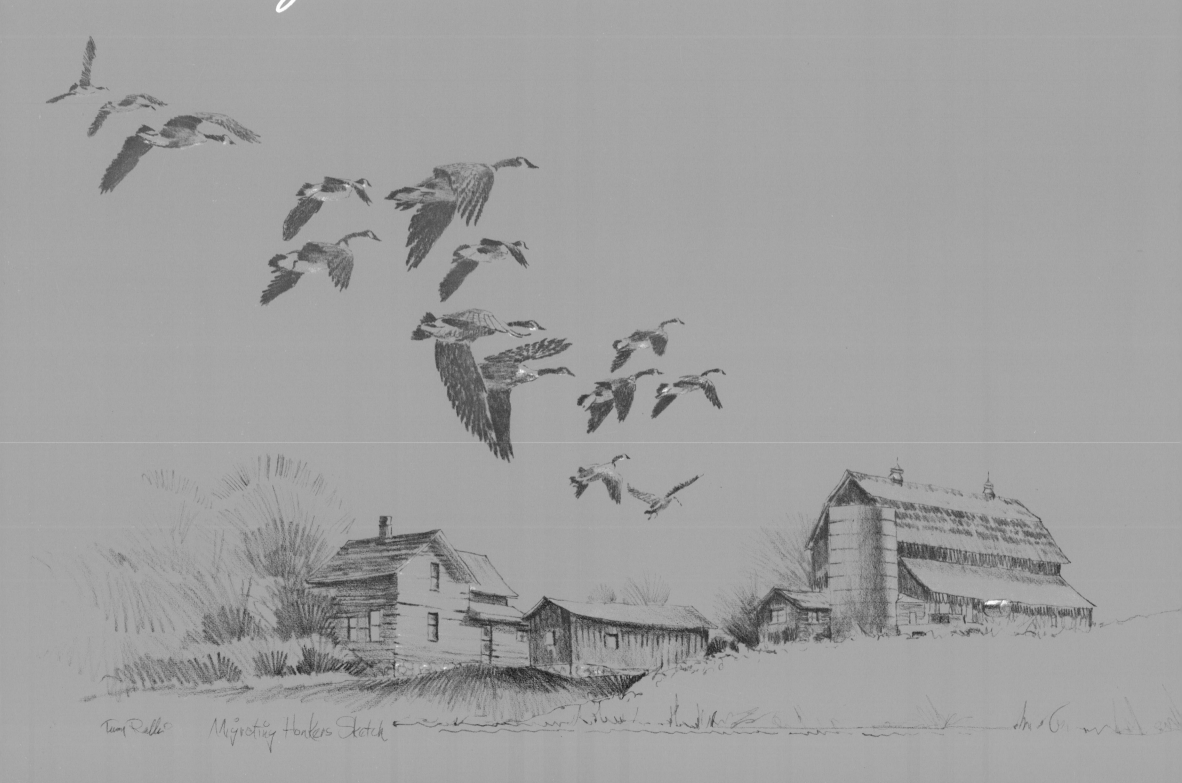

Terry Redlin Migrating Honkers Sketch

The Great Migration

It's a magical time of the year that holds special import for those in tune with nature's rhythms.

To the person caught up in the hurried pace of modern life the subtle changes in temperature and color are little noticed.

But to the lover of wildlife, autumn is a season of high anticipation. There is an instinctual sharpening of the senses. Eyes scan the northern sky. Minute changes in foliage are quietly recorded.

The first sure signal of the unfolding drama may be a slowly moving grey streamer on the distant horizon. Or the faint calls from high in the night sky. An ancient ritual has begun.

Hundreds of thousands of waterfowl will soon fill the fall air. Mallards, teal, pintails, whistlers, redheads, honkers, species well known and little known, have responded to a primordial urge to head south.

Leaving their nesting grounds in Canada and the northern tier of states, these graceful wanderers will mysteriously guide their way to winter resting areas as far south as Central America.

The high drama of this annual migration has been one of Terry Redlin's favorite subjects. In these paintings he offers us a precious gift, allowing our imagination again to recapture one of nature's most memorable events.

These flights of giant Canada geese have started late on their annual journey south. The wind swept, snow capped ridge covers the easy ground feed, but the sun burnished corn shocks are tempting a few honkers to set down. Off in the distance a wisp of smoke from the farm house indicates another species is also awake and about their daily work.

High Country

High Country (detail)

From a distance the corn shock is a dominating but relatively simple series of triangular forms. Upon closer examination we see its true structure, an intricate pattern of thin, interlacing brush strokes.

The intense warm hues from the sun seem to be setting the shock on fire, creating a dramatic contrast to the banked snow and cool shadows at the base.

In the background a feeling of great depth is achieved with the meandering and receding water courses, and the faint, grey silhouettes of on-coming flights.

These mallards have decided to set down for a moment and rest in the natural protection of a small slough. The stiff head wind bends the long flowing marsh grasses, creating an appropriate complement to the graceful mallards approaching their landing. This scene is an actual location near a series of prairie potholes.

Over the Rushes

Drifting

The day is cold and blustery, with strong wind gusts breaking loose small patches of snow from the exposed river bank. Highlighted by the low winter sun peeking through the clouds, these late season whistlers are pushing hard along the rapids to reach the main lake upstream.

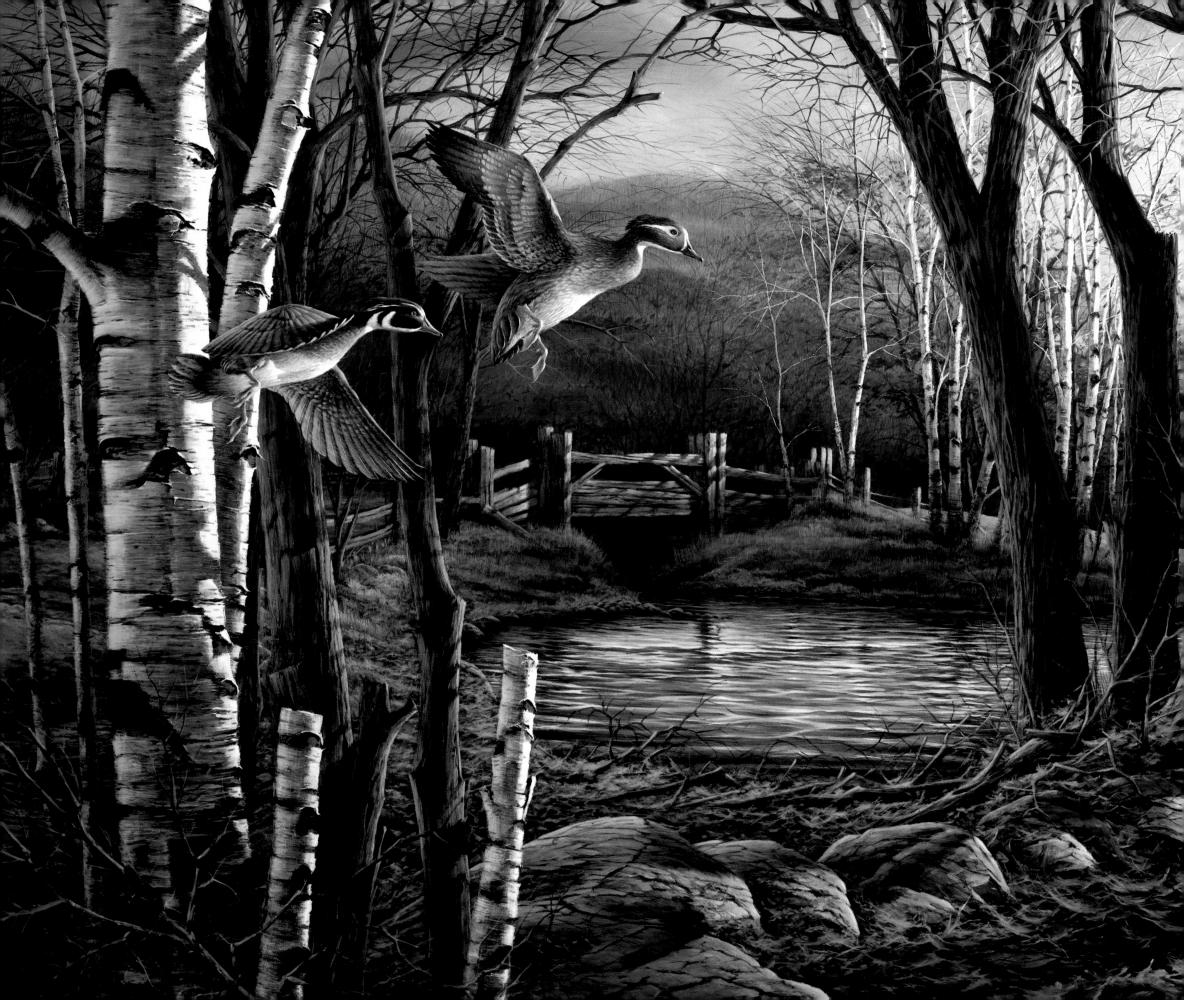

Riverside Pond

It's an autumn afternoon and this wood duck pair is preparing to leave. Perhaps they are taking one last trip around their riverside pond home before heading south.

The quiet water, the deep woods safety, the available ground seeds, all combine to make this an ideal haven.

Only the rough hewed hiking bridge in the background interrupts the natural tranquility of the scene. But the wood duck, like the mallard, is an easy companion to man and this one intrusion did not disturb their stay.

Careful observers will also note a small dark opening high in the tree trunk at the top right of the painting. This now empty nest awaits their return next spring.

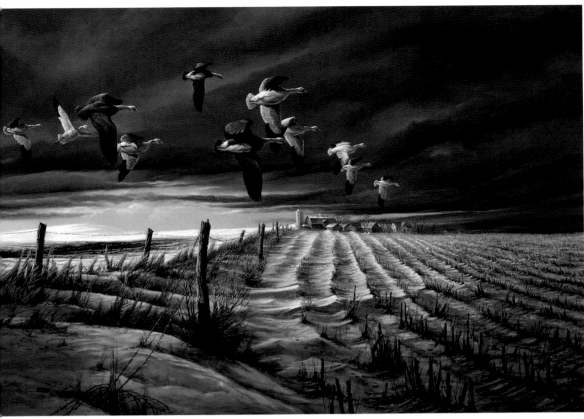

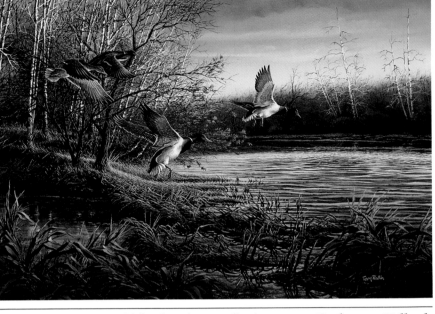

Against a backdrop of fall colors these mallards search out their resting place. The hour is late, and the setting sun casts one last moment of light on both the mallards and the stand of birch.

Backwater Mallards

The snow geese, dramatically contrasted against a dark and foreboding sky, fly over an old cattle row. Preoccupied in looking for breakfast, they are unaware of being in full view of the farmer's house.

Winter Snows

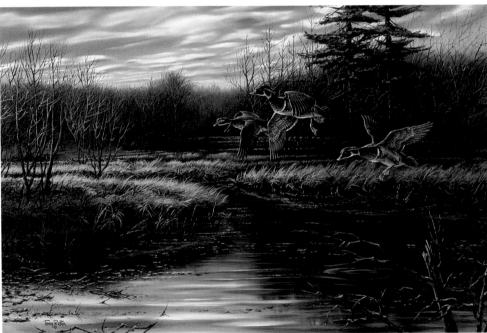

In this painting the colorful wood ducks are shown in a subdued backlight setting, thus enabling the artist to tone down the species' high contrast markings and present a beautiful and natural scene.

Colorful Trio

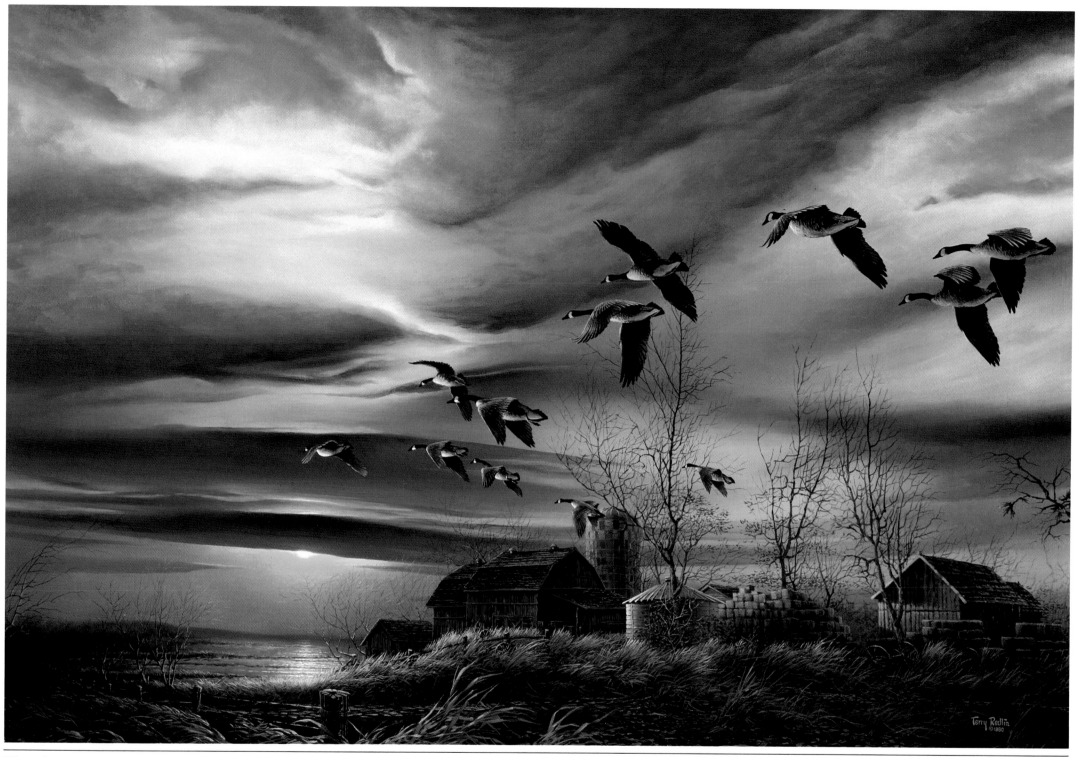

Silent Sunset

This is one of those rare evenings when silence is truly golden. As the Canada honkers swoop low over the farmstead the only sound is the flow of night air over their wings. Those who have experienced this magic moment count it among their most cherished memories. This painting appeared on the cover of Outdoor Life.

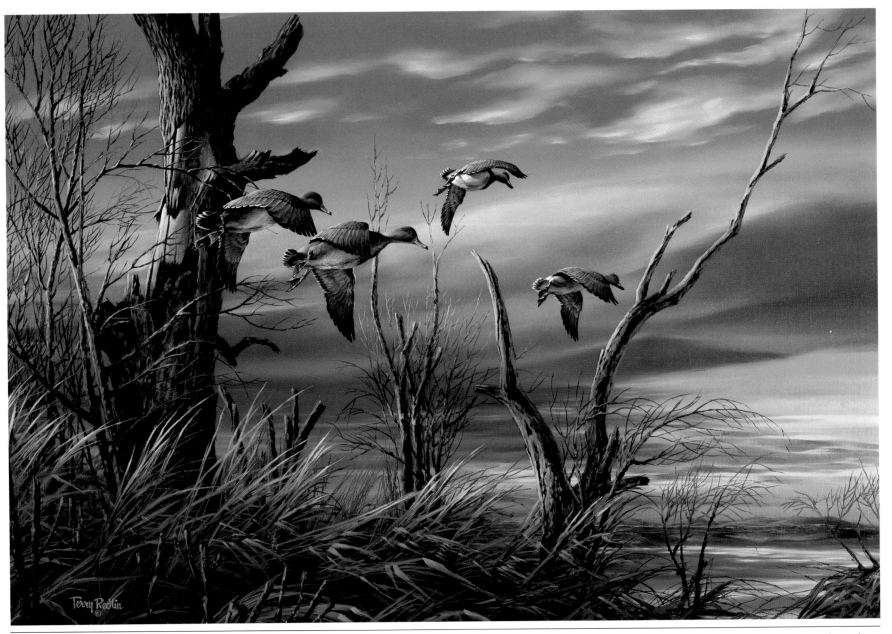

As quiet observers hidden low in the shoreline grass, we glance up to see four redheads gliding silently through a stand of dead trees. The late day sun bathes the foliage with a warm light, creating an inviting calm to this autumn scene.

Aging Shoreline

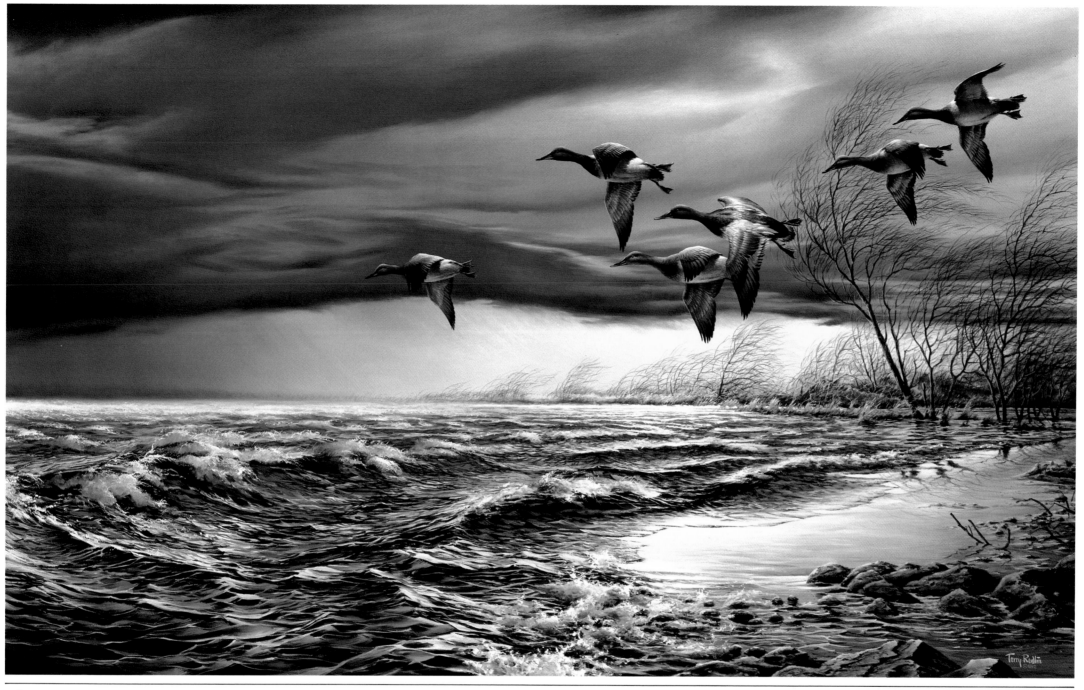

Whitewater

The heavy rain line on the horizon, the bending willows and the roiling whitewater all indicate that severe weather is not far off. This poses no problem for the powerful canvasback who, built for speed with their sleek design, will easily keep ahead of the approaching storm.

Cans in flight

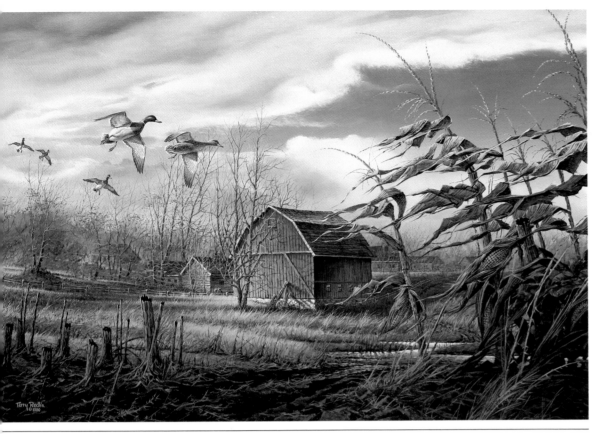

The Homestead

The warm sun and gentle breeze imbue this scene with a special nostalgia. Ample water, available corn and a friendly farmer all invite this flock of mallards to return again to familiar surroundings.

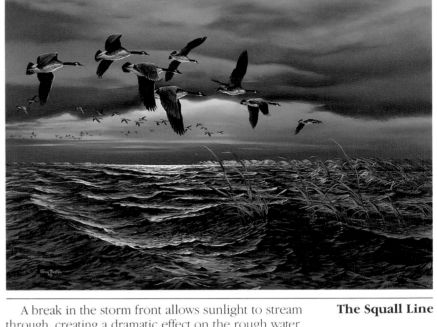

A break in the storm front allows sunlight to stream through, creating a dramatic effect on the rough water and the honkers heading for cover. This painting was created for and donated to Ducks Unlimited.

The Squall Line

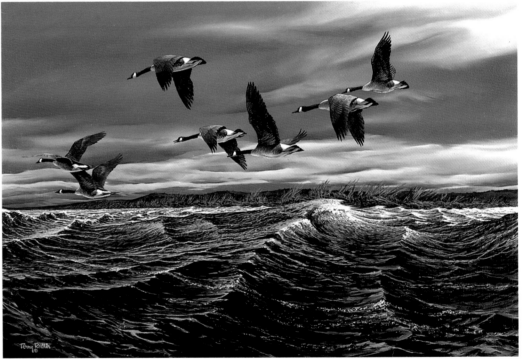

Against an ominous backdrop of broken clouds, the dark water is whipped into whitecaps. The Canada honkers strain to round the distant point and reach a protected spot on the far side of the lake.

Whitecaps

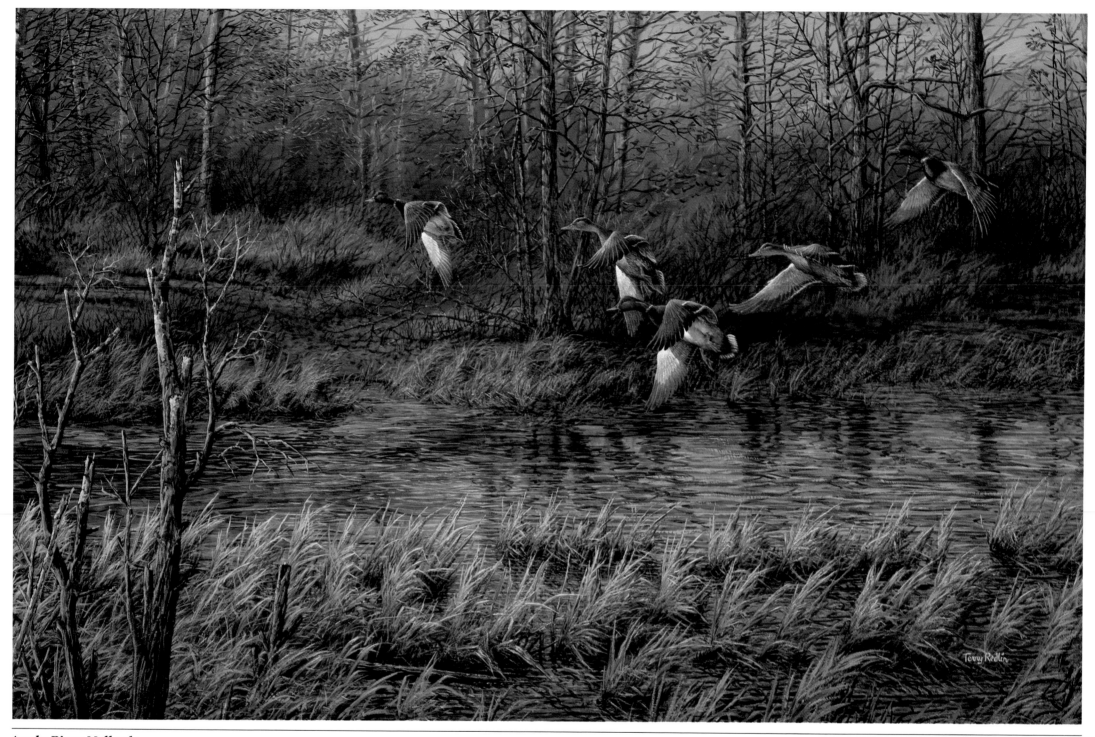

Apple River Mallards

The time is a warm, sunny autumn afternoon along a backwater near the Apple River. The rich seasonal brown and orange hues seem to permeate the very air as five mallards coast silently to a secluded resting place. This is one of the artist's first wildlife paintings and its mood is reminiscent of an old Currier and Ives print.

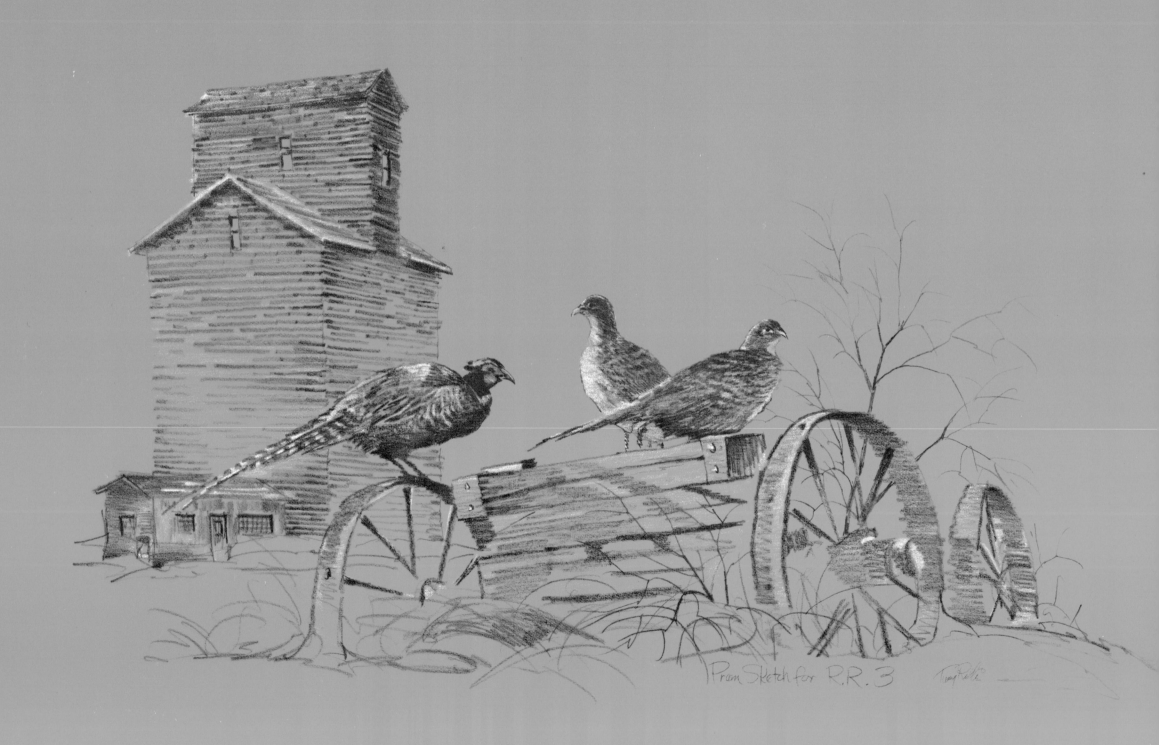

Prem Sketch for R.R. 3

Living in Harmony with Man

The uneasy relationship between man and wildlife is one of modern civilization's continuing dilemmas. Tension between these two forces is sometimes dramatic, often subtle and unseen, but always in a state of negotiation.

This on-going conflict is a subject of deep concern to Terry Redlin. Its dynamic is apparent in much of his art, and is always portrayed from sympathetic perspective.

Man and wildlife, Terry Redlin's art informs us, are capable of sharing the common land and living in harmony. His art suggests that this condition is part of the natural law. And this ideal has become a highly visual part of the artist's world view.

Throughout his paintings we find wildlife co-existing peacefully among the activities and artifacts of man: the farmer at work in the field, rusting equipment, abandoned buildings, broken fences, deserted backroads, weekend campers, even prospering on the edge of bustling commerce.

The close relationship is clear, but the adaptation is often one-sided. We reflect that those who wield the power also make the choice, and with power of choice comes great responsibility. Wildlife, with its beautiful capacity to accommodate and share, has done its part. Man must remember to do his.

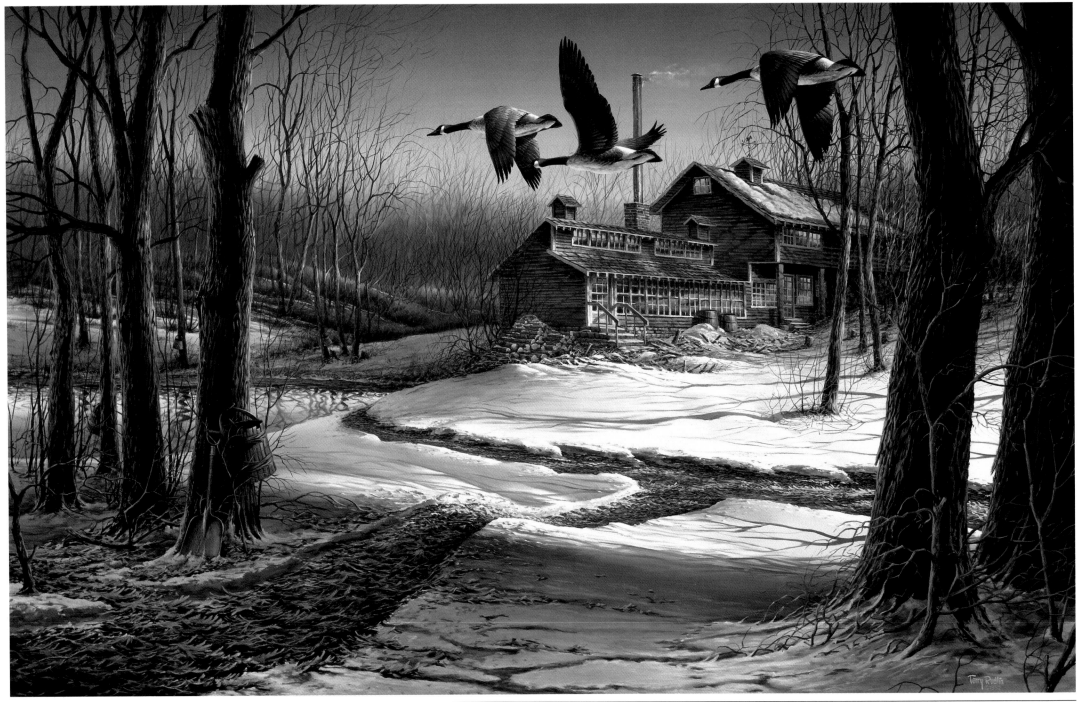

On this bright spring day the Canada geese are headed north, but have dipped low for a close inspection of a circa 1900 "sugar shack." The idea for this painting was inspired by mapler friends who, along with the artist, walked the shoveled paths and once again appreciated the rustic setting. Note the building's functional design, suggesting an unknown architect's anticipation of today's solar homes.

Spring Mapling

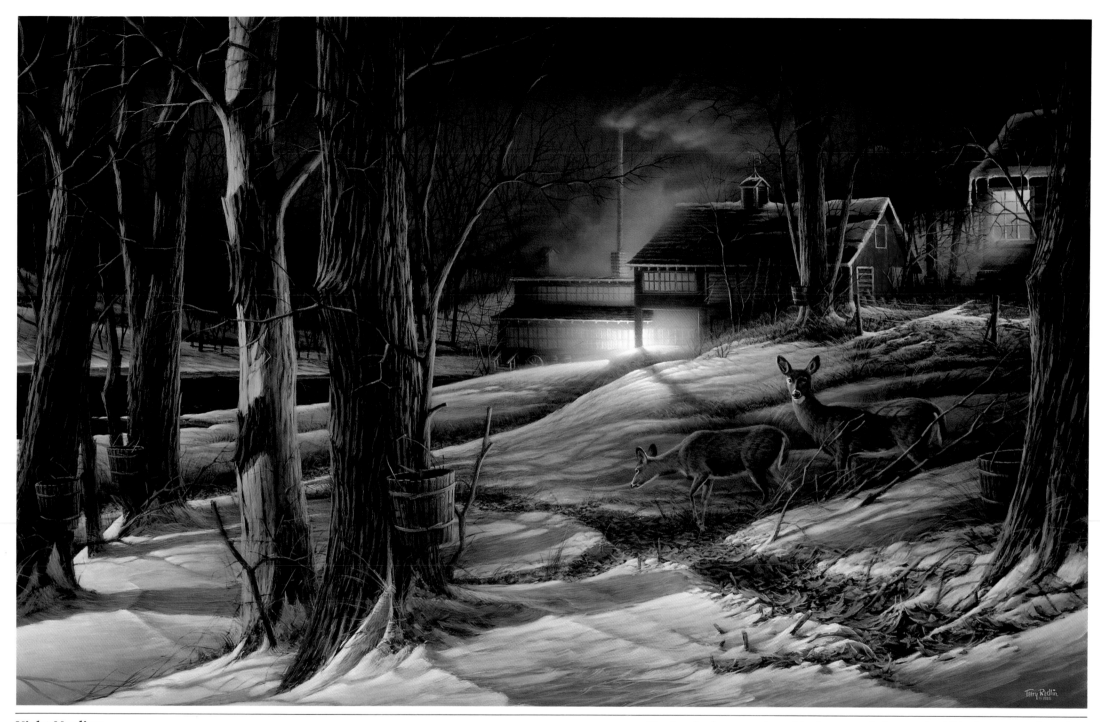

Night Mapling

During the long evenings this deep woods "sugar shack" is the center of much activity. Inside workmen boil down the collected sap and carefully prepare the refined syrup for market. Outside two curious white-tailed deer have been attracted by the lights. Following the same pathways taken earlier in the day by the artist and his friends the deer pause, tempted by the sweet, still running maple sap.

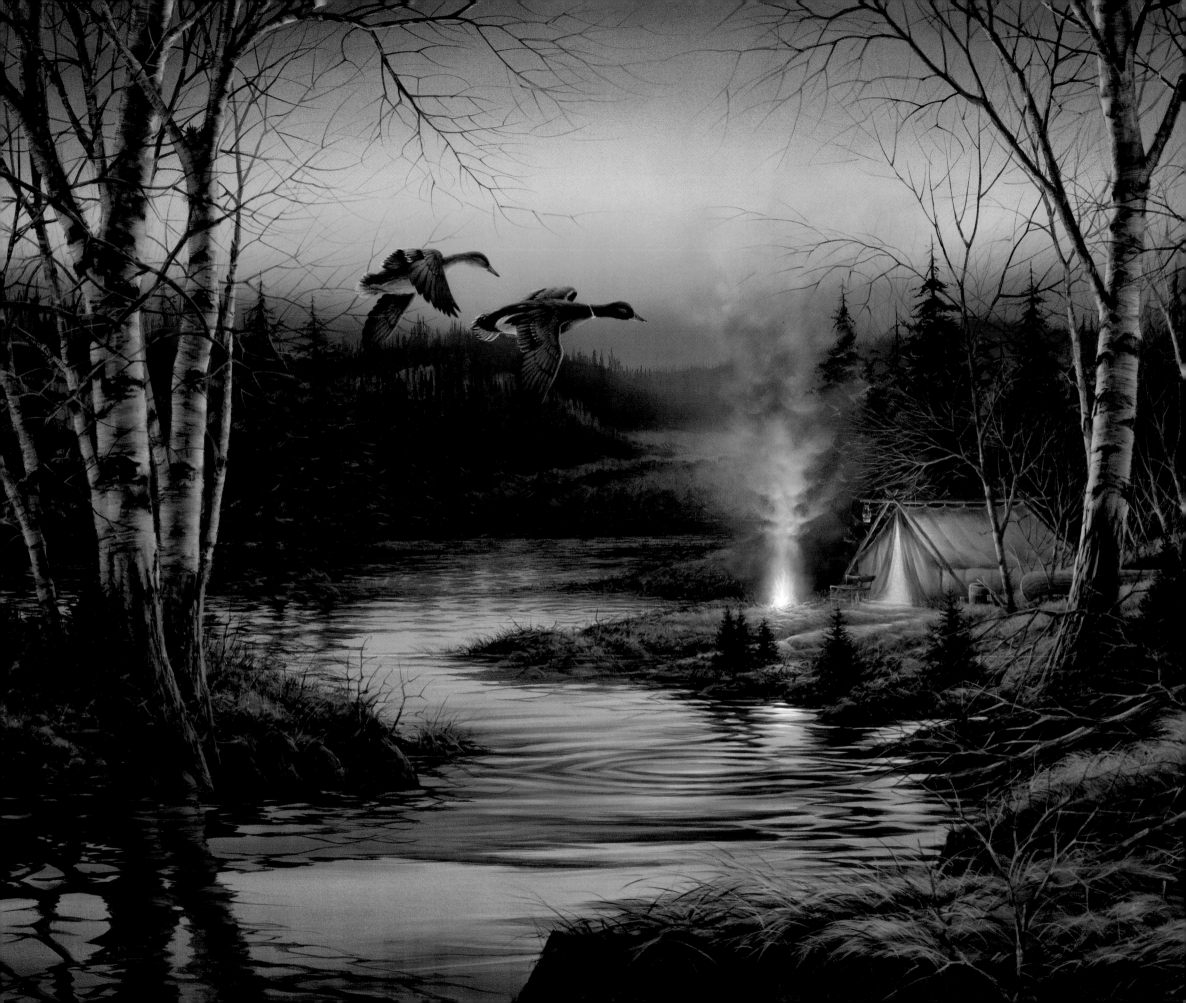

There is no clearer evidence of man's deep need to commune with nature than when he leaves his modern sanctuary and confronts the wild on its own terms. Man recognizes instinctively that in this space and solitude there can be the whisper of an answer.

Stripped of recreational jargon, engaging nature is at its best a spiritual experience. The message may not be realized at the time, but often surfaces when it is time to pack up and head home.

Then comes a sense that something special has happened, and that something special is about to be left behind.

We come to understand that nature and her wildlife have valuable insights to share with us. The scene we see here, and the images on the following three pages, address this primitive truth.

Twilight Glow

Birch trees frame this serene setting as the day's last light lingers on the horizon and reflects in the still waters. The campers have retired to their tent, but will return shortly to enjoy the crackling fire. A mallard pair swing by for a short visit, and then will continue on to their own resting place.

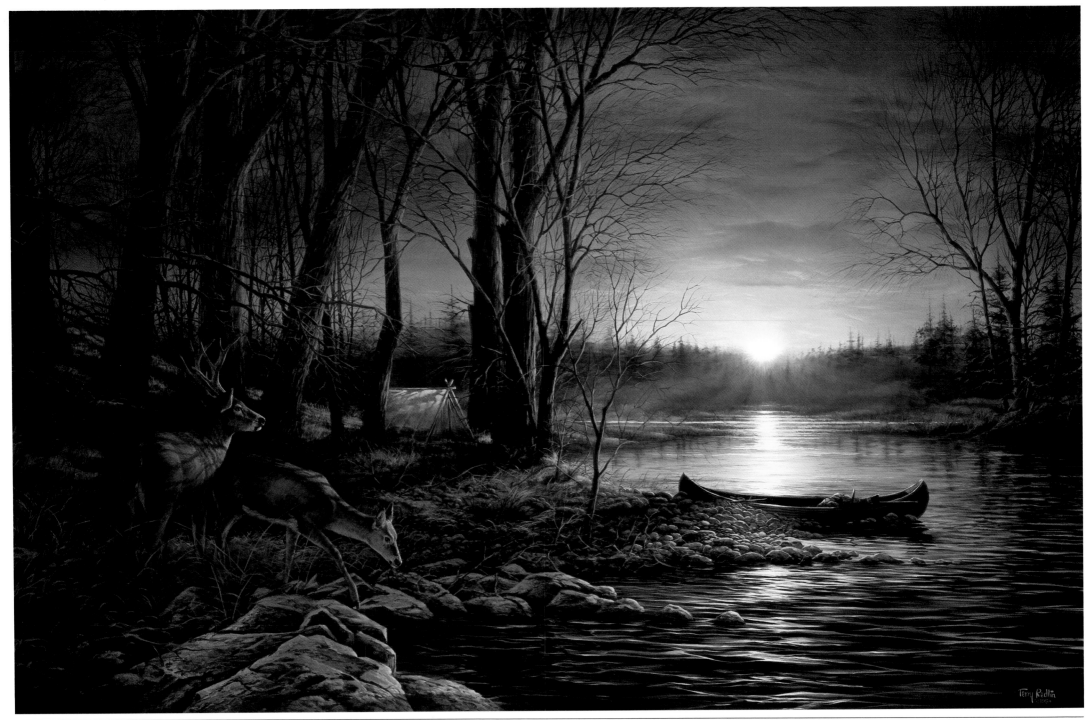

The rising sun has just topped the distant tree line revealing a camper's tent and canoe. A white-tailed buck and doe appear from the forest depth and cautiously approach the water's edge. The beginning of a new day has been signaled, and the tranquil mood suggests that in this corner of our world man and nature live in harmony.

Morning Glow

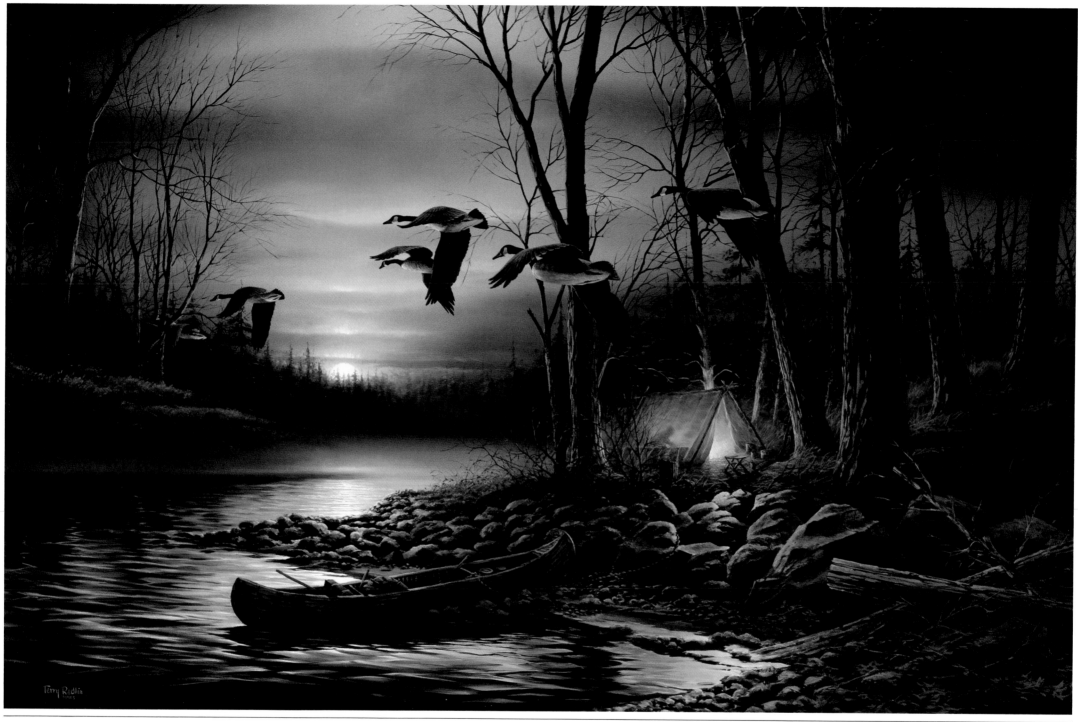

Evening Glow

It has been a day filled with deep satisfactions. No other camper has been sighted. The deer trail discovered back in the woods led to a hidden spring. A grouse was flushed from the aspen thicket. The wild call of the loon trivialized all human sounds. Now, as the day's activity turns to quiet reflection, Canada geese swoop low as if to say goodnight.

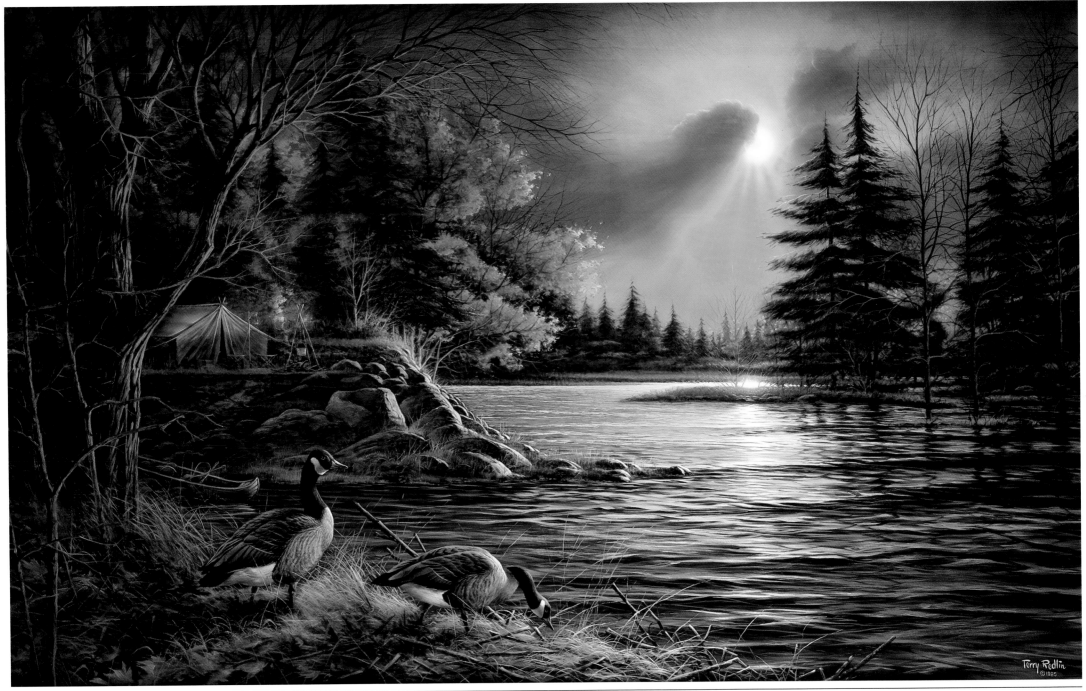

Afternoon Glow

It's that magic moment when the sun breaks through the overcast and showers nature with a mystical glow. The water surface is momentarily turned to fire, and casts its warm rays over the feeding geese. Such idyllic scenes cannot be recorded by camera. They are the province of those blessed with a romantic memory and the capacity to see beyond the literal and through the merely mechanical.

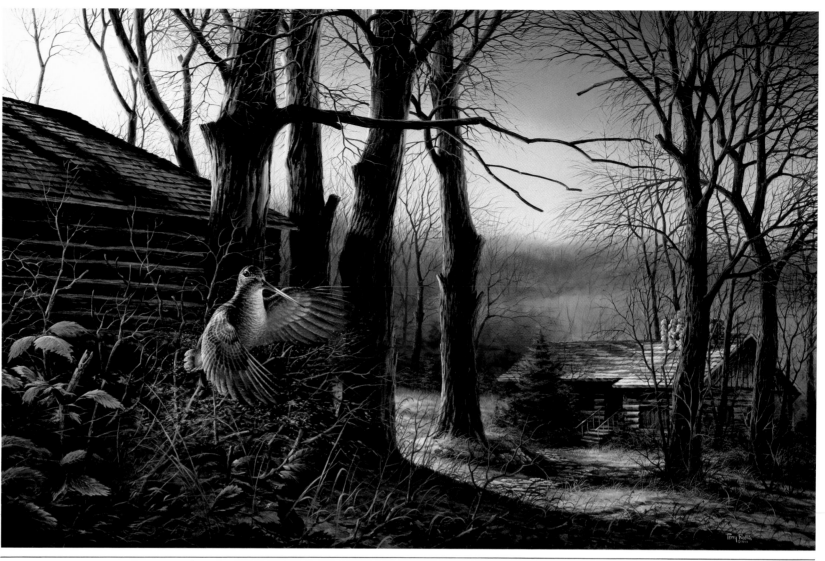

Closed for the Season

It's late in the season, the cabins are secured, and all human echos stilled. Now the elusive woodcock ventures forth to cavort about the silent buildings. This distinctive bird is one of nature's loners, seldom seen by the average person. But in this nostalgic fall scene the artist treats us to a close-up view.

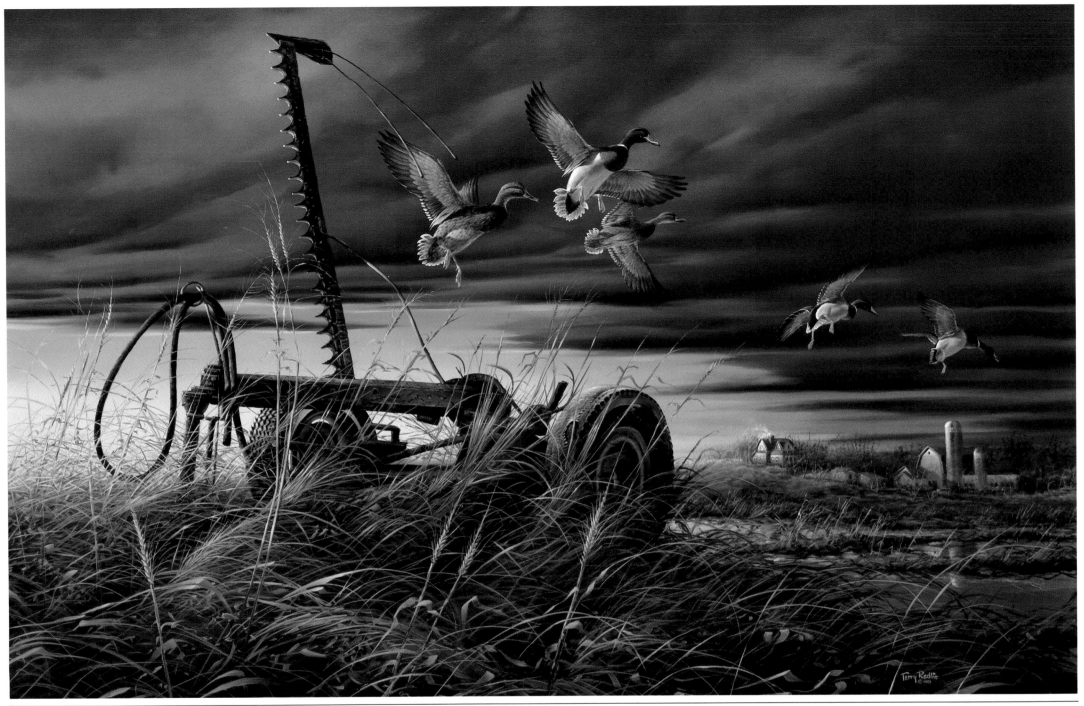

An aging sickle abandoned on the ridge provides a familiar bearing for the incoming mallards. Ironically, mother nature is slowly reclaiming the machine with the very element it was designed to control. Prairie grass has begun to cover this rusty relic, but by looking closely we can still see the jerry-rigged rims and bald tire, all of different vintages.

The Landmark

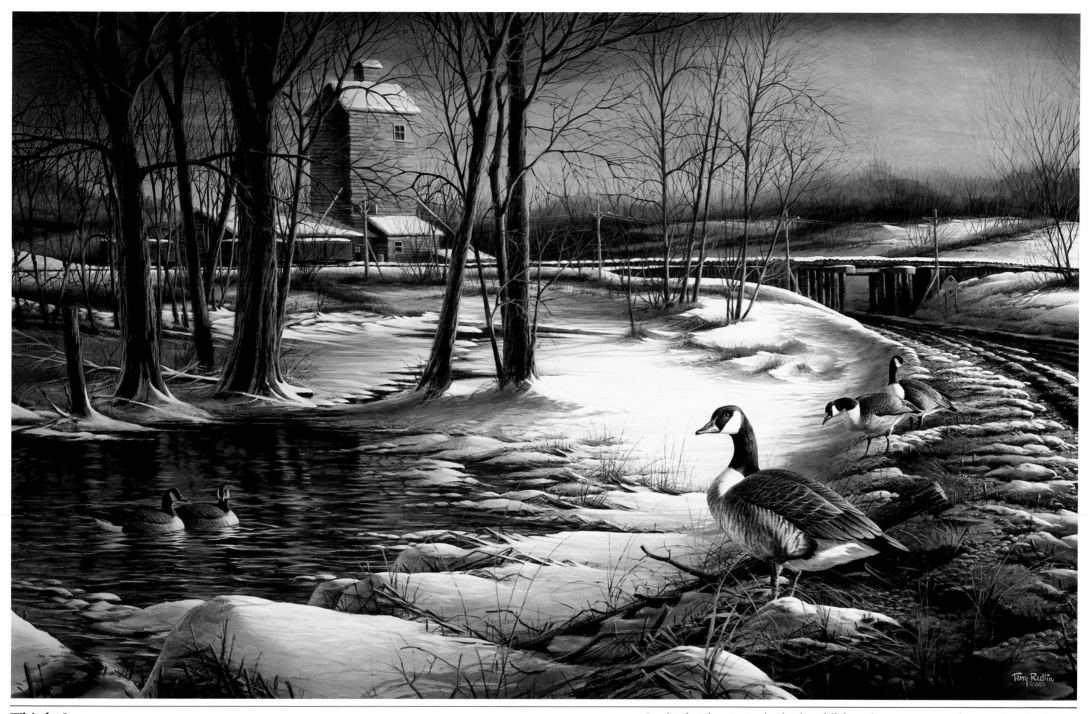

Whistle Stop

On this bright winter day both wildlife and man are at work providing for basic needs. The Canadas feed in simple style at a convenient roadside slough. In the distance a grain elevator and freight cars suggest a more complicated way of life. At peace with the world, the stately geese are unconcerned and will deal with man's noisy presence when necessary.

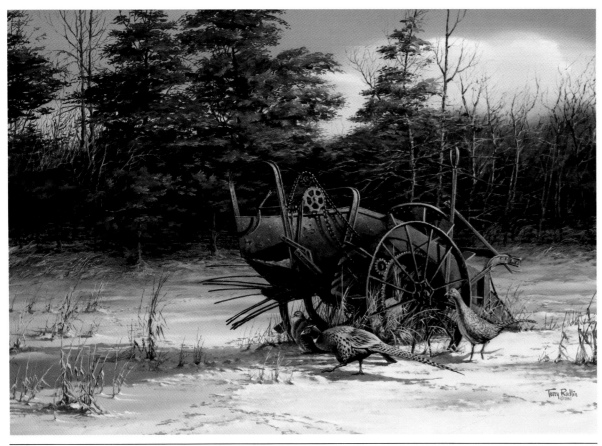

A trio of ring-necked pheasants find shelter in the lee of an old potato digger.

Rusty Refuge I

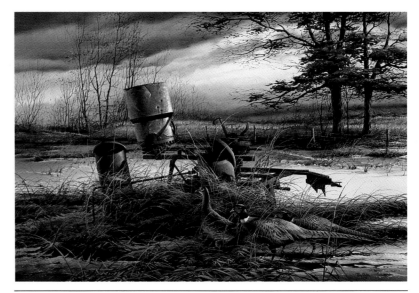

Curious pheasants inspect a discarded two row corn planter with missing fertilizer head.

Rusty Refuge II

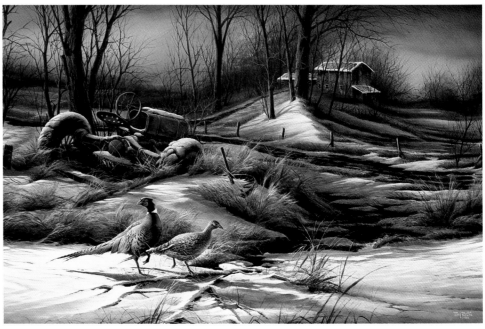

The low winter sun casts long shadows as this pheasant pair skirt an abandoned tractor.

Rusty Refuge IV

Both the farmer and pheasant are immigrants to America. Man and his tools arrived from Europe. The ring-necked pheasant was imported from China in the late 1800's.

The two first met as civilization crowded into the wild. They contested briefly and then slowly learned the art of accommodation.

Today, farmer and wildlife live in harmony, and with mutual respect. Their relationship is of special dimension. It is based on a deep understanding that the well being of both is subject to the same capricious forces.

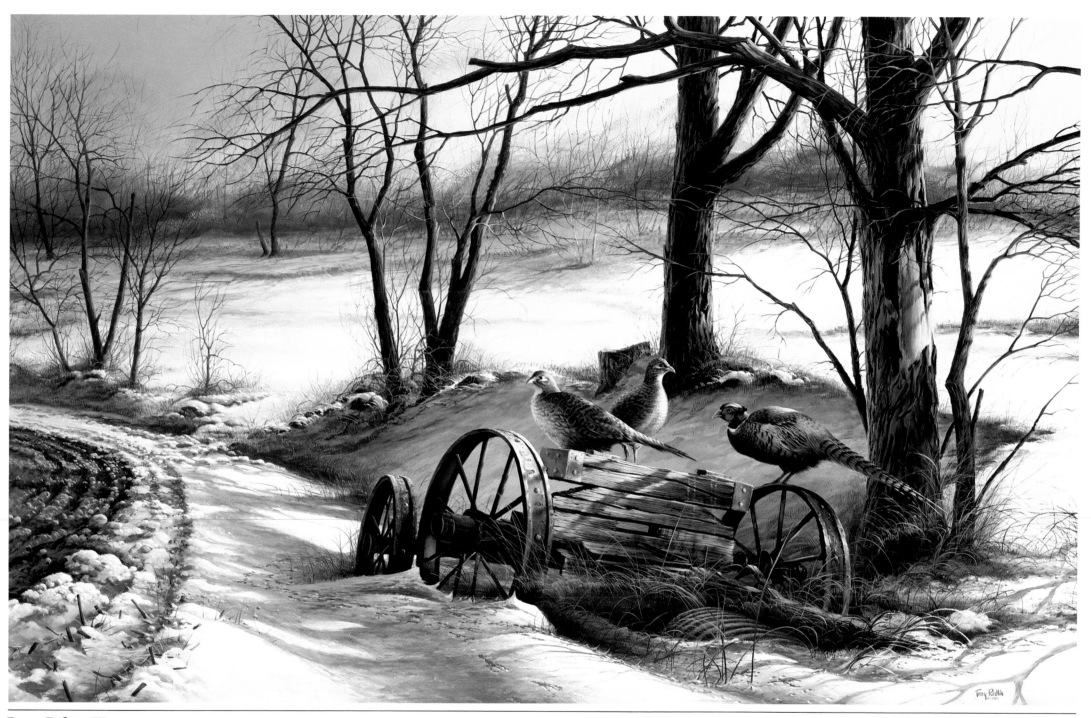

Rusty Refuge III

It is one of those almost perfect winter afternoons. The wind is stilled, and the warm sun reflects up from the bright snow cover. In this peaceful setting three ring-necked pheasants have found the ideal roost. A long ago farmer has left his worn out wagon by the side of the road. It is only a skeleton now, but serves as a poignant reminder of people and their dreams passing from the land.

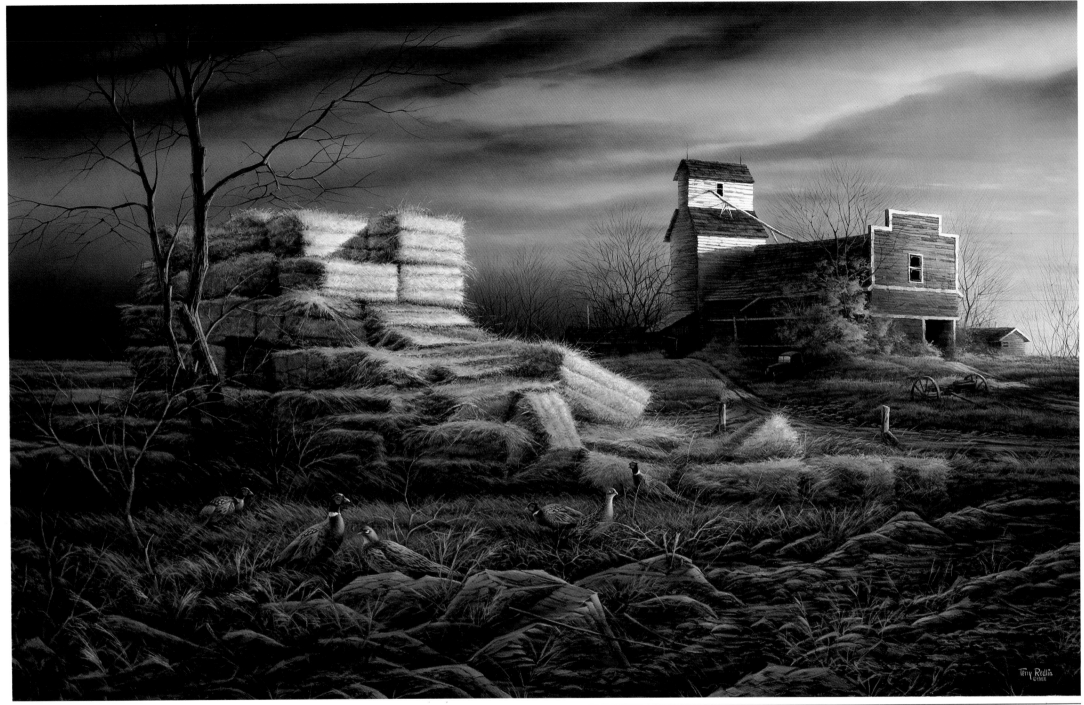

Prairie Monuments

The deserted crossroads elevator was once at the center of a thriving farm community. It now stands mute, a victim of man's progress. In the foreground freshly stacked hay bales seem to mock, in both form and substance, the abandoned elevator. Their presence indicates man still occupies the land, but with a new set of priorities. The only witnesses to this transition are the calmly feeding pheasants.

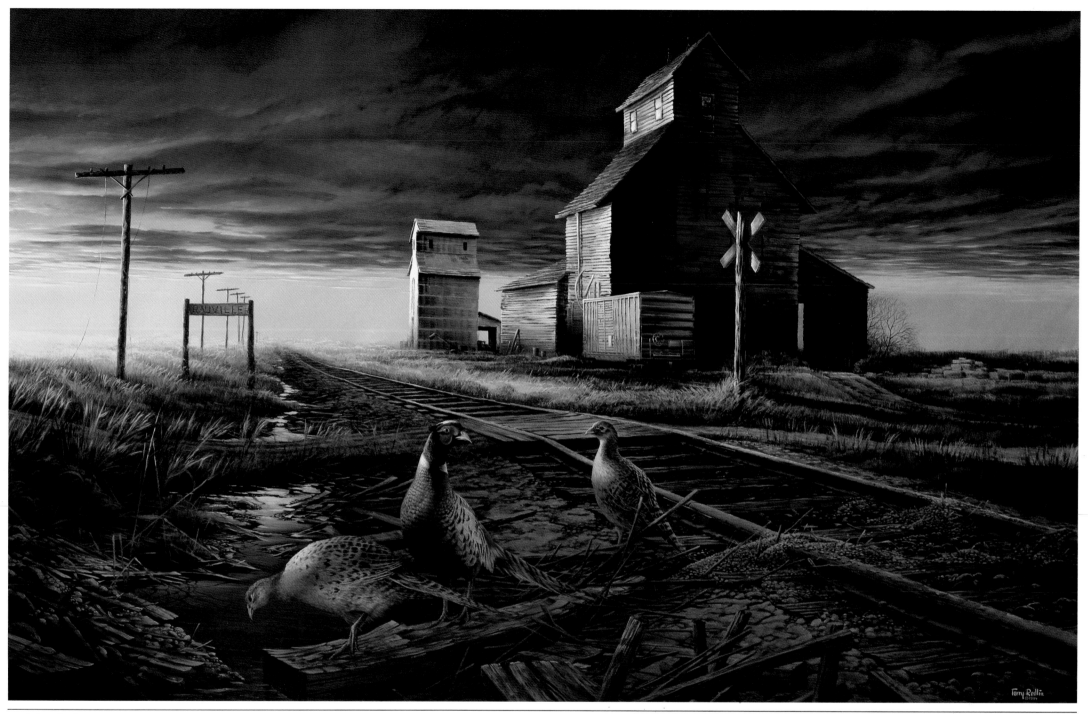

Prairie Skyline

This isolated prairie elevator is an actual location four miles from the artist's hometown in eastern South Dakota. As a young boy Terry Redlin often visited the area, sketching and honing his creative skills. Forty years later he returned to renew the vision. The result is this dramatic painting that captures both the vastness of the plains country, and the wildlife who survive regardless of man's intrusions.

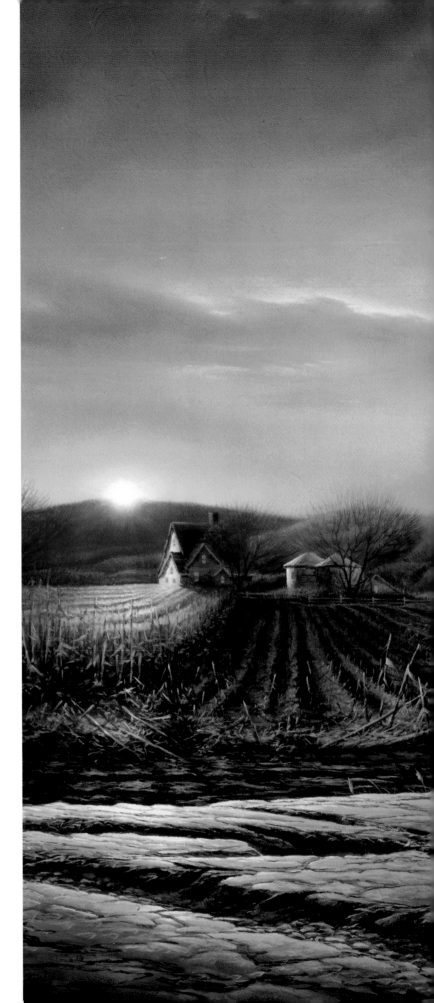

Evening Harvest

To those fortunate enough to have lived in rural America the scene is a familiar one. It's a beautiful fall evening, the fields are dry and tonight the farmer is working late to harvest the corn.

Even when the sun dips completely behind the hill line he'll continue in the cool night air, operating with tractor lights which have already been turned on.

The ring-necked pheasant pair watch from field's edge, keeping the rock out-crop between themselves and the noisy equipment. The farmer will complete his work tonight, and in the morning the pheasants will leave their hiding place and scour the field for their share of the harvest.

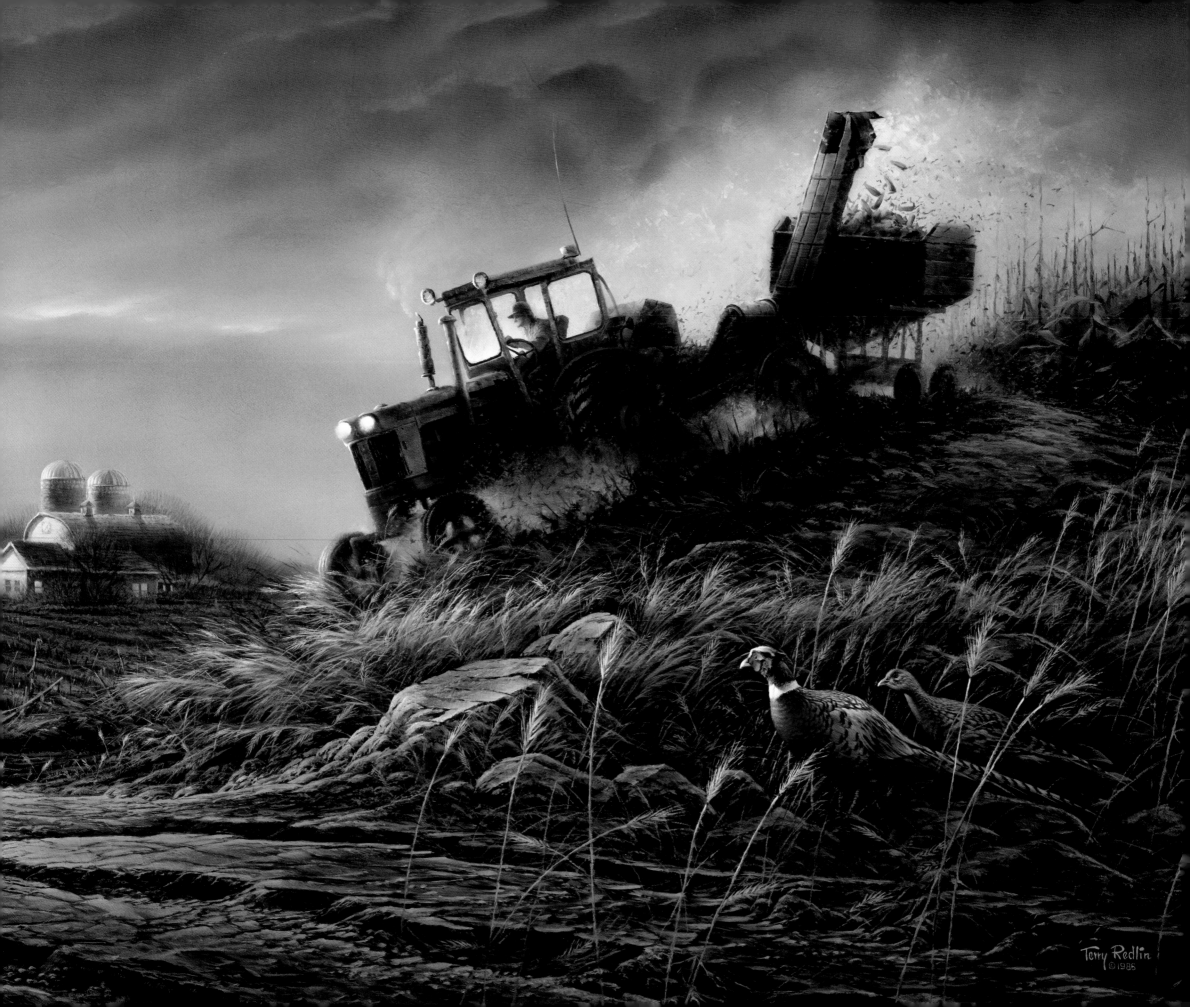

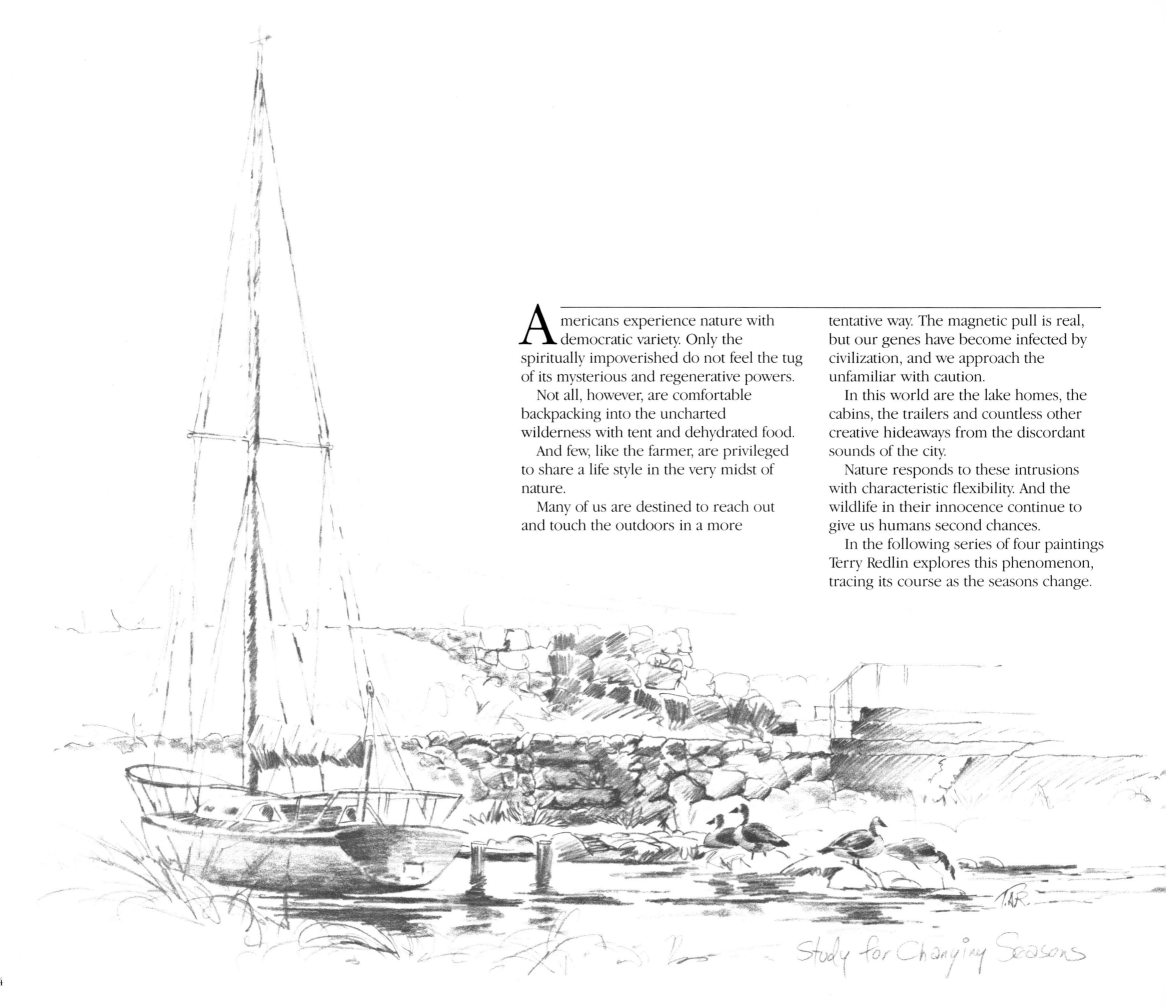

Americans experience nature with democratic variety. Only the spiritually impoverished do not feel the tug of its mysterious and regenerative powers.

Not all, however, are comfortable backpacking into the uncharted wilderness with tent and dehydrated food.

And few, like the farmer, are privileged to share a life style in the very midst of nature.

Many of us are destined to reach out and touch the outdoors in a more tentative way. The magnetic pull is real, but our genes have become infected by civilization, and we approach the unfamiliar with caution.

In this world are the lake homes, the cabins, the trailers and countless other creative hideaways from the discordant sounds of the city.

Nature responds to these intrusions with characteristic flexibility. And the wildlife in their innocence continue to give us humans second chances.

In the following series of four paintings Terry Redlin explores this phenomenon, tracing its course as the seasons change.

Study for Changing Seasons

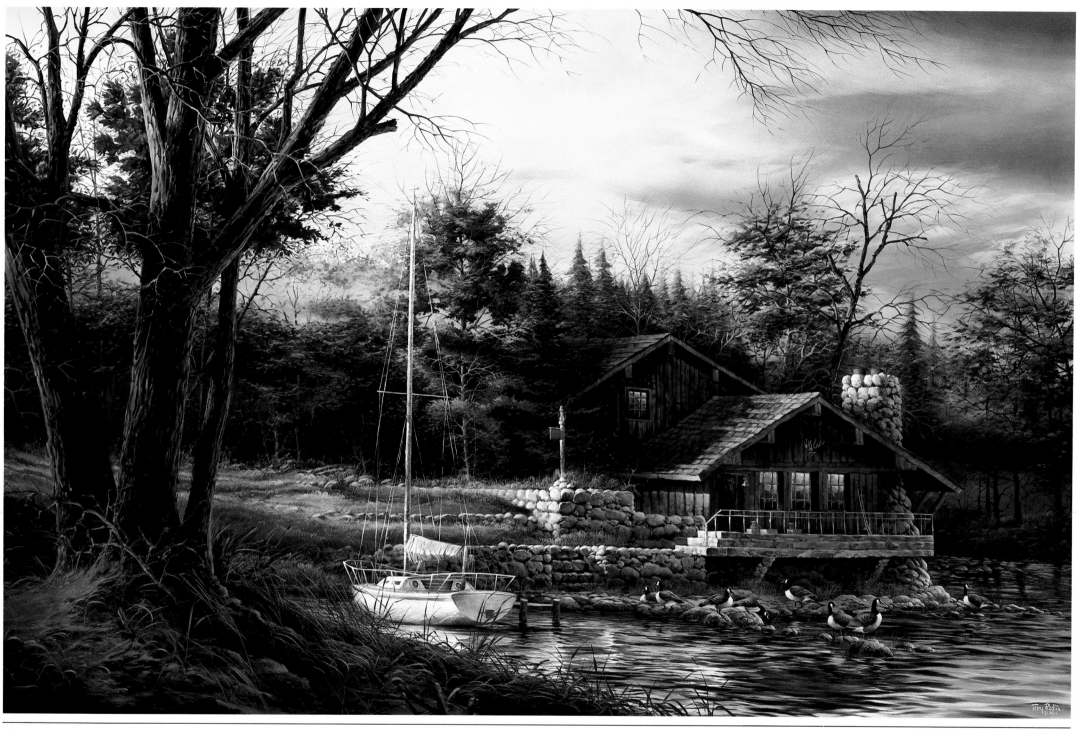

Changing Seasons—Summer

Somewhere, tucked away near the water's edge, is a wilderness dream home. One version of this reverie is presented to us here: a spacious log home with stone fireplace, a balcony from which to watch the geese who have taken up residence just below, and a sailboat for those windswept days on the bay. Expected soon are friends from the city to share for a few hours a portion of this deep woods poetry.

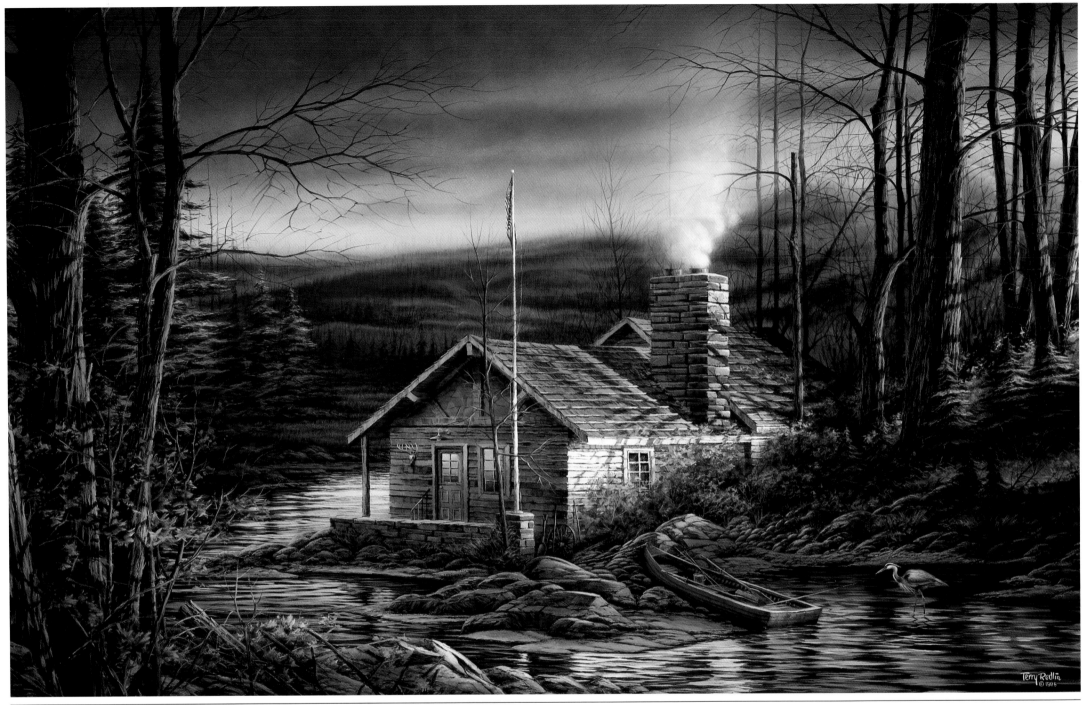

For many autumn is the most thoughtful season of the year. The trees and foliage have proudly displayed, and then quietly shed their colorful apparel. The old wooden fishing boat has taken its last trip until spring. A great blue heron has made a final surprise visit. A pensive mood permeates the air. As nature slips into low gear the more reflective among us are reminded of their own changing of the seasons.

Changing Seasons—Autumn

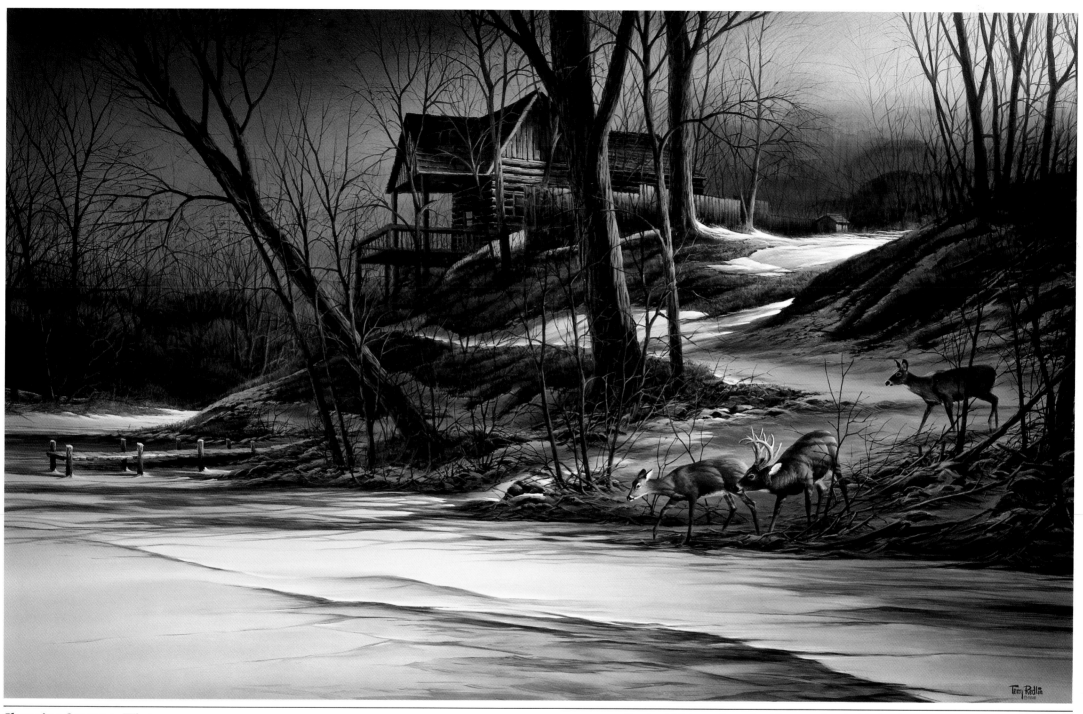

Changing Seasons–Winter

Perched high on the ridge like a castle of old, this log house is a commanding presence. However, winter's attack has dispatched its human inhabitants to warmer quarters, leaving the field to more hearty creatures. The deer are now in charge, free to roam in search of browse. Although winter still reigns the sun has melted away patches of snow on the exposed south slope, awakening small areas of grass.

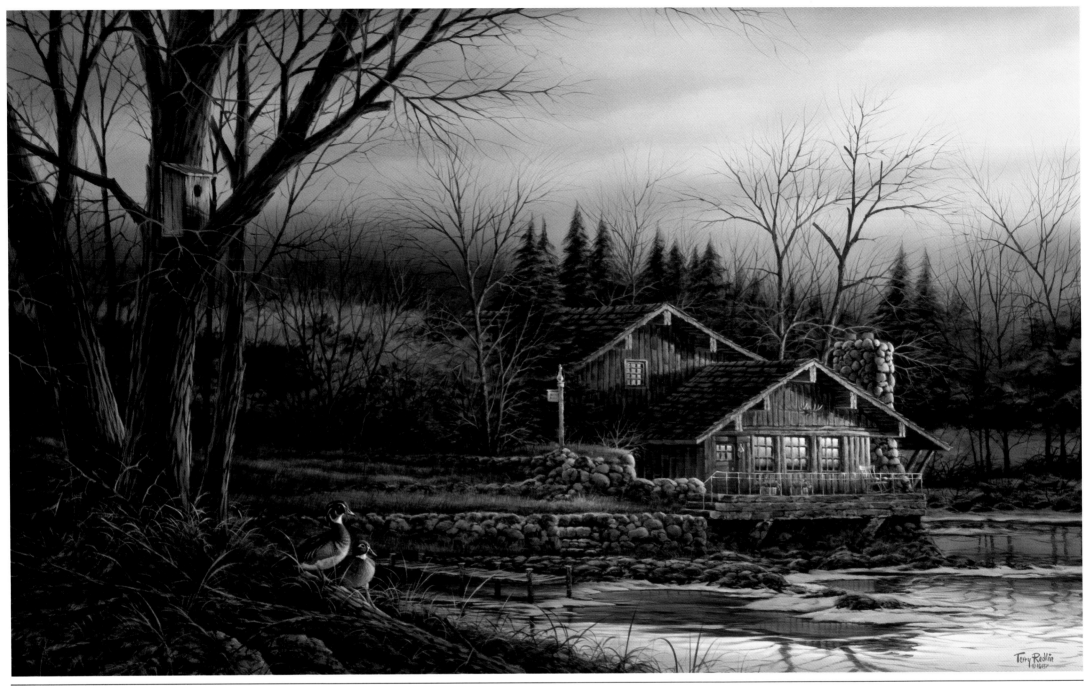

It is the beginning of a new cycle. The ice has retreated except for stubborn strips along the shoreline. The spring sun's nurturing rays have begun to turn the sleeping ground cover to green. The log home glows in the warm spring light, and a rocking chair on the balcony tells us the owners have returned. From the nearby bank two wood ducks survey the scene. Just returned from their southern vacation they, also, will enjoy a man-made home to celebrate this season of fresh beginnings.

Changing Seasons—Spring

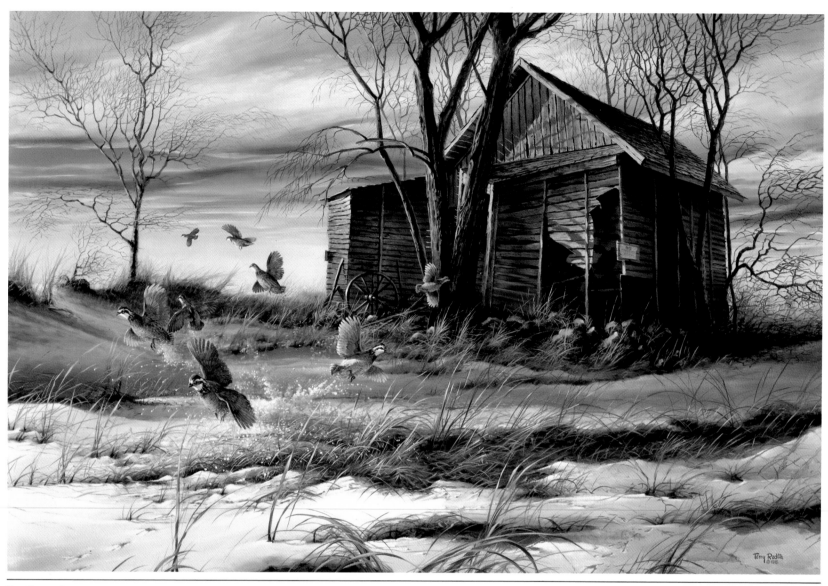

Broken Covey

A small covey of bob-white quail have been startled out of their weed and seed patch. The intruder may have been a hungry fox, or perhaps only the wind stripping the tree of a dead branch. Regardless, this protected location is an ideal feeding spot, and there is little doubt the quail will return.

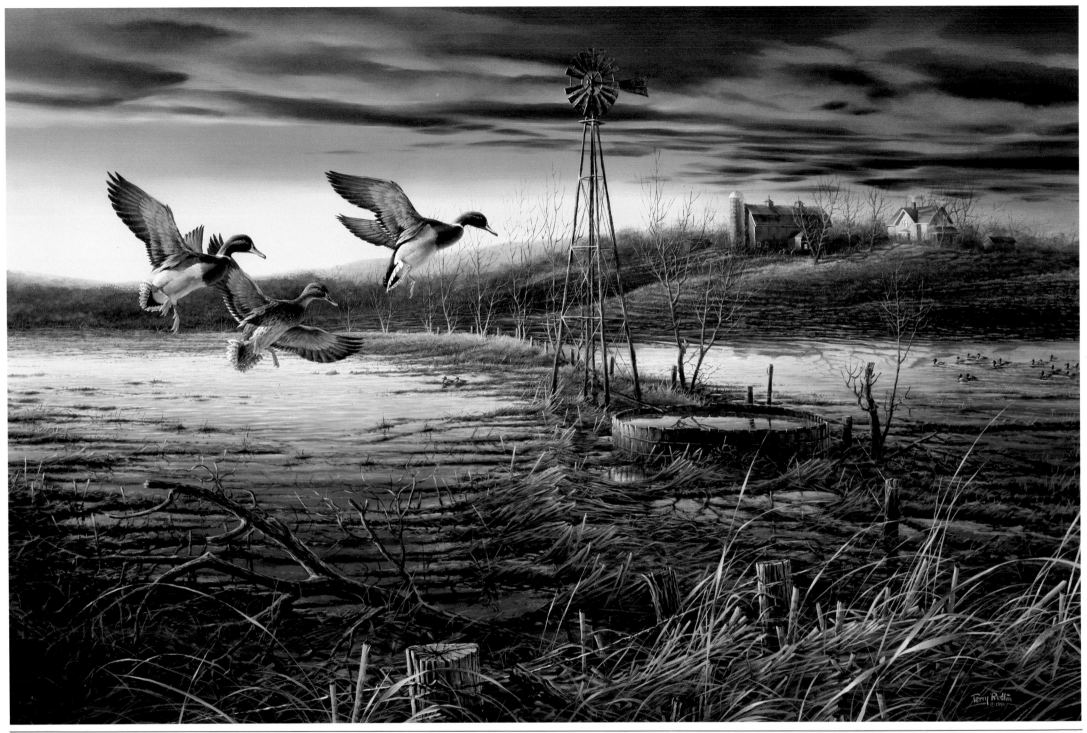

The tree lined ridge between two spring flooded fields creates a mini-pass and alternate resting spots for the three in-coming mallards. They'll stay overnight, then join the earlier arrivals and continue their journey north. While the farmer does not begrudge the mallards the use of his land, he hopes the fields will dry soon for spring planting.

Spring Run-Off

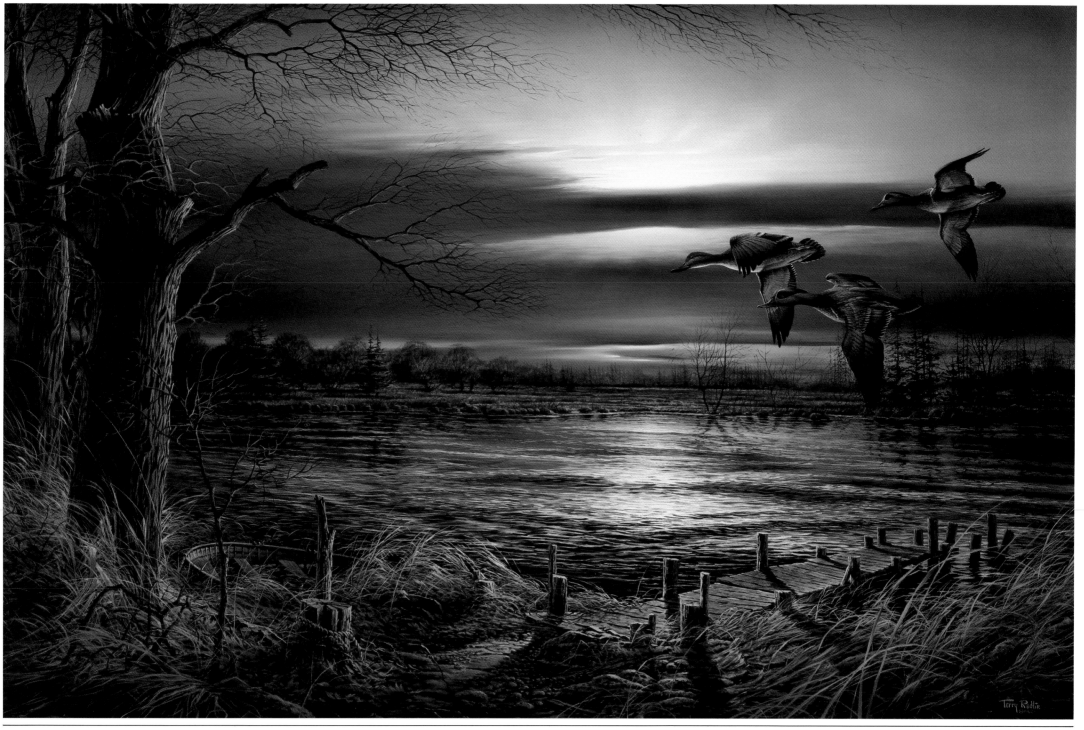

Reflections

Set against the mood of a late afternoon sun, three green-winged teal twist and slip silently past two familiar landmarks. The old wooden fishing boat lies neglected and partially submerged. The dock has been witness to many a big catch, but is now badly in need of repairs. Both vestiges of man's presence give pause for reflections of another time and place.

Eyes on the Future

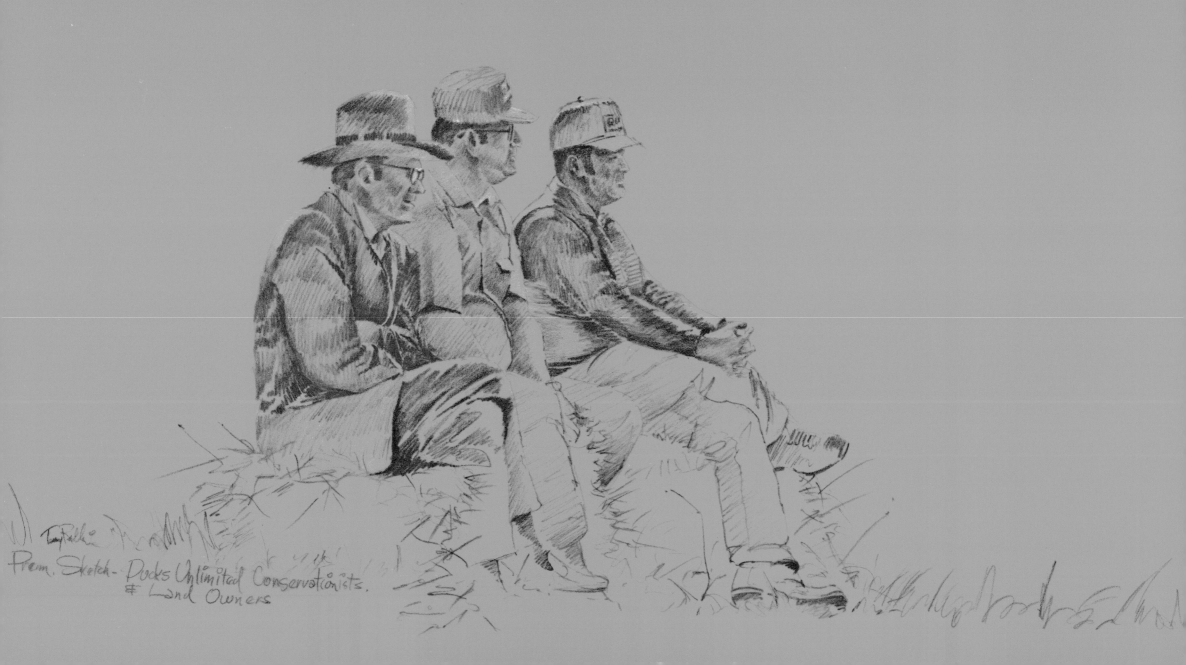

Prem. Sketch- Ducks Unlimited Conservationists.
& Land Owners

Protecting a Common Heritage

To many, the wildlife about us are seen primarily as a moving panorama of colorful decorations. To those of cynical calling, wildlife exists solely to be conquered and exploited.

However, to a growing number of sportsmen wildlife is viewed quite differently. To these outdoorsmen wildlife is to be both enjoyed and used in its manifold forms, but also protected and given every opportunity to prosper.

Working against a history of over abundance and under concern, wildlife conservation organizations are striving to maintain a balance between the wants of man, and the survival needs of our wildlife populations.

They have accepted the important connection between all of nature's creatures. They understand that as any part of nature is carelessly destroyed, to that extent our humanity is discounted.

There are many such conservation groups operating in the United States, Canada and Mexico. Without their intervention species we now take for granted would no doubt be, if not extinct, gravely threatened.

Terry Redlin, as both sportsman and wildlife artist, has actively supported many of these conservation groups. During the past ten years alone, he has donated original paintings and prints of his art that have raised over six million dollars to purchase and restore wildlife nesting and feeding areas.

A selection of these paintings is illustrated in the following pages, representing one man's effort to protect a heritage we all share.

Hunters are a distinct species which defy easy generalization. They are manifested in a colorful variety of shapes and sizes. But, however packaged, they share in common two characteristics: an optimistic outlook and a romantic imagination.

To this breed of outdoorsman the next flight of teal will surely turn toward their hidden blind and come in low. The next slough, just over the rise, will reveal ample potential to fill out the limit. The weather tomorrow will be just right to keep the migrating flights in range.

And, eventually, as nightfall ends the wait or the search, the talk among hunting buddies turns to a favorite subject. In this relaxed mood the imagination conjures up that ideal hunting lodge. The details vary as the stories unfold, but all share a common vision.

This rustic cabin will be located in the deep woods, within a stone's throw from water. It will be far enough from home to create the sense that civilization has been left behind. But not so far as to make the return trip a burden. It will have plenty of room to sleep best friends. The weather will always be just right for either fishing or hunting. And the sunsets, of course, perfect.

Golden Retreat

Terry Redlin understands every hunter's need for a golden retreat. One such hideaway is beautifully recreated here, and also in the following two images. The regular print editions from all three paintings in this Retreat Series were donated to Ducks Unlimited Inc.

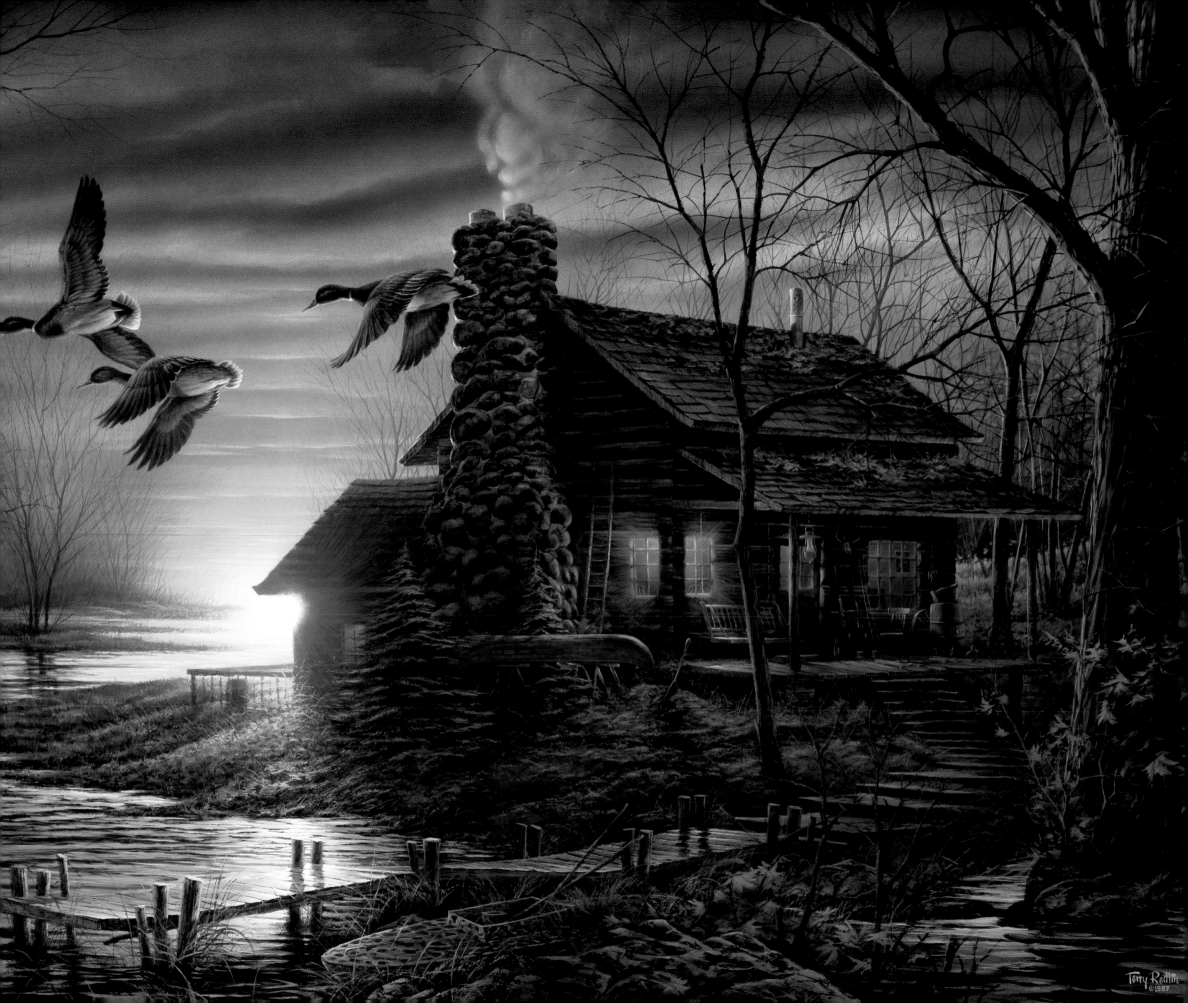

Terry Redlin ©1987

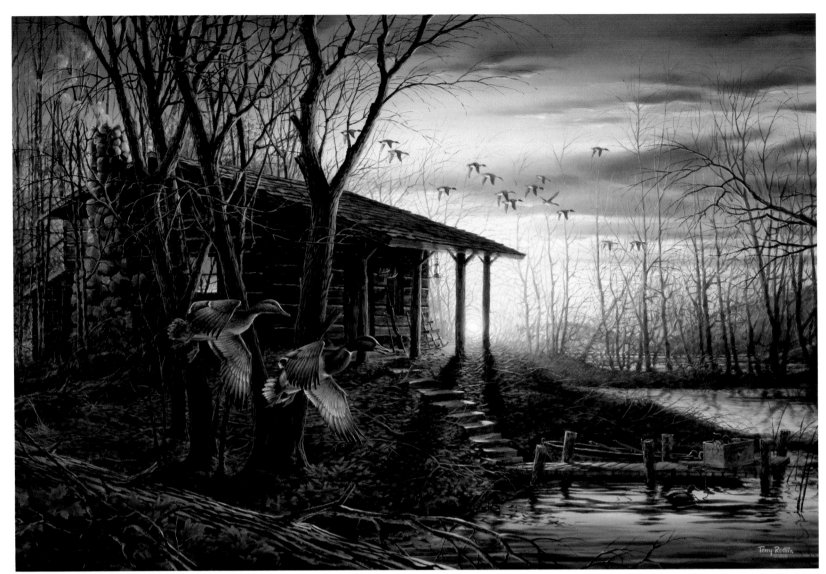

Morning Retreat

The single gun leaning by the cabin door indicates the first hunter has arrived. The lighted window suggests he is awake, but on this first morning too late to see the high flying honkers, or the mallard pair sweeping gracefully across the foreground.

Evening Retreat

It's early evening, and the geese are searching for a place to roost. The two shotguns propped against the cabin wall indicate our friend's partner has arrived. And, because at this retreat all ends well, we can report the day's hunt a success.

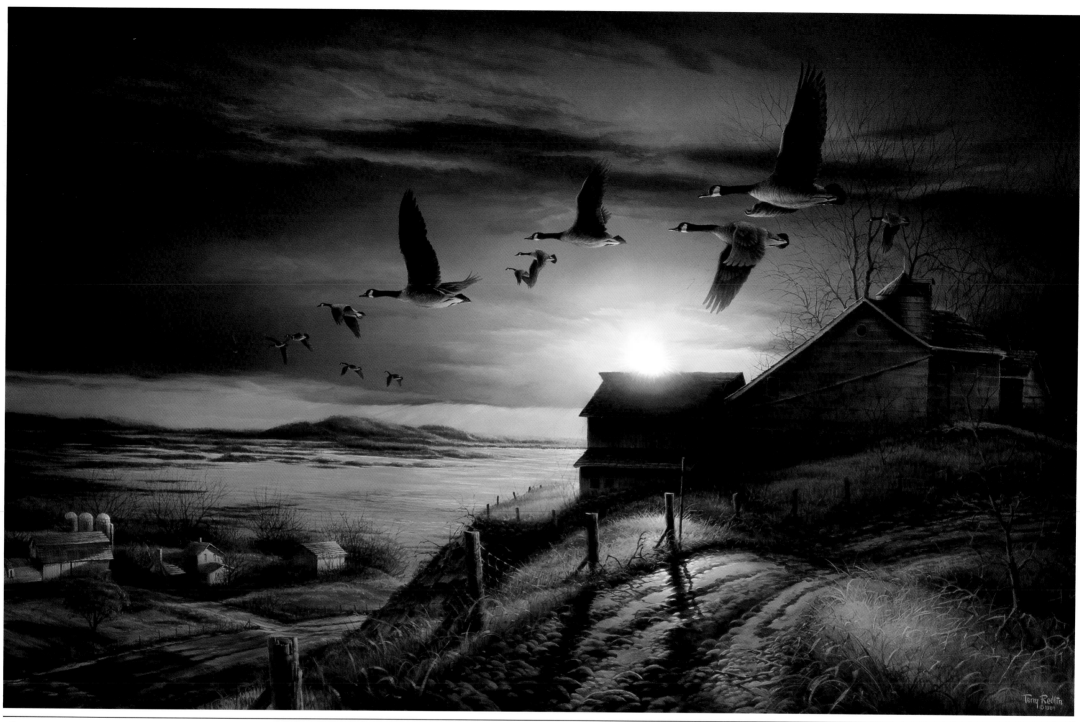

Clear View

As the sun breaks through a heavy cloud cover, the low flying honkers get a clear view of their destination. The lake below has been momentarily bathed in warm light, as have the deserted buildings on the ridge. The eroded road and the broken fence line indicate that the farmer has moved to more modern facilities at the bottom of the hill. Regular edition prints from this painting were donated to North Dakota Ducks Unlimited.

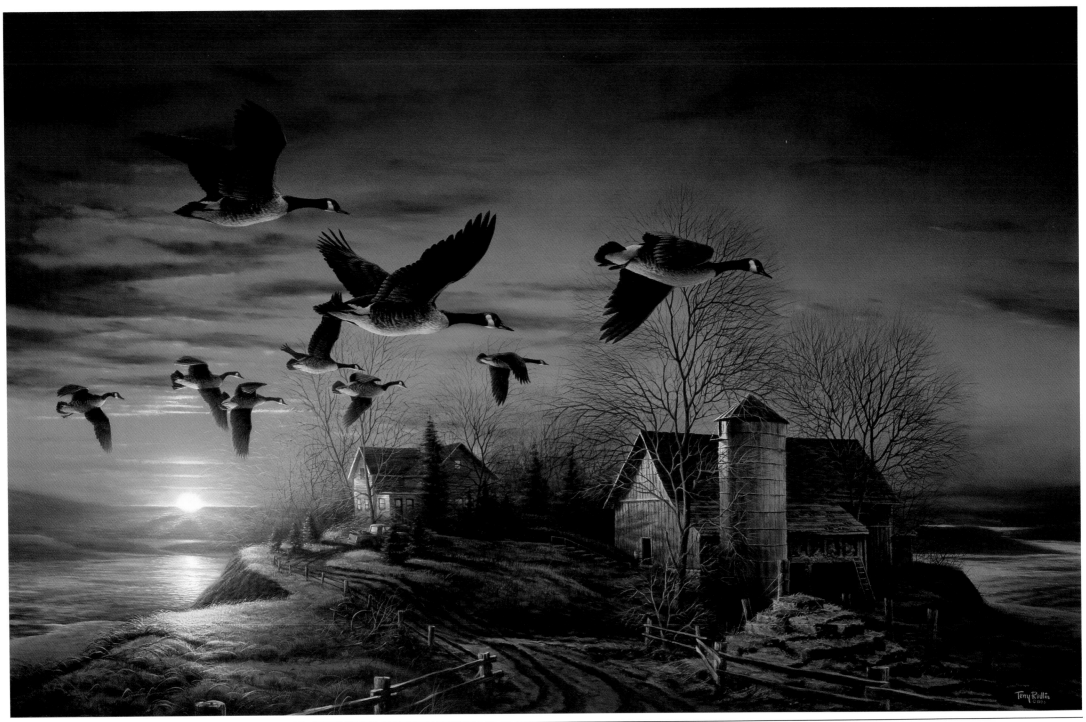

Sundown

The farmer has chosen a spectacular location high on a jagged point of land. It not only offers a grand panorama of the surrounding country, but a vantage point from which to watch the migrating waterfowl. At sundown he is rewarded by a close-up of giant Canadas as they pass a few feet overhead. Regular edition prints from this painting were donated to South Dakota Ducks Unlimited.

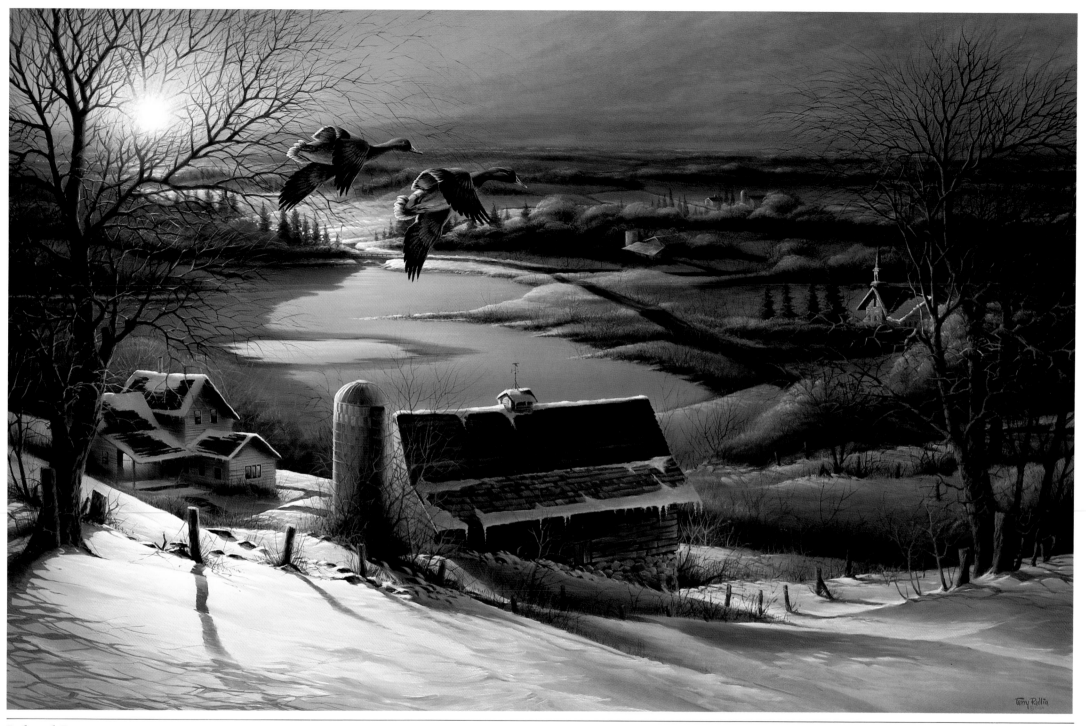

Delayed Departure

This green-winged teal drake and hen have gotten a late start on their annual journey south. The ground is already covered with deep snow, and only a small area at the center of the frozen lake offers open water. With the late sun reflecting brightly off this open surface, the teal pair will soon notice and head down to spend the night. Regular edition prints from this painting were donated to Wisconsin Ducks Unlimited.

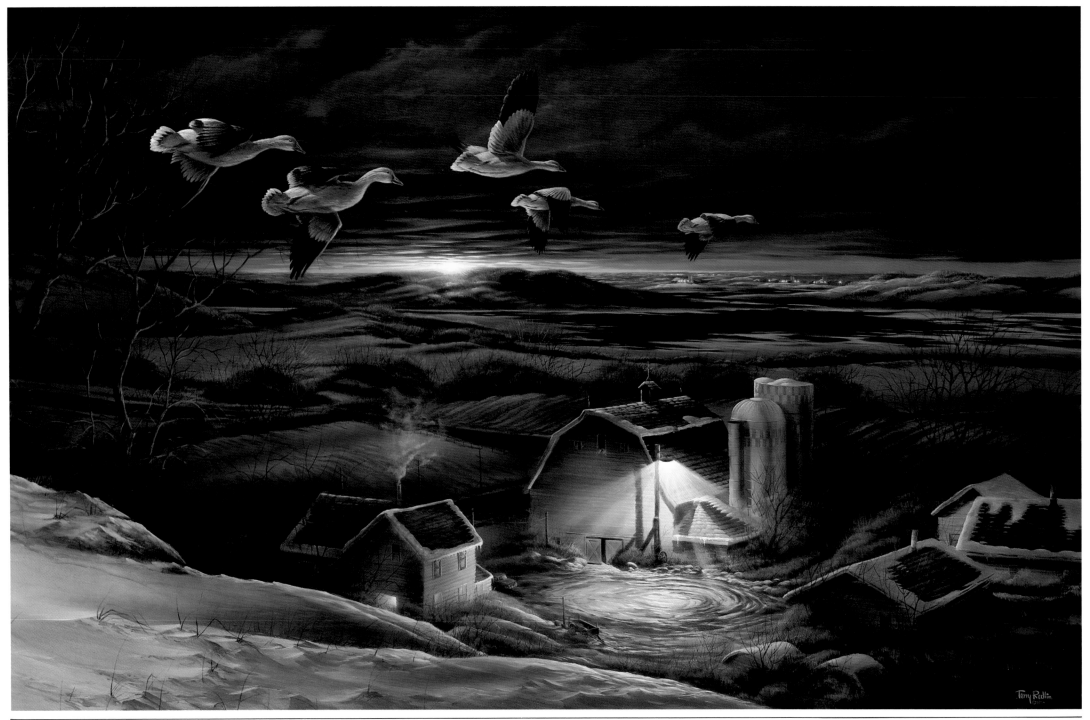

Boyhood experiences gave inspiration to the artist for this dramatic scene. During winter nights he hunted the countryside for cottontail rabbits, and yard lights from nearby farms became friendly beacons to guide him home. These snow geese, contrasted against the dark sky are attracted by the same lights, but unlike the artist have been directed to the wrong home. Regular edition prints from this painting were donated to South Dakota Ducks Unlimited.

Night Light

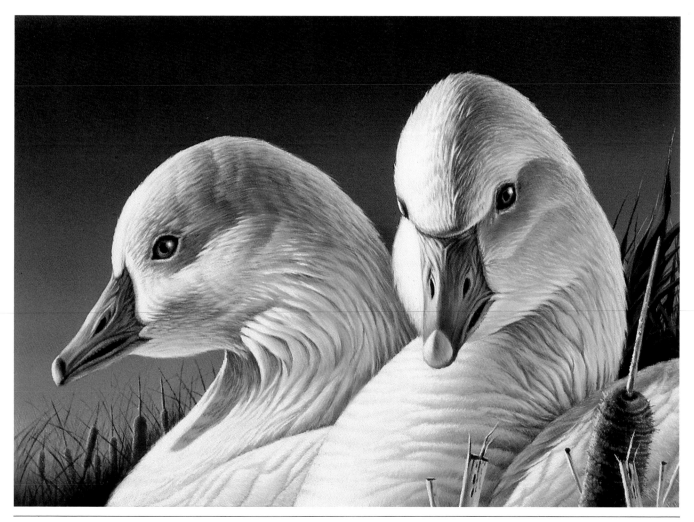

Ross' Geese – Head Study

Ross' geese are almost identical in appearance to snow geese, but considerably smaller in size. They breed in the far north of Canada and, using western flyways, winter in California. Relatively rare in the 1950's, this beautiful species has recently made a remarkable comeback.

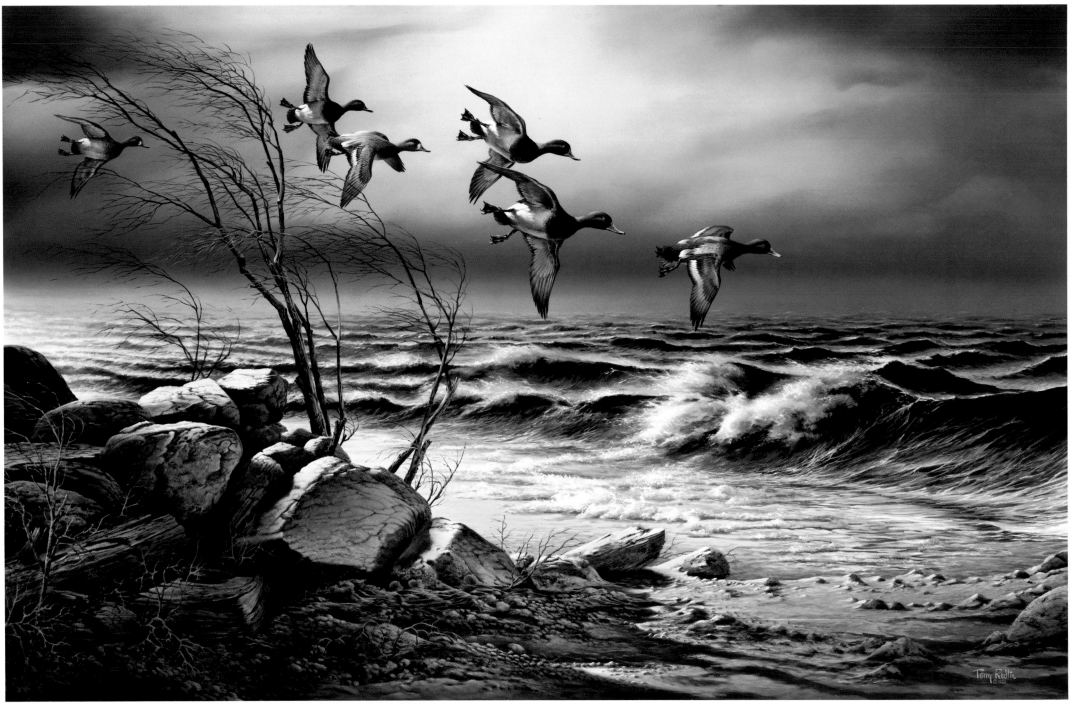

Strong onshore winds whip the wave tops into spray, and bend the small trees on this barren shoreline. The day has turned nasty on the big bay, and the bluebills are flying low, working hard to round the point and reach a resting area on the lee side. The artist has pictured for us an elemental struggle, pitting the raw power of wind and wave against the relatively frail waterfowl. We can be assured that, at least for the present, the bluebills will prevail. The original painting and regular print edition were donated to Minnesota Ducks Unlimited.

Bluebill Point

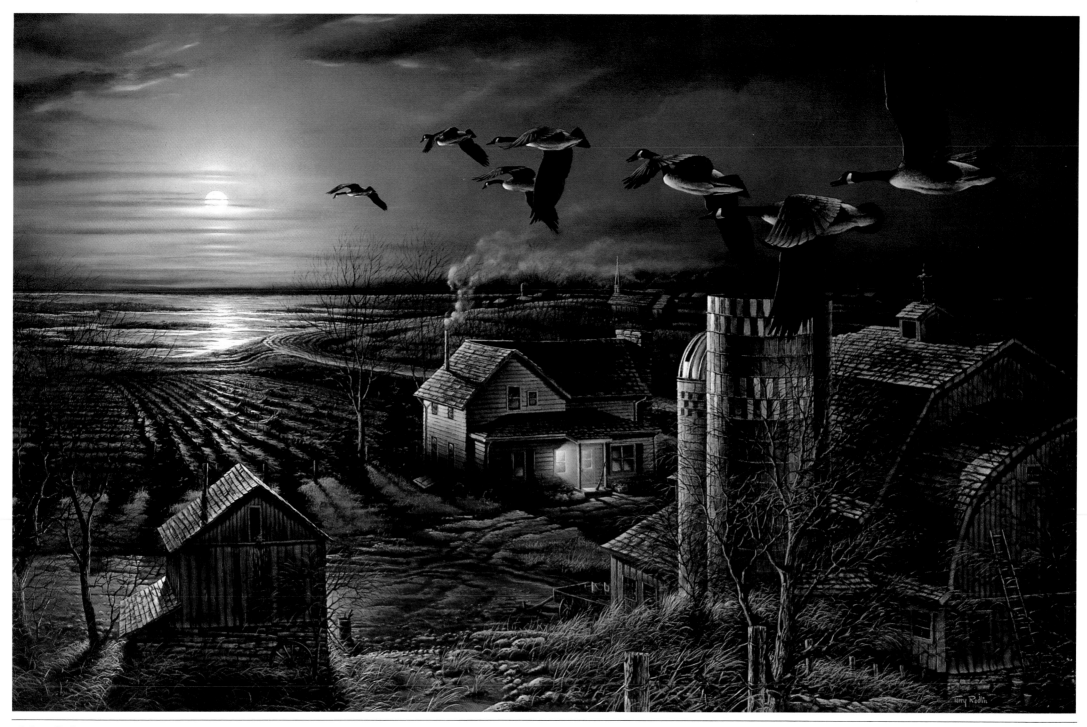

Night Flight

In 1983 Terry Redlin was named Ducks Unlimited Artist of the Year. This honor by the premier waterfowl conservation organization recognized both his artistic achievements and the many contributions to their on-going programs. The painting itself exemplifies what such efforts accomplish. As the geese pass over man and his works, they head for a spacious wetland area that has been preserved for their use. The original painting and the copyright to reproduce the painting were donated to Ducks Unlimited Inc.

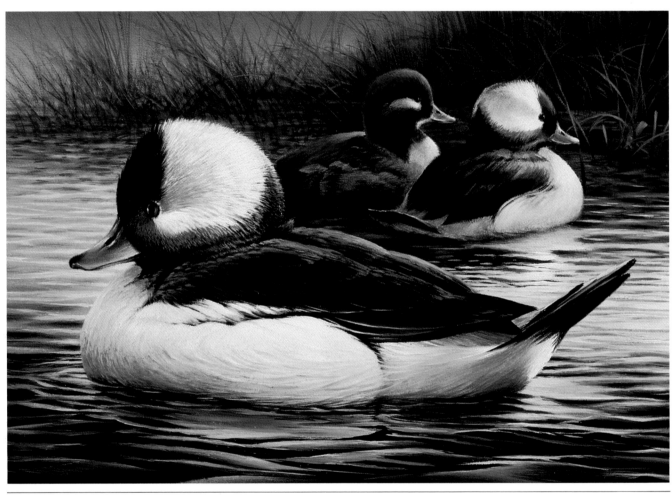

Often called "butterballs" to describe their appearance after a summer of eating and resting, the bufflehead is nevertheless a fast flyer. Here we see clearly two drakes with their distinctive white-crested heads and the hen with her white cheek accent.

Buffleheads

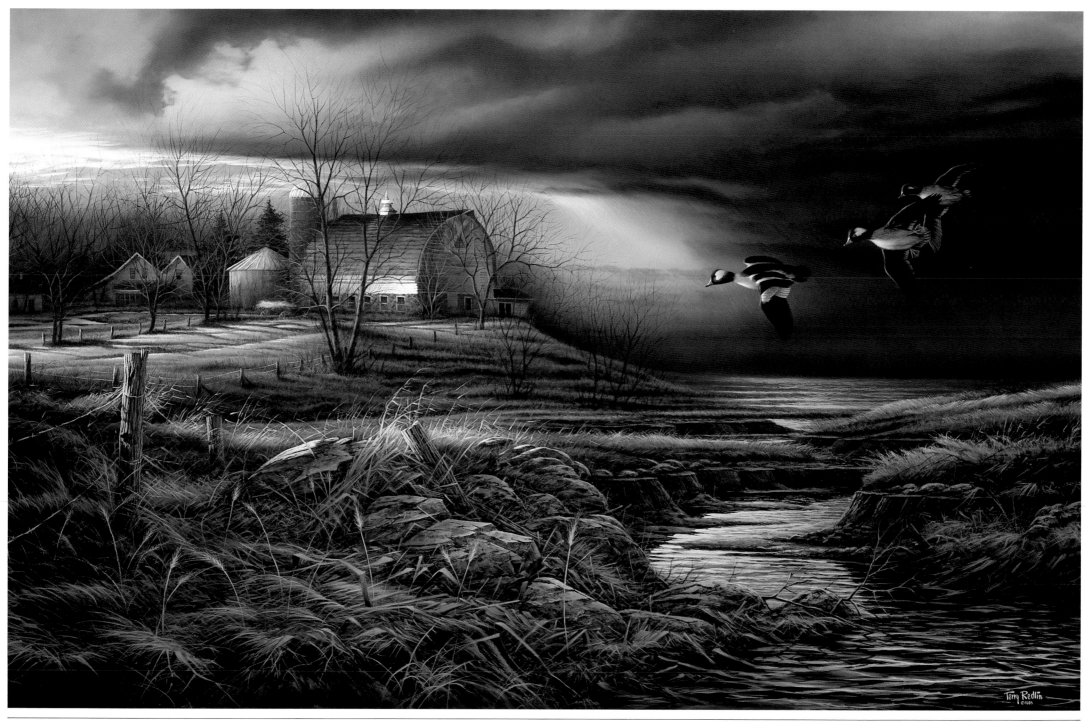

Stormy Weather

A storm is brewing across the lake. Ominous dark clouds are preceded by a rain line which is quickly capturing the blue sky and covering the land with a shadowy mantle. Three buffleheads strain to keep ahead of this threatening weather and are about to find shelter in the protected creek bed. Regular edition prints from this painting were donated to South Dakota Ducks Unlimited.

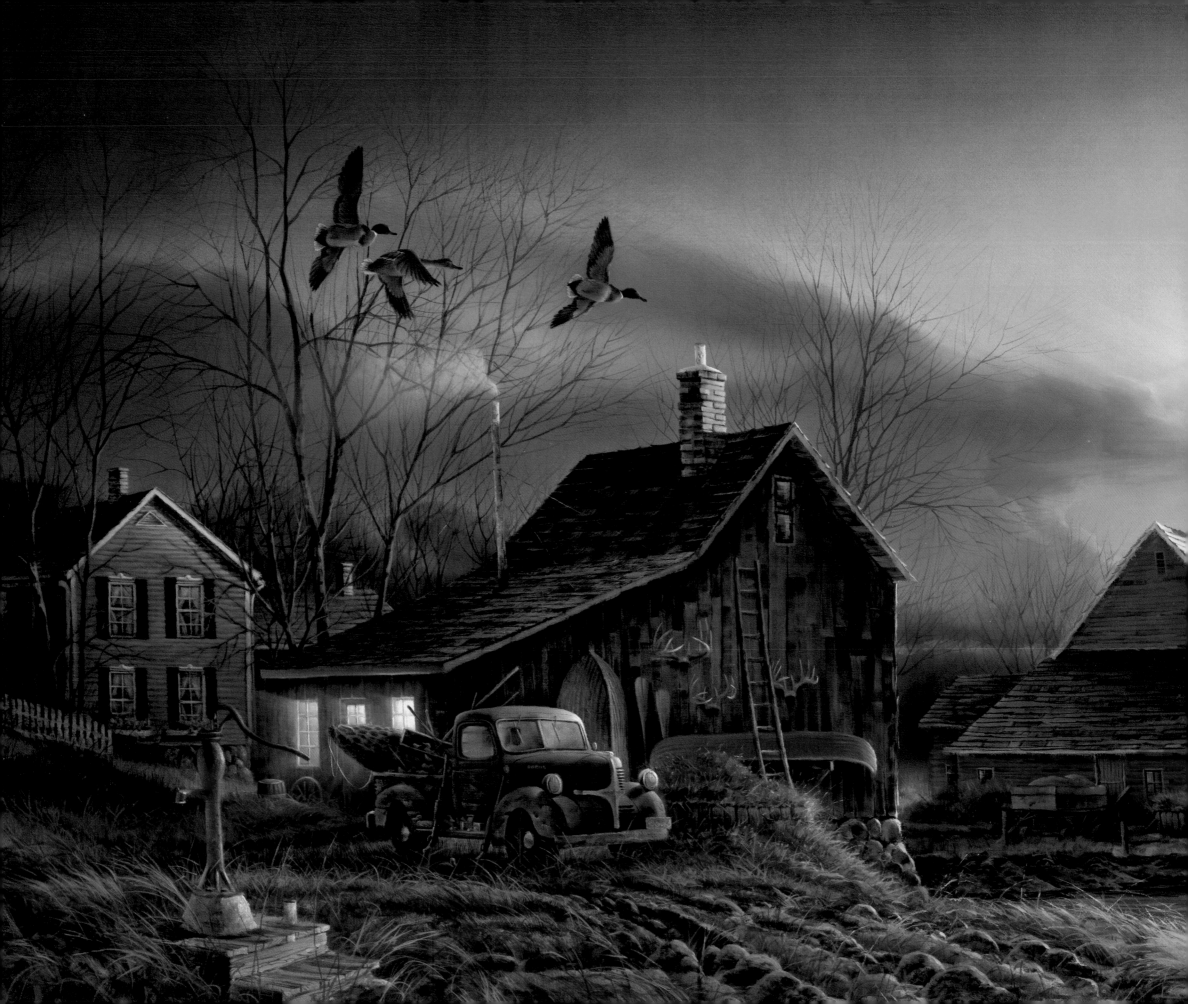

Prepared for the Season

We see that hunting and fishing activities have been a tradition with this farm family. Three deer racks decorate the barn wall. Beneath, the fishing boat and canoe patiently wait for spring.

But today attention is on the opening of duck season. Equipment reclaimed from its annual hibernation has been checked, cleaned and rechecked. The Dodge pickup is loaded with homemade duckboat and wooden decoys. Two favorite shotguns stand guard at the cab door. Last minute plans are reviewed in the nearby shed.

Then, as if to officially signal both the beginning of an annual ritual and the end of a truce, three mallards break the still air in a final flyby. Prints of this painting are used extensively by wildlife conservation groups for fund raising activities.

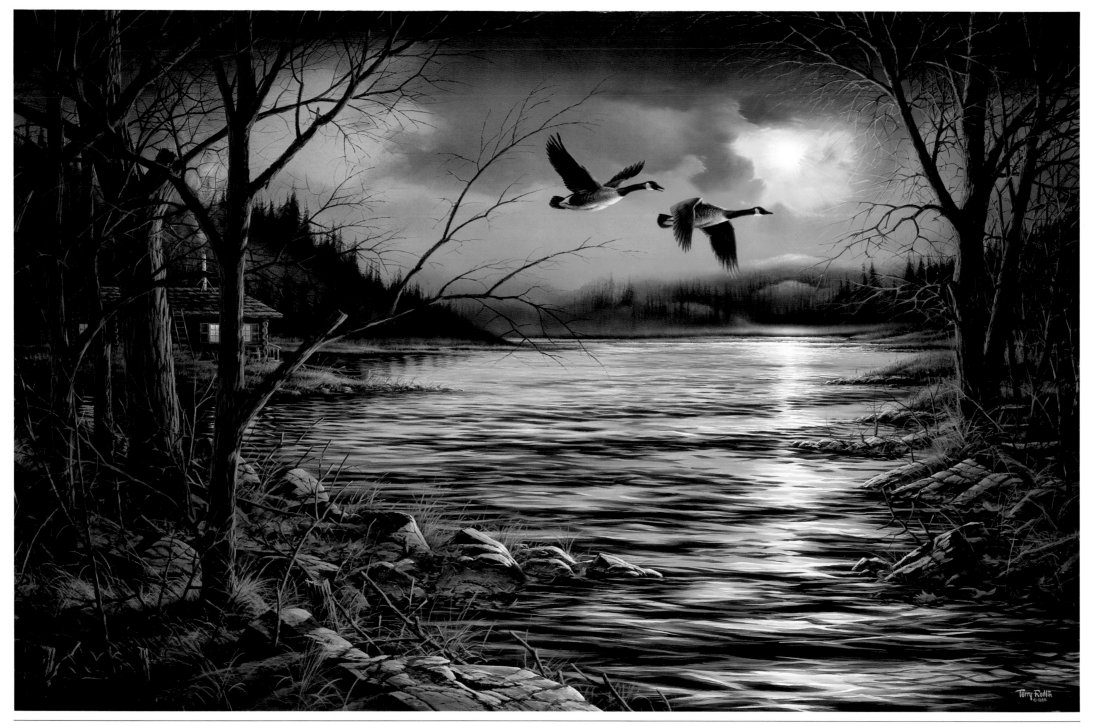

The wind that spilled the leaves on water's edge has been stilled. Smoke from the cabin stove floats directly skyward. A soft mist has begun to envelop the distant hills. As the sun burns its way through heavy clouds, two Canada geese seem to offer the only movement on this hazy afternoon. Regular edition prints from this painting were donated to the Midwest States Ducks Unlimited.

Hazy Afternoon

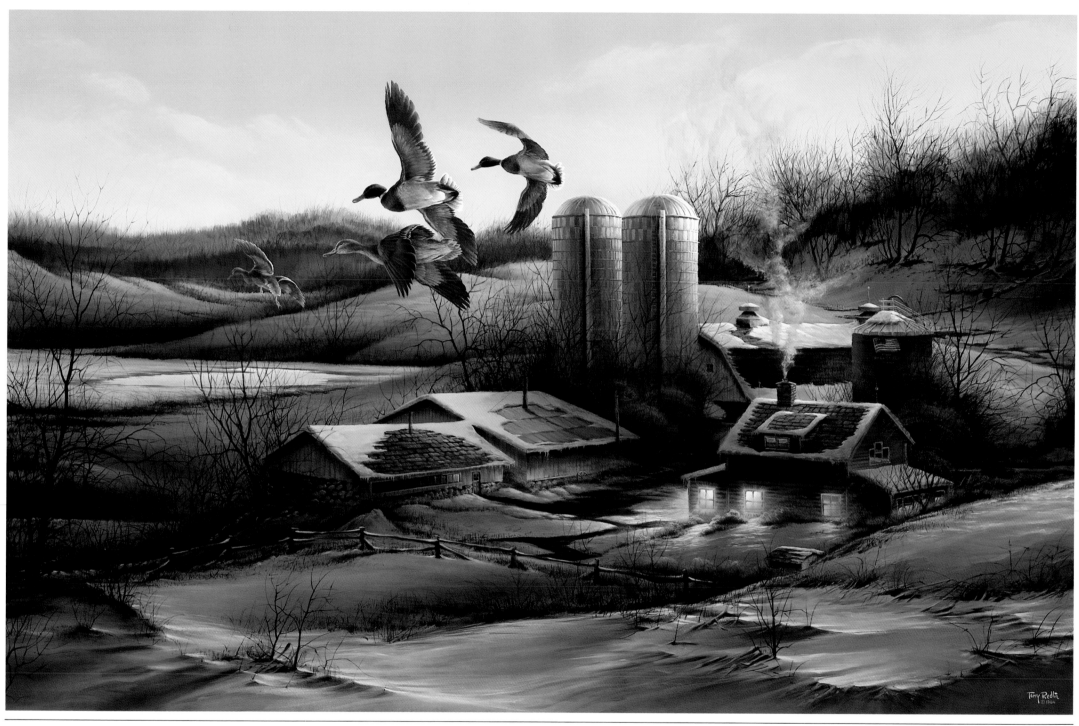

Evening Company

As evening approaches two pair of late leaving mallards are attracted to the farm lights below, and then to the open water in the small lake beyond. They have a choice of resting here or continuing on, hoping for warmer conditions in the morning when they will be several hundred miles further south. Regular edition prints from this painting were donated to Minnesota Ducks Unlimited.

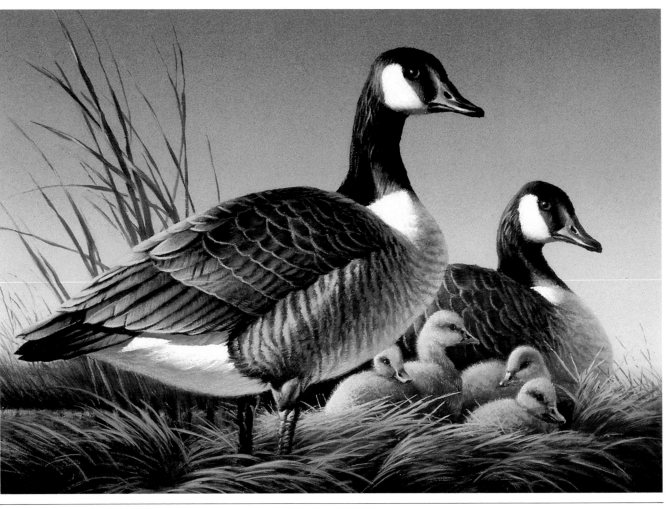

Canada Geese

These honkers have made it safely to their northern breeding grounds, and the new family is coming along just fine. Canada geese mate for life, and in a few months both mom and dad will again be part of a great V-shaped flight headed back south.

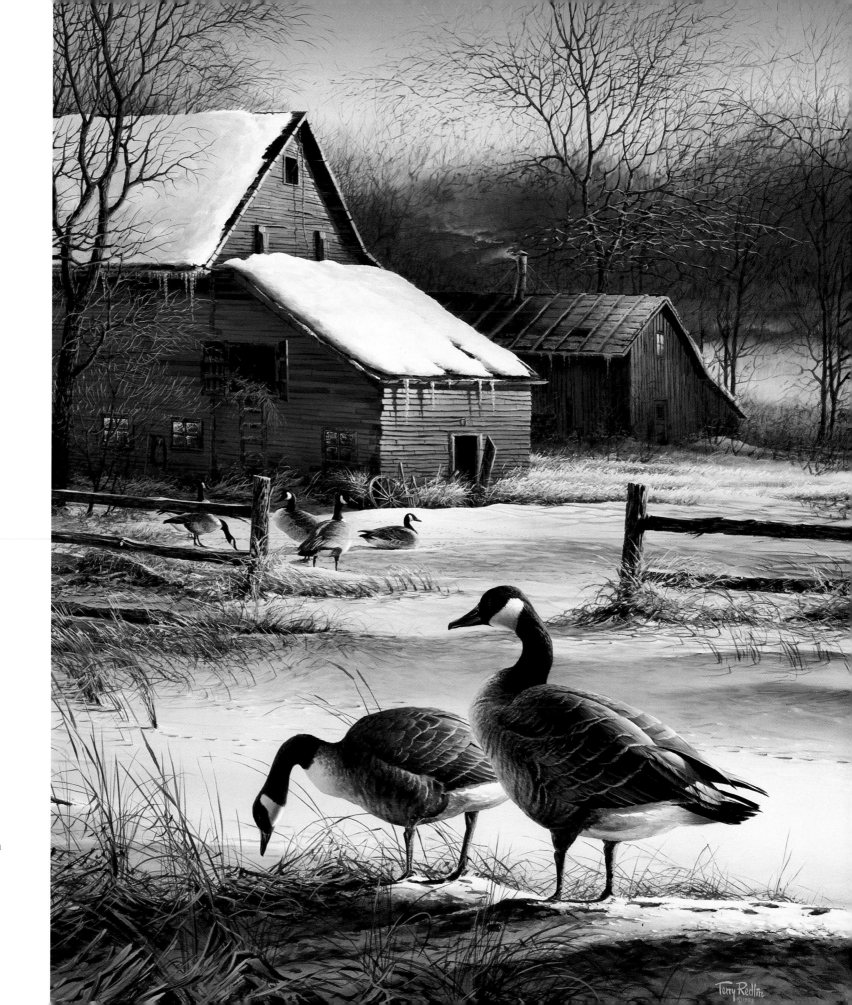

Winter Haven

In many parts of the country wildlife management areas offer safe havens for migrating waterfowl. Shown here is one such facility being enjoyed by Canada geese. Hay for nesting is stored in the barn loft. In the spring, melting snow will be contained by a log dam to form a small pasture pond. The regular print edition from this painting was donated to the Minnesota Wildlife Heritage Foundation.

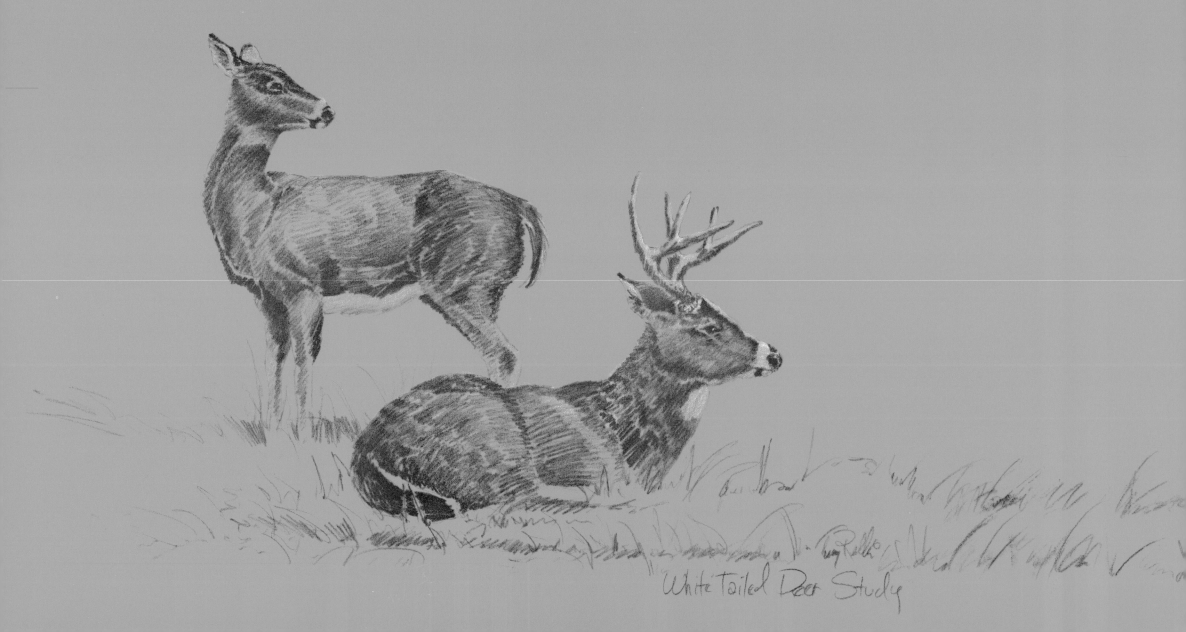

In Close Touch

White Tailed Deer Study

Noble Portraits from Nature

The world of wildlife is most often seen from a great distance. Or, close in for only an elusive moment.

The teal becomes a swiftly moving shape at the far side of the point. The concealed woodcock a noisy apparition breaking cover from under our feet. The pheasant a blurred flurry when flushed from its grassy hiding place. The white-tailed deer a half invisible shadow disappearing silently into the deep woods.

In this context of time and space our senses are compromised. The momentary display of stealth or power or agility has given insight into the forces that rule nature, but left only a vaguely comprehended image.

In the following pages Terry Redlin puts a temporary hold on this wild but ephemeral energy. We are invited to focus with imaginary binoculars on these noble creatures. We are to savor at a more leisurely pace the majestic contours of the giant Canada, the proud stance of the alert deer, the loon observed secretly resting on shore.

Terry Redlin often treats himself to such reflective musings. This corner of his world is filled, not with bursting speed, but with serenity. He has asked his wild companions to sit for their portraits, to give a command performance for those of us with faulty vision.

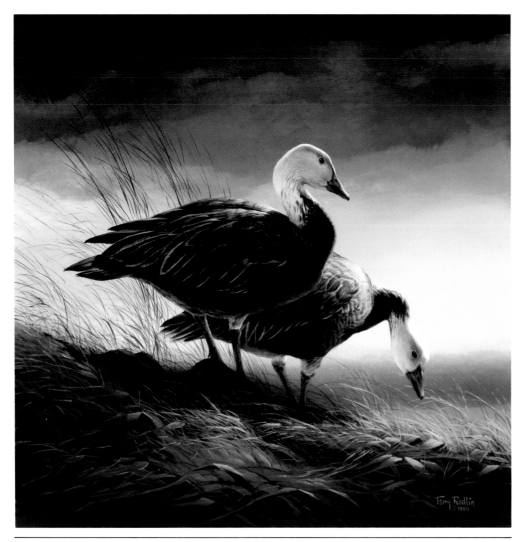

Blue Geese

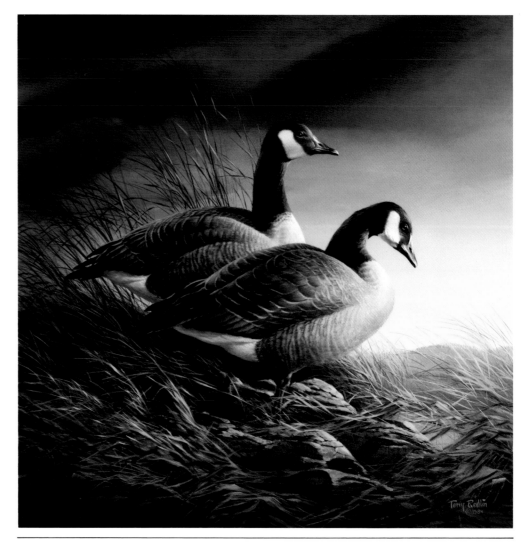

Canada Geese

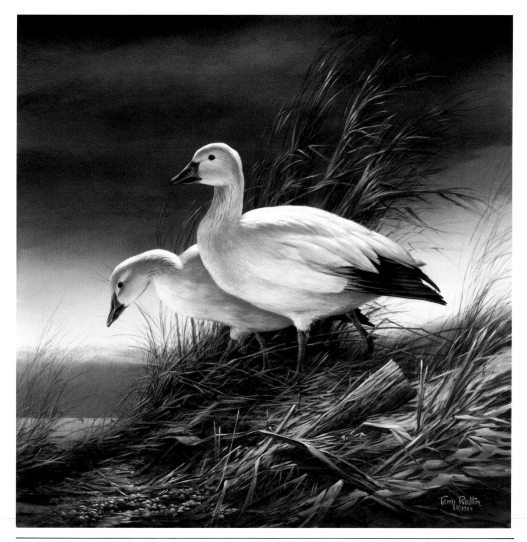

Snow Geese

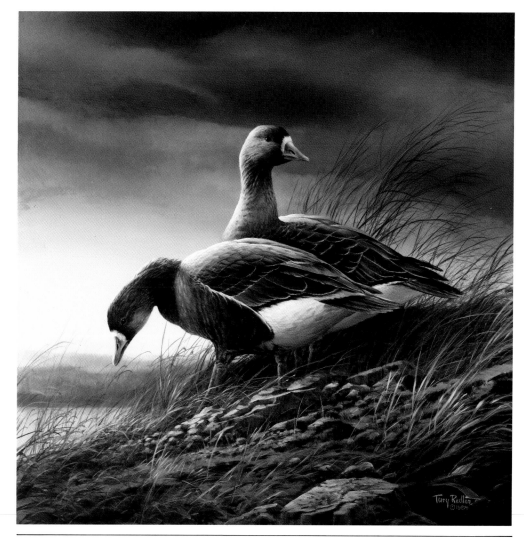

White-Fronted Geese

Geese, more than other species of waterfowl, seem to capture our imaginations. Perhaps it is their stately presence, impressive size or handsome plumage. Or, who has not felt a sense of awe at the sight of migrating flights in long, undulating lines or great V's as they pass high overhead?

Terry Redlin has chosen to honor the majestic goose with this series of dramatic portraits featuring four of America's most popular species. The pairs are presented in a characteristic but little noted position. As one gracefully dips its head to feed, the other remains with head held high, ever watchful and alert.

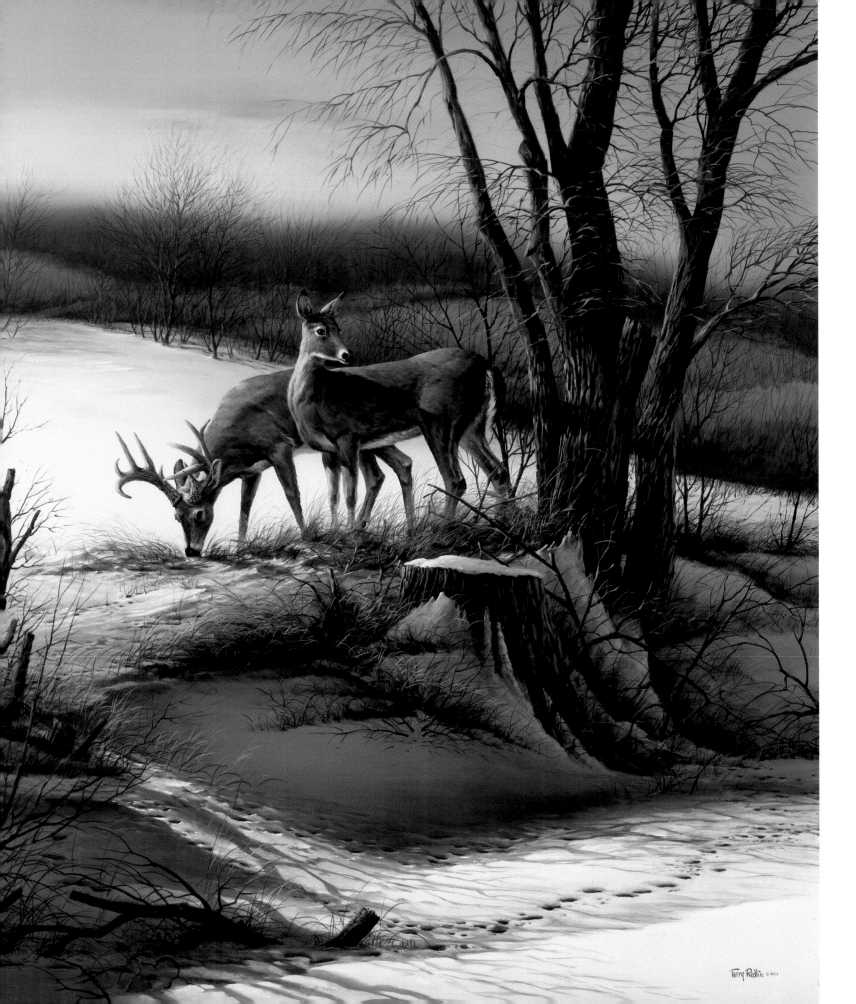

On the Alert

As the buck leans down to feed on the exposed grass, the cautious doe listens intently, separating natural sounds of the wind from potential danger. Man, we see, has already left his mark on the land – a stump at the side of the frozen creek and the cleared field behind. These white-tailed deer will soon move silently away, leaving only tracks as evidence of their visit.

So. Dakota Pin T

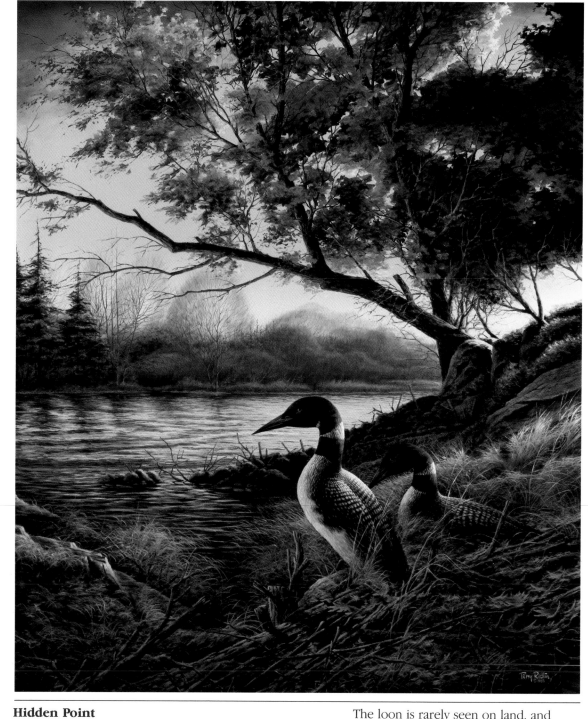

Hidden Point

The loon is rarely seen on land, and generally leaves the water only to nest. However, here the unusual has taken place. For several years the artist and this loon pair shared the beauty and solitude of a northern lake. One fall day, while scouting for picture ideas, he happened on this scene and has recorded for us the seldom seen large and sleek body of this unique species.

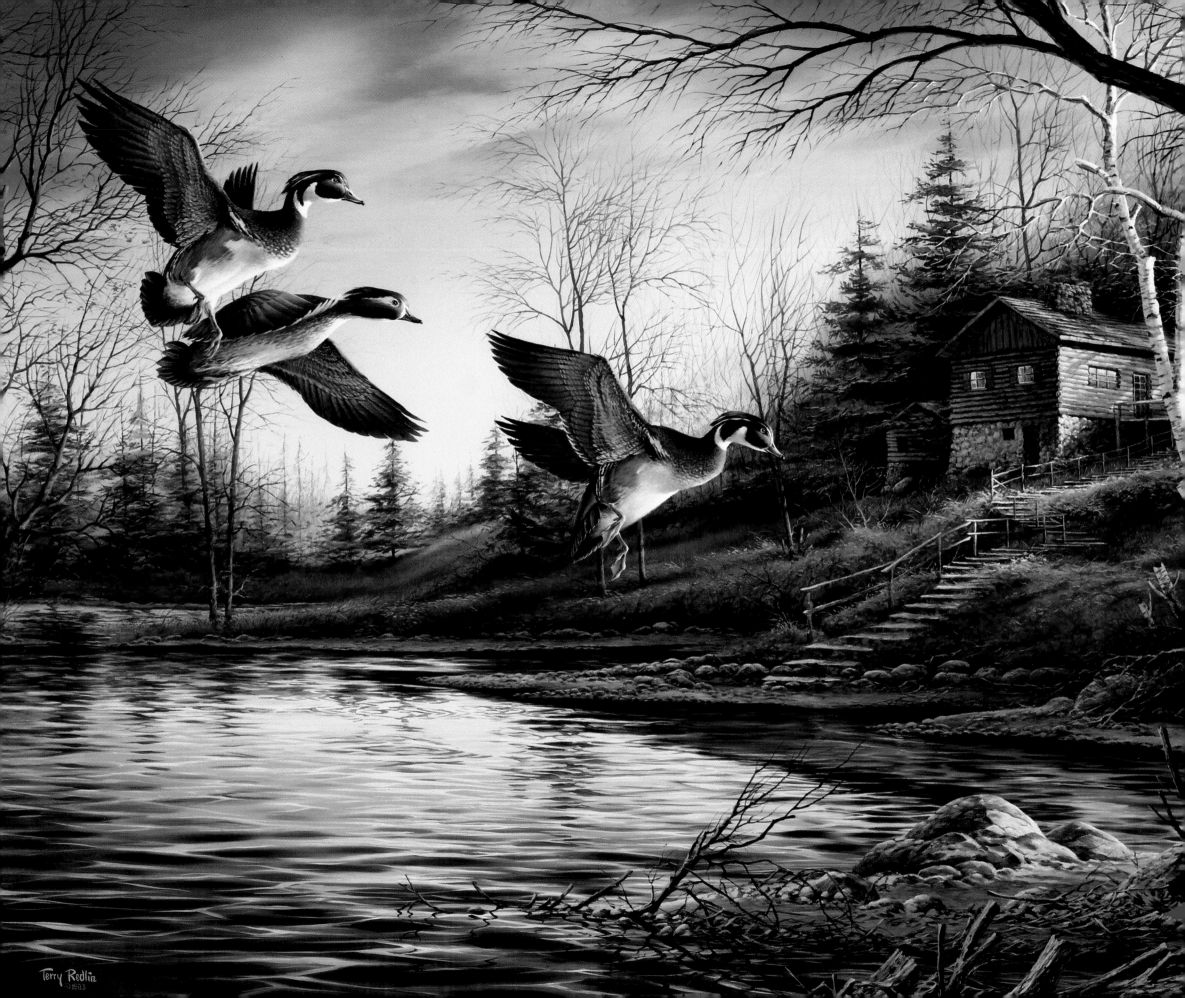

Terry Redlin
©1983

Backwoods Cabin

Somewhere is that special hideaway that puts us in close touch with the wild. When found, and if we are in the right mood, the roles between man and wildlife are reversed.

The experience becomes the opposite of that offered by the nation's zoos, where we safely observe from behind fence or glass. In this place we are surrounded by a grand variety of nature and nature's wildlife. We become the imprisoned ones. We sense the myriad faces and forms that have come to stare.

But there is no need to be alarmed. The wildlife at this backwoods cabin mean no harm. And if we enter into their world with respect we will be allowed to share in its splendor.

On this fresh morning stroll down the steps from the hillside cabin. Sit by the lake, quiet and watchful. There, see? One of nature's wonders, a trio of wood ducks, glide to a landing just across the inlet.

Banded Giant Canada Geese

1981 Minnesota Duck Stamp

S tamp designs are a special category of wildlife art. They are portraits with a purpose, close-up views painted to predetermined specifications for wildlife conservation groups and government agencies.

With proceeds generated by stamp programs, these groups have protected and restored millions of acres of wildlife habitat. And Terry Redlin has been well represented in this specialized art field for many years.

Today Terry Redlin leaves the confines of stamp design to others. His creative impulses have taken him in a new direction, one that allows for the full range of moods and landscapes, from desolate windlashed shores to the quiet beauty of an autumn sunset.

However, his strong support of wildlife conservation efforts continue, as described in the section of this book titled "Eyes on the Future, Protecting a Common Heritage."

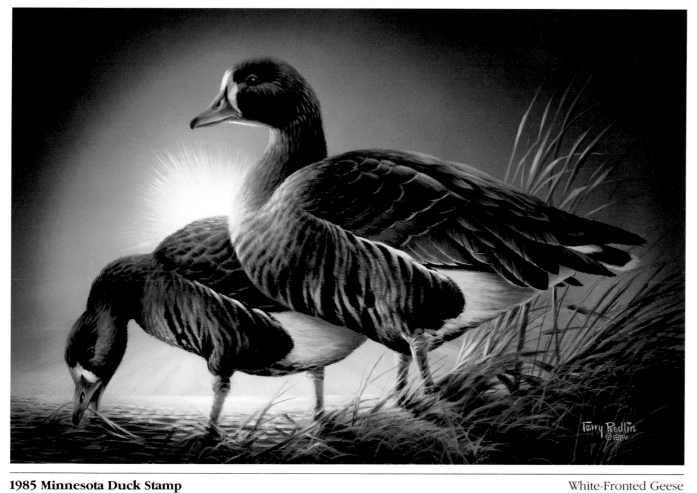

1985 Minnesota Duck Stamp White-Fronted Geese

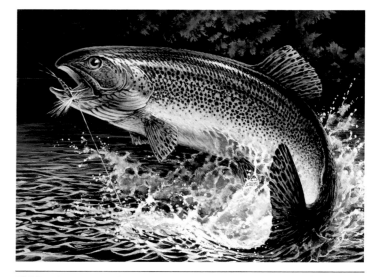

1982 Minnesota Trout Stamp Rainbow Trout

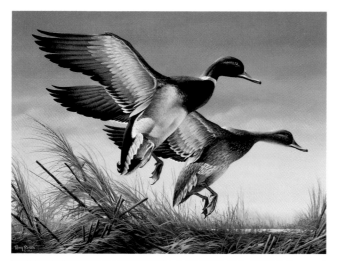

1983 North Dakota Duck Stamp Mallards

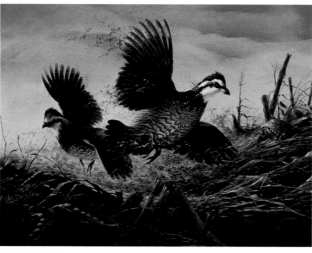

1984 Quail Unlimited Stamp Bob-White Quail

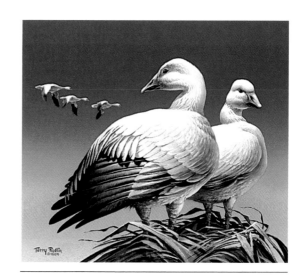

1984 National Waterfowl Stamp Snow Geese

Windows to the Wild

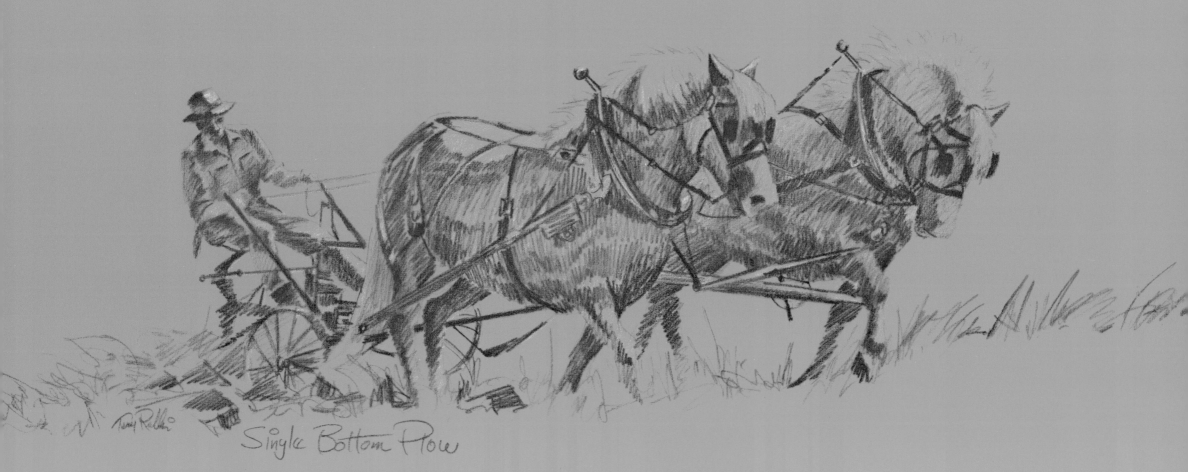

Single Bottom Plow

Celebrating Nature's Bounty

In the press and pressures of daily life there is a tendency to contract our personal world, to withdraw into ourselves. The smaller our universe, we reason, the more manageable.

However, as our world shrinks we often experience a strange uneasiness. Something, the unconscious self tells us, has gone wrong.

This is the first sign that, without knowing, we have somehow discounted ourselves. Our intuition tells us it is time to listen for deeper rhythms.

And if we listen carefully, or are lucky, we hear a call from far beyond the cacophony of modern life. At first it is a faint call that only partially penetrates our protective shell. But the closer we listen, the clearer the message becomes.

It is, we come to realize, an invitation to get out into the wild and celebrate nature's bounty. It is permission to accept and enjoy nature's wonderful medicine, the magic potion that can regenerate both body and soul.

Come, join Terry Redlin in a leisurely walk through his special wilderness. Let his art open up new views of forgotten vistas. Leave behind for a few moments the superficial world we in our haste have created, and touch if ever so slightly the healing hand of nature.

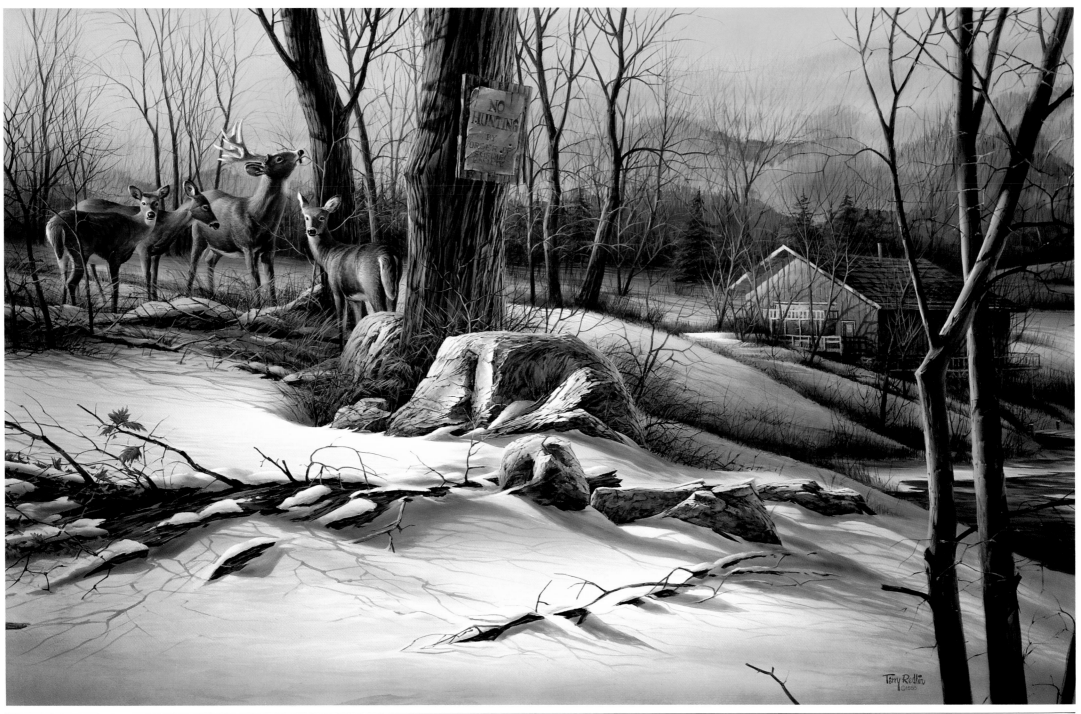

It's a peaceful late winter afternoon. The white-tailed deer are out foraging for browse. While the buck nibbles at the tender branch two does intuitively sense that something is out of order, and peer intently toward the hidden viewer. However, it is obvious these deer understand the limits of their territory and have retreated behind the sign left from the last fall.

Back to the Sanctuary

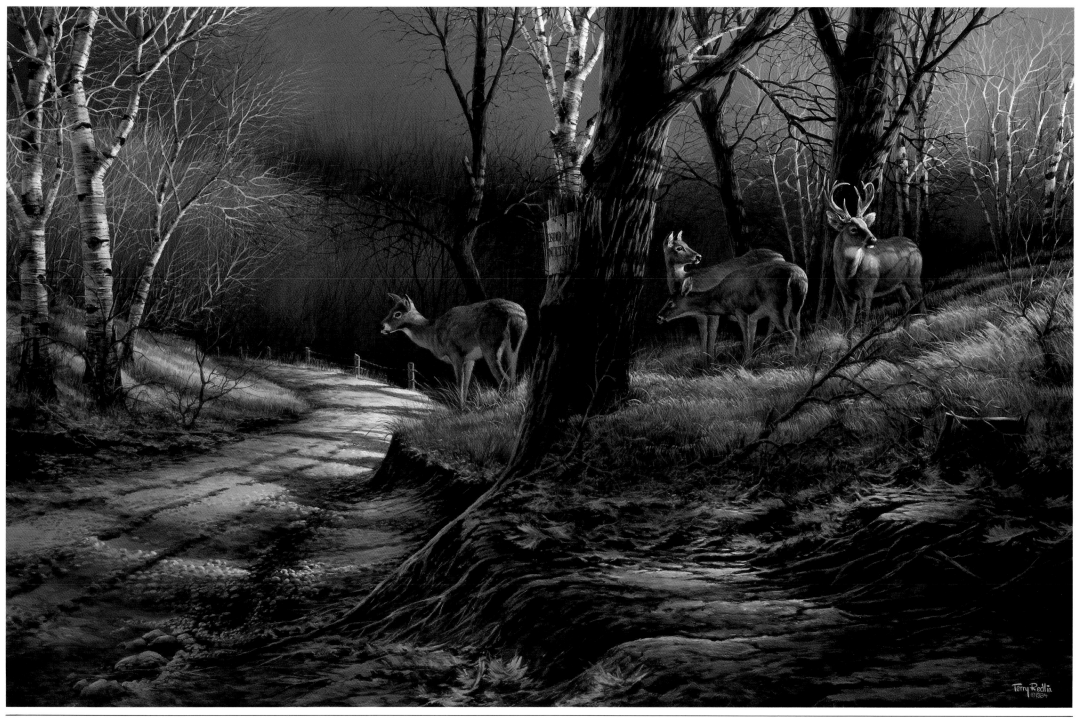

Leaving the Sanctuary

The deer are hesitating before venturing out of their deep woods sanctuary to cross the road. The sign informs us humans that there may be trouble on the other side, but curiosity is likely to prevail. In this serene atmosphere of autumn browns and oranges, sunlit faces and stands of white birch, we prefer to imagine that nothing could possibly happen to disturb the tranquility of the scene.

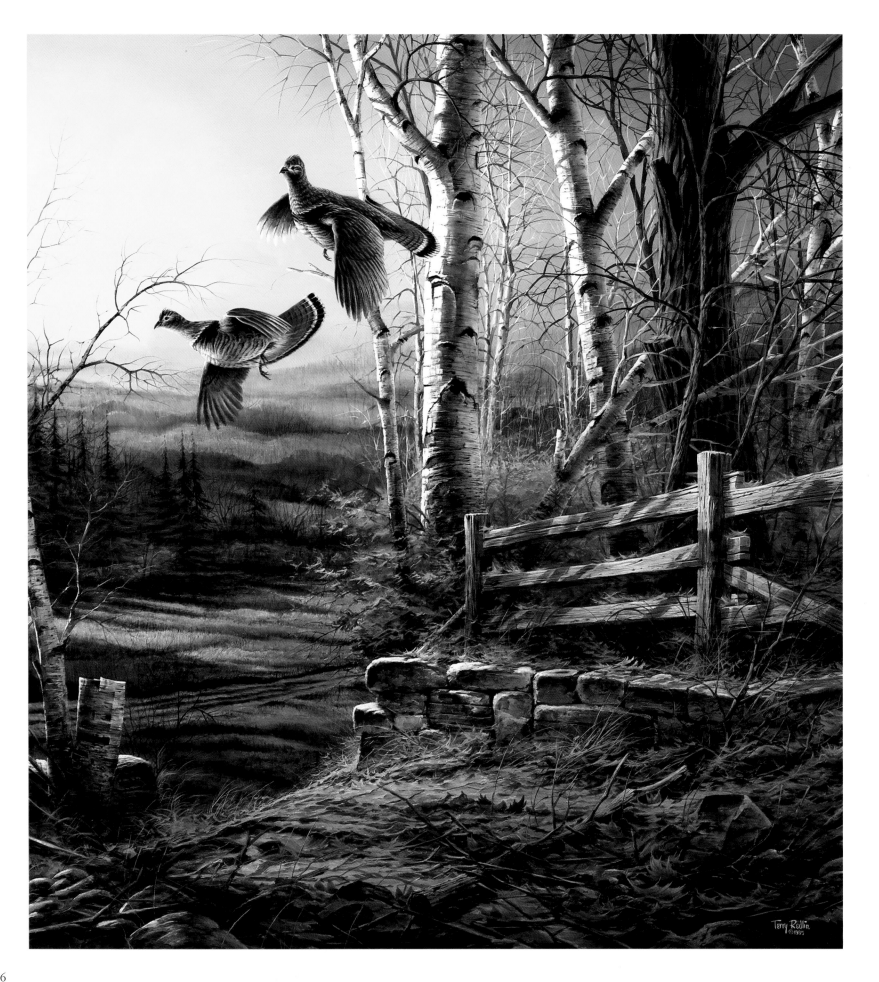

Breaking Cover

We have startled the ruffed grouse from the dense underbrush, and they break cover with a great rush of beating wings. Before veering away and again disappearing into the woods, we can clearly see their distinctive reddish brown fan shaped tails and dark neck ruffs. They will quickly disappear from sight, leaving us with only a blurred image and a beautiful view across the valley.

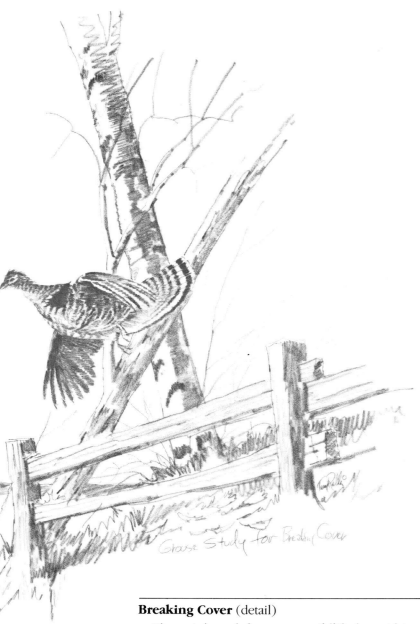

Grouse Study For Breaking Cover

Breaking Cover (detail)

The artist's work focuses on wildlife, but within his paintings we often discover other hidden riches. In this landscape detail he skillfully blends four elements into a visual song of form, color and texture.

The angular lines of the stone wall and split rail fence suggest the rational, and anchor the composition in earthy tones. In contrast, nature seems to burst out with unbridled energy. The firey hot oranges of autumn propel the birch trunks skyward, finally breaking out of all spatial limits.

We can imagine this miniature without wildlife framed and displayed, perhaps on the wall of those who are still discovering the full range of nature's offerings.

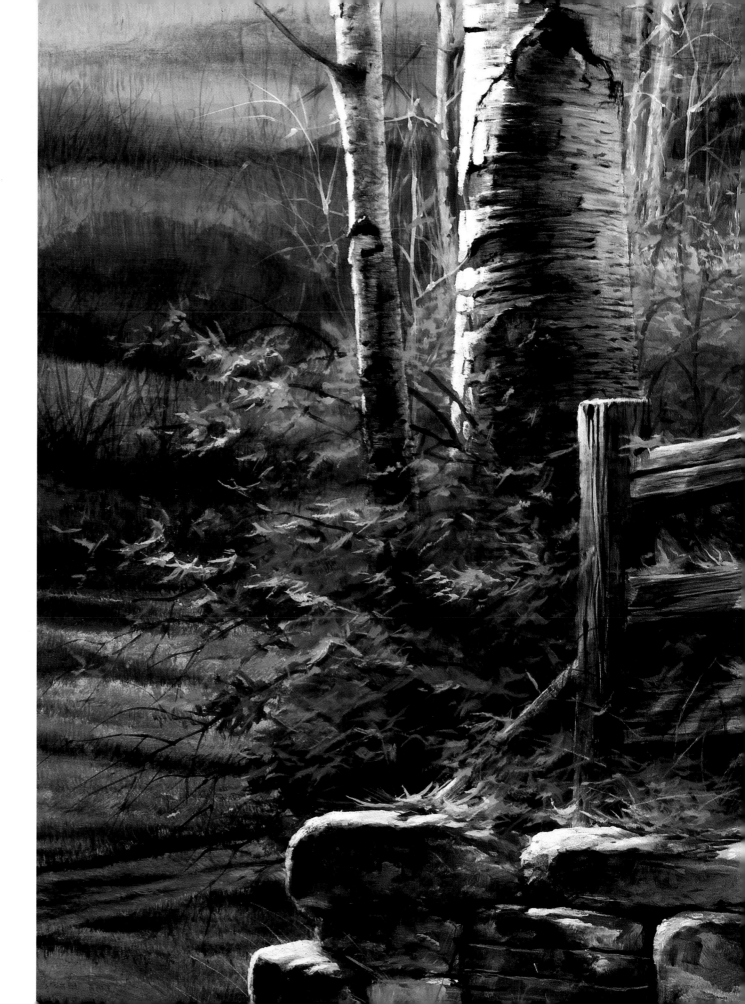

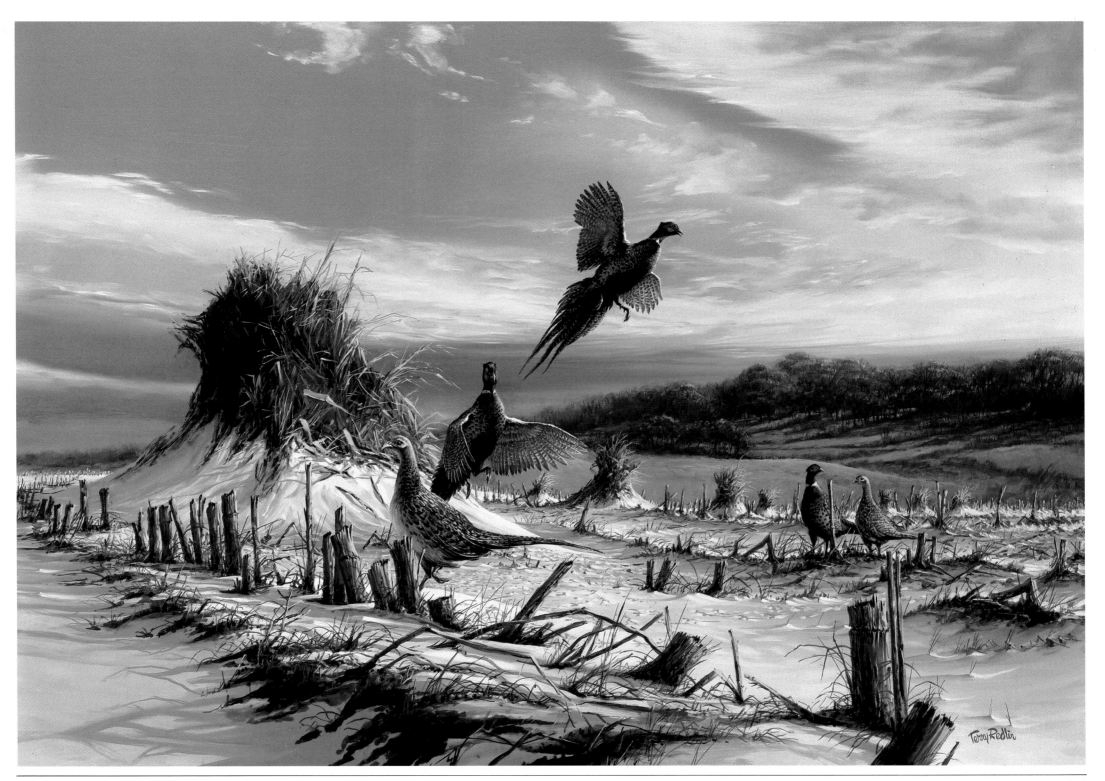

The peacefully feeding ring-necked pheasants have been caught off guard and break the still winter air with a flurry of sound and action. This corn patch was an actual field, hand planted and harvested with an old corn binder, then laboriously collected into large shocks. The artist found the setting a unique contrast to the straight rows and clean cuts made by modern farming equipment.

Startled

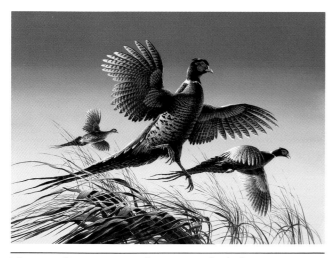

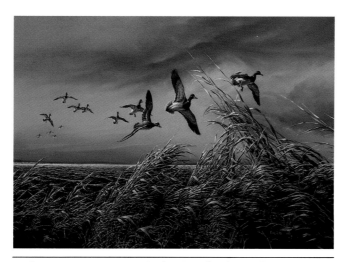

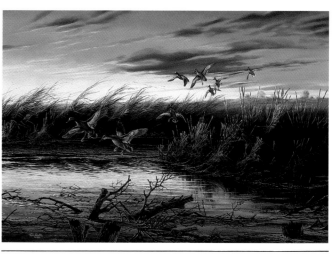

The Landing This ring-necked pheasant rooster treats us to a colorful display as he slips over the tall grass and, spreading his wings, brakes for a landing.

Fighting a Headwind The lead mallards are flaring against a strong wind, twisting and turning to keep their balance while preparing to set down near the rushes.

Secluded Pond A small flock of blue-winged teal, skirting low over the rushes, discovers an algae covered pond hidden from view of the surrounding fields.

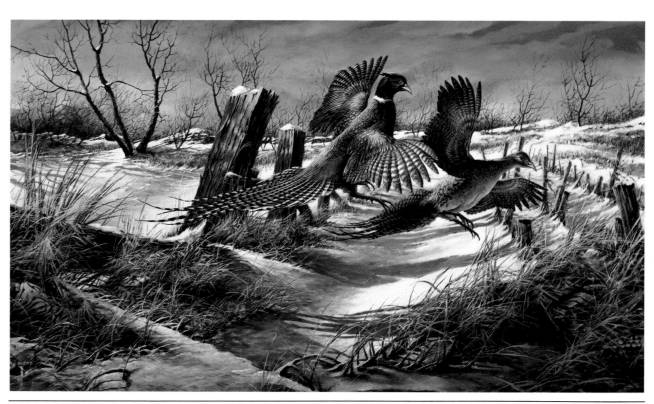

Clearing the Rail The long shadows tell us it grows late on this winter afternoon as the pheasants descend over the remnants of an old rail fence. The snow covered cornfield has attracted the birds, offering them the tempting possibility of both food and cover for the night.

Silent Flight

Considered by many to be a painter only of waterfowl and upland game birds, in reality Terry Redlin's interests extend well beyond the boundries of redheads and ring-necks.

This painting of the great horned owl offers a good example of, not only his subject versatility, but also his skillful handling of landscape detail, atmospheric mood and arresting composition.

As darkness approaches the owl is preparing for an evening of good hunting. Its ability to maneuver in near perfect silence means trouble for all small nocturnal animals.

Few people are privileged to see this largest of our eared owls, but you may have heard its soft and haunting "hoo-hoo-hoooo" from deep in the night.

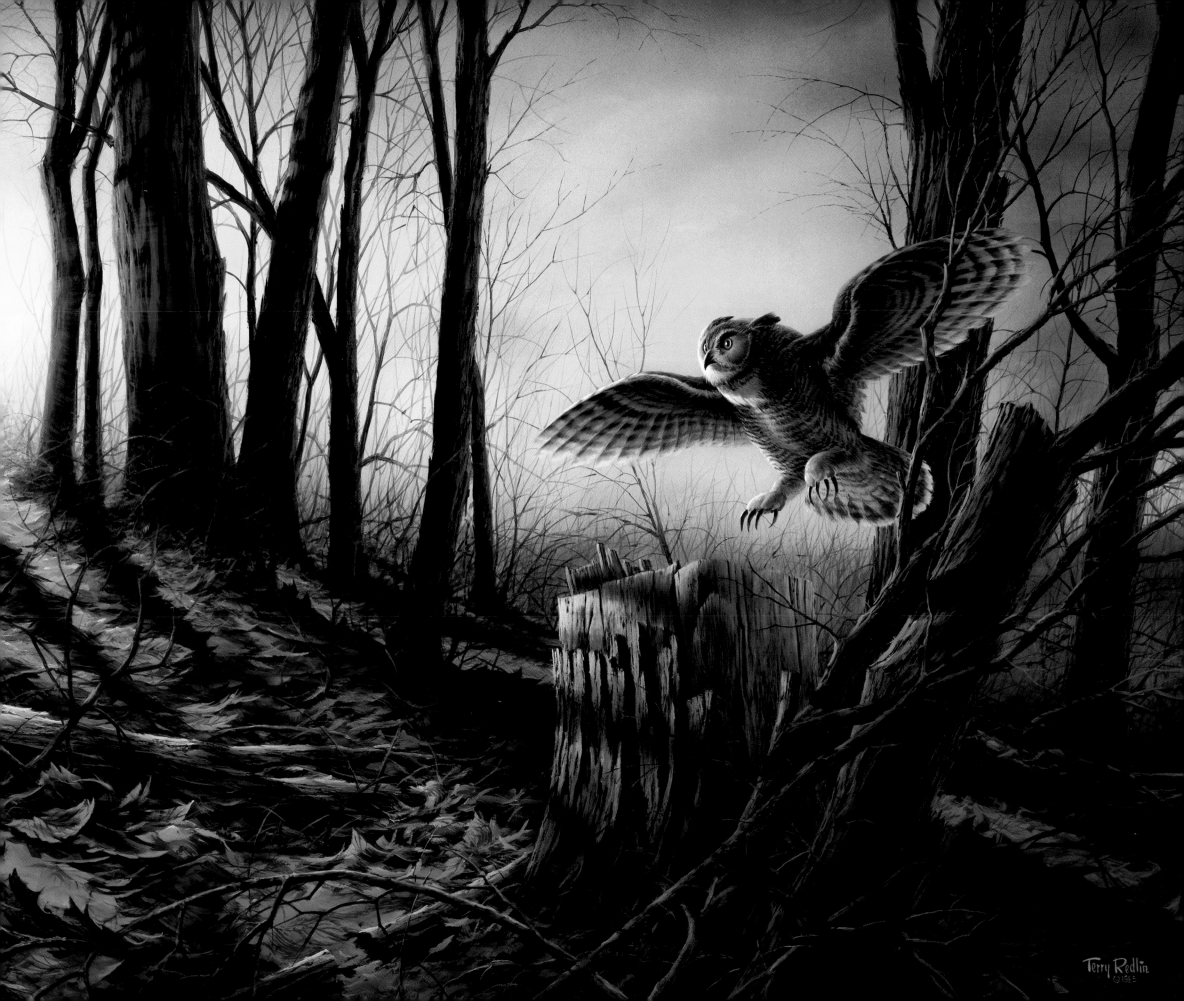

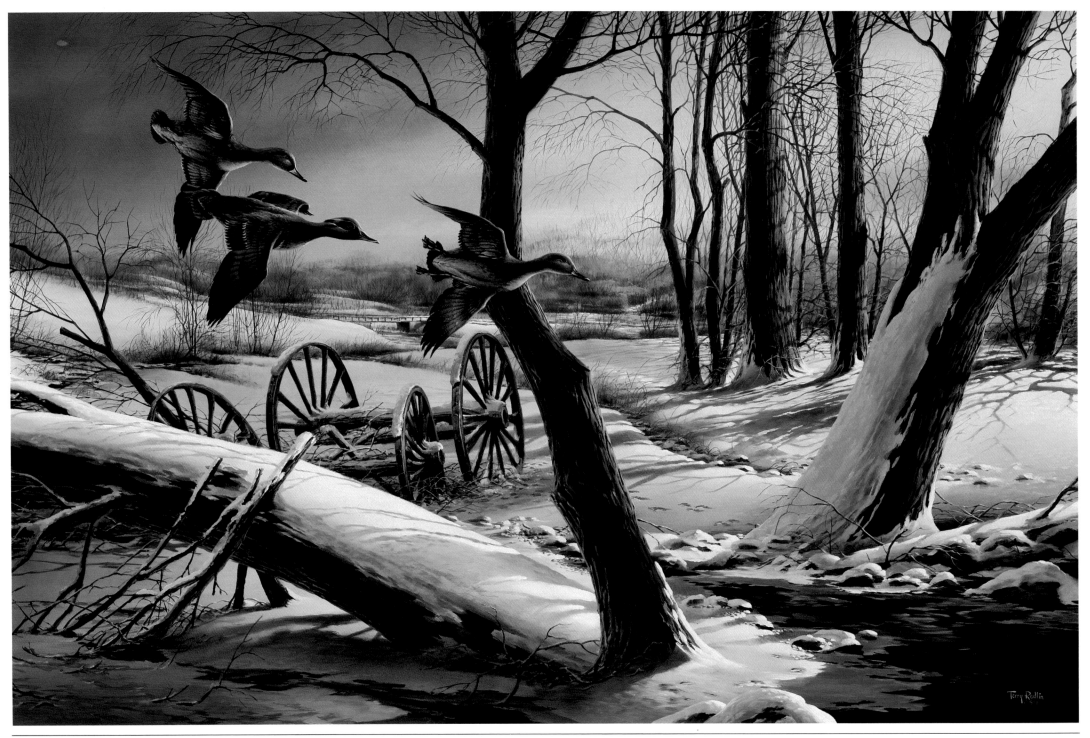

The ground is still covered with a heavy mantle of snow, but warmer temperatures have allowed the spring to open, attracting this trio of early arriving green-winged teal. The abandoned wagon hints of previous callers, but the once busy location has now been bypassed by modern transportation and the high speed road in the background.

Prairie Springs

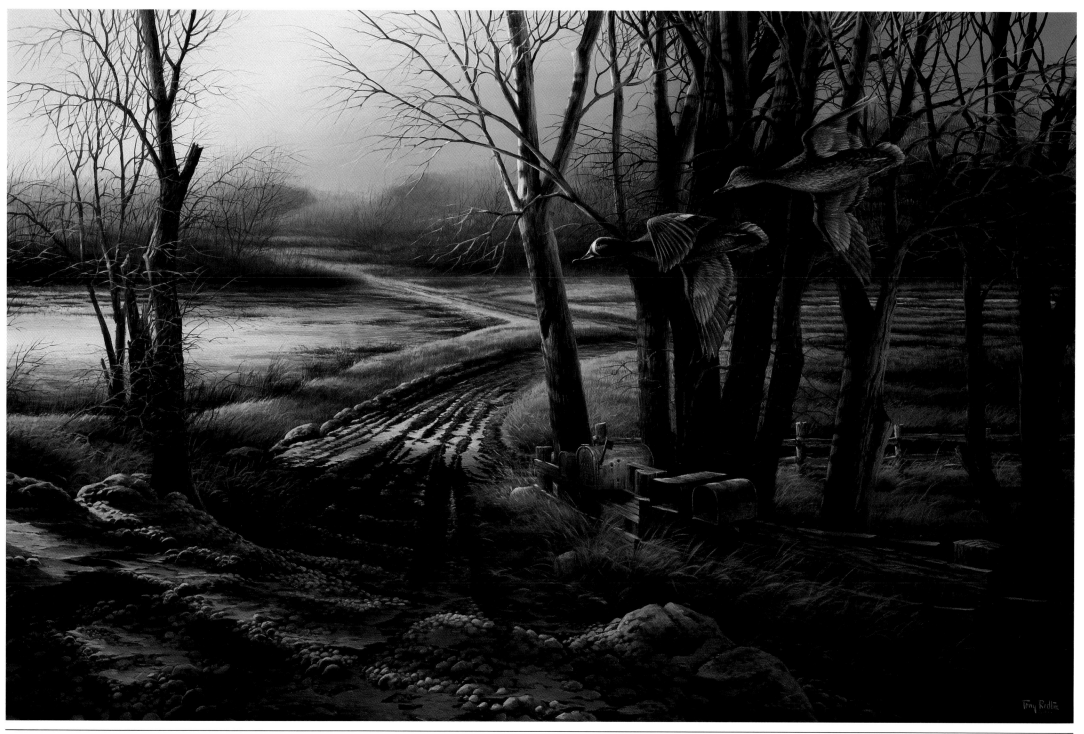

Rural Route

A blue-winged teal drake and hen maneuver through the trees and head for the slough just beyond the edge of the forest. Heavy rains have left the low road running through this marshy area wet and risky for strangers to cross. However, the farmers know what rut to follow, and will have little difficulty picking up their mail at this rural post office.

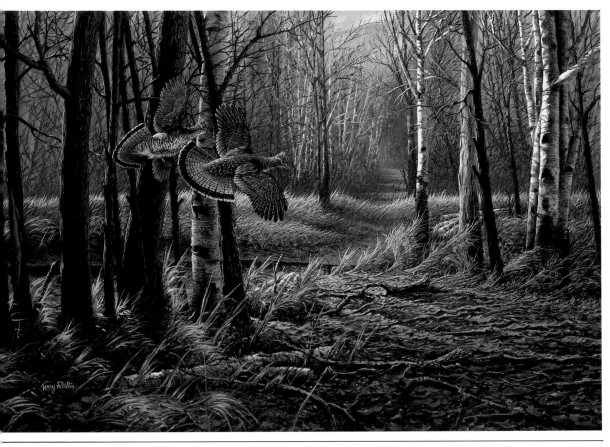

This warm, hazy day is ideal for the thermal glide of the hawk. The grouse, one of the hawk's natural preys, is well camouflaged in the shadows and can observe with impunity.

Soft Shadows

Old Logger's Trail

Winding through the trees with the sun breaking on their backs, a pair of grouse take advantage of the clearing made by early loggers. This painting was created from an actual scene near the artist's cabin.

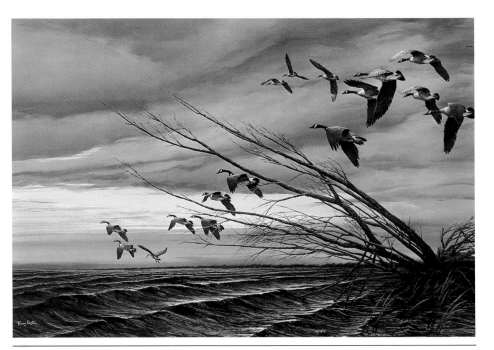

During high water years shoreline trees often succumb to the undercutting of waves. This blown down position makes an interesting composition as the trees, like the geese, strain into the wind.

Over the Blowdown

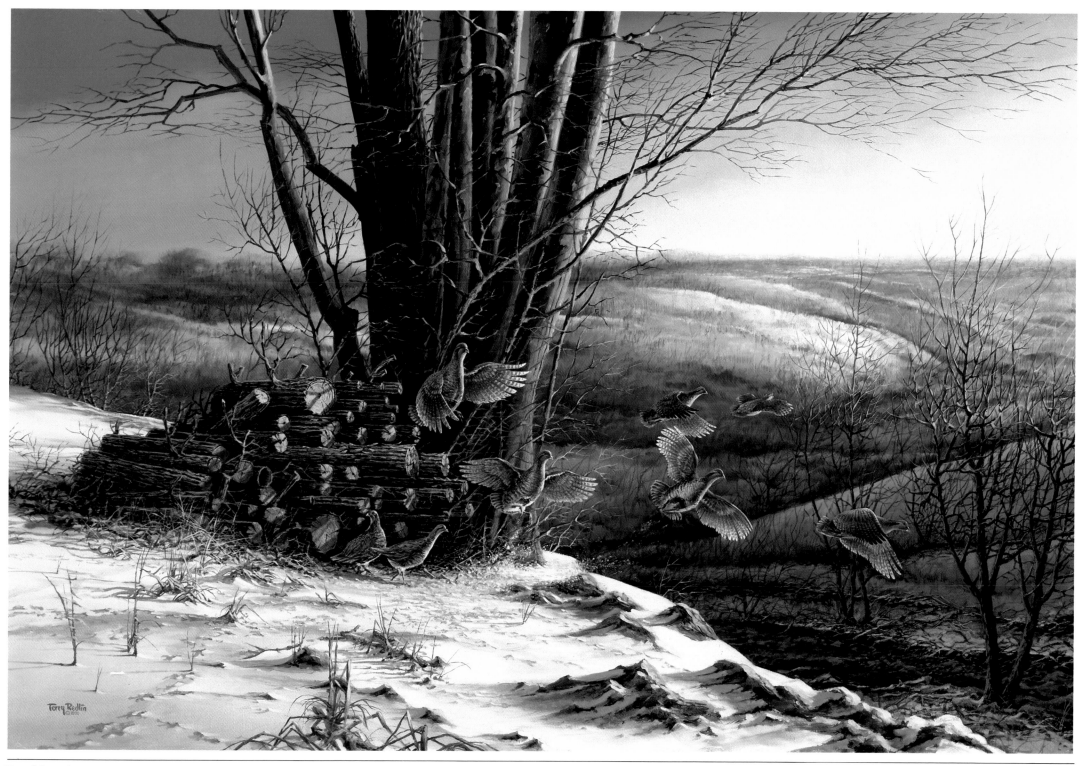

Breaking Away

Spooked by a noise from upwind, a covey of Hungarian partridge have been flushed from the protection of their hillside wood pile. Until danger passes and they can return, the "Huns" have plenty of options. Wood patches and undergrowth abound in this area and extend for miles into the distant valleys and ravines.

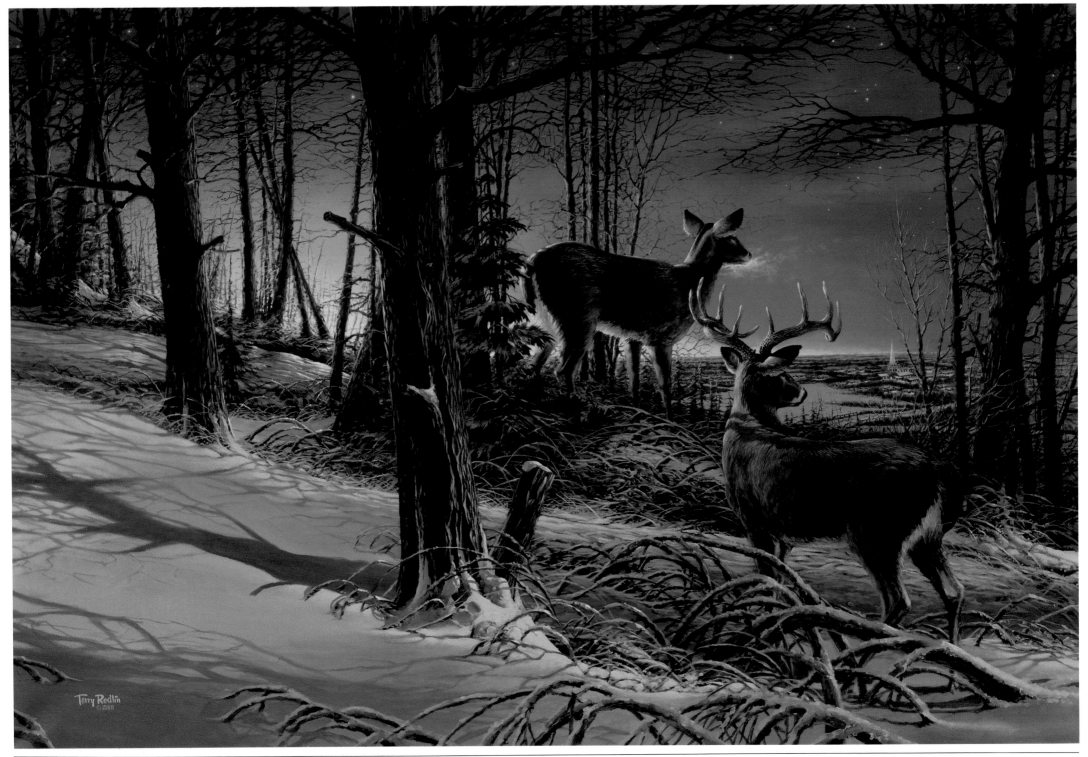

It's that special time in early evening when the western horizon still reflects a dim light and the stars are beginning to assert their rightful presence in the night sky. Standing in silence, the two white-tailed deer watch this transfer of colors and listen to the faint sounds from the small town out in the flats. This painting was used as a Christmas cover for Outdoor Life.

Night Watch

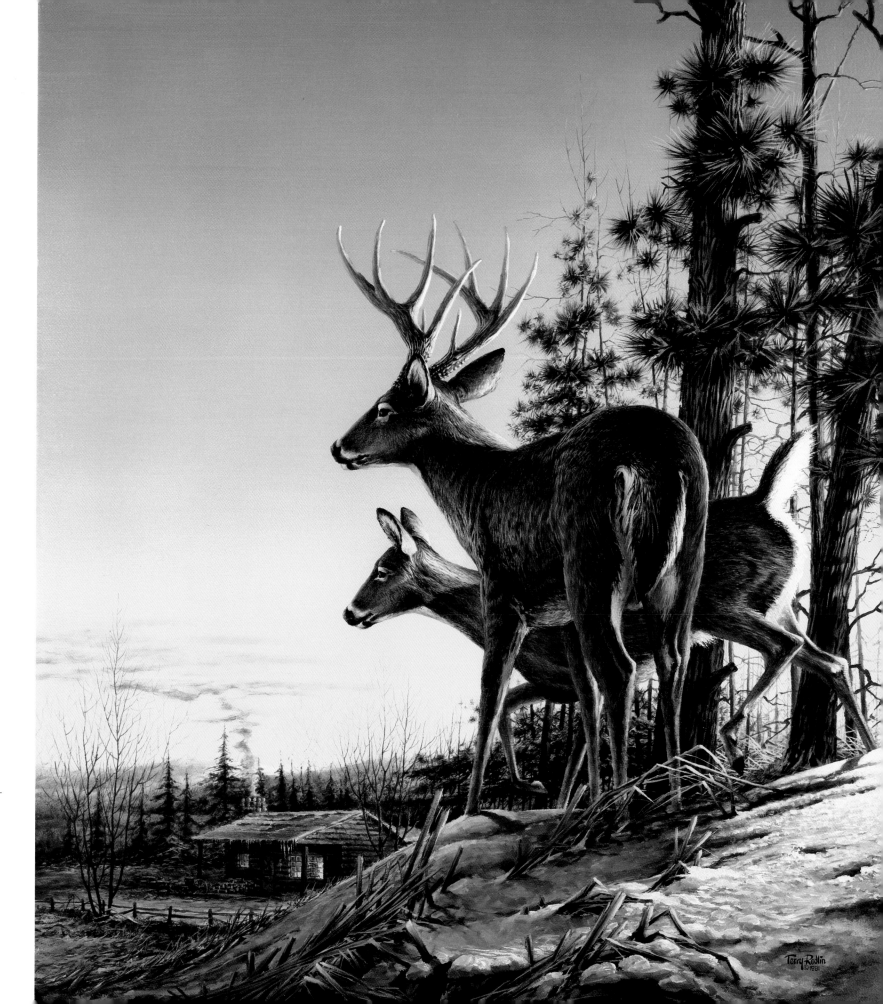

All Clear

The day is drawing to a close and the residents of this wilderness log cabin have moved inside for the evening. Two white-tailed deer, watching from the hill, see that all is now clear and will soon venture down to feed in the open area. This painting, like Night Watch on the opposite page, was an Outdoor Life Christmas cover.

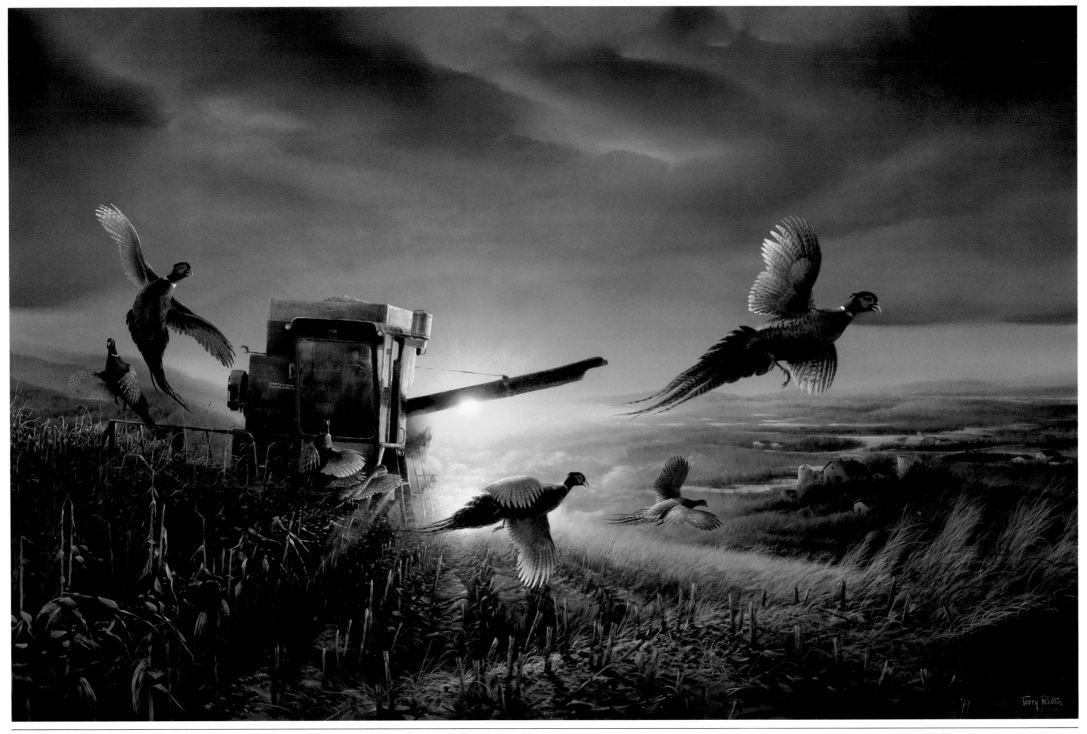

In this dramatic painting ownership of the corn field is briefly contested between man and the ring-necked pheasants. The farmer means no harm, and on this fall evening wishes only to use the land on a temporary basis. He will soon willingly relinquish the territory to the wildlife and, as payment for the disturbance, offer the harvest leftovers.

Evening Surprise

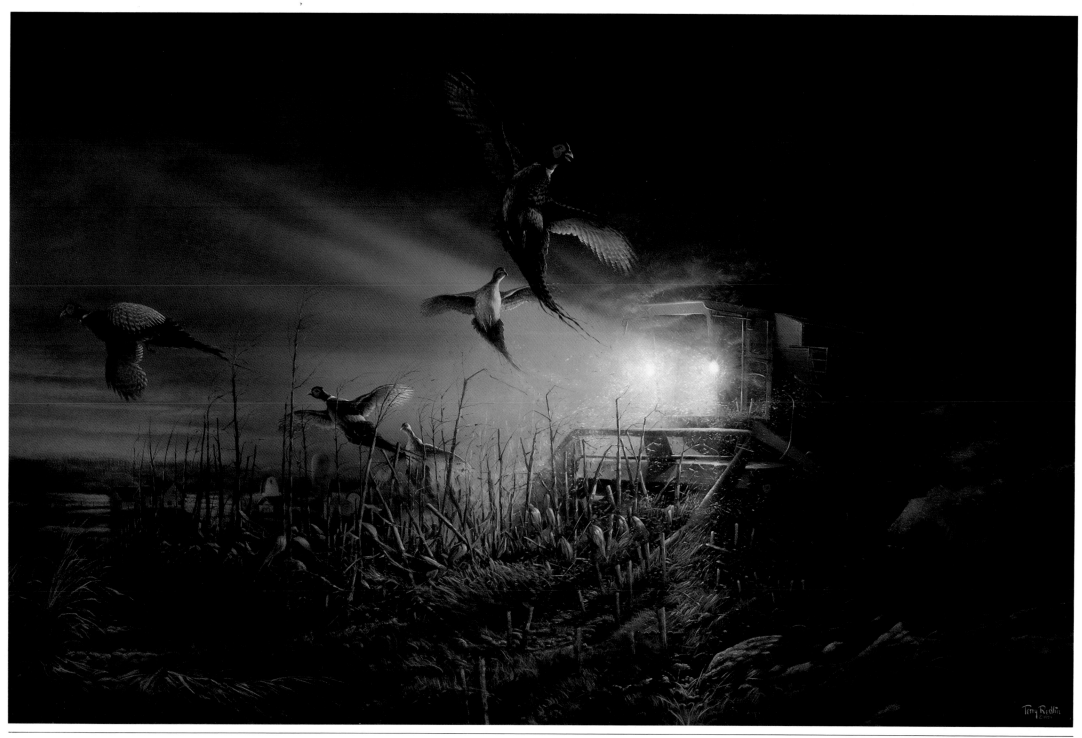

Night Harvest

While traveling through a rural area the artist became fascinated by the night combining. He stopped, wandered out into the fields and absorbed the full flavor of its unique drama. Both this painting and Evening Surprise are beautiful treatments of the same theme. While city dwellers sleep the farmer, when the crops are ready, responds to an age-old imperative.

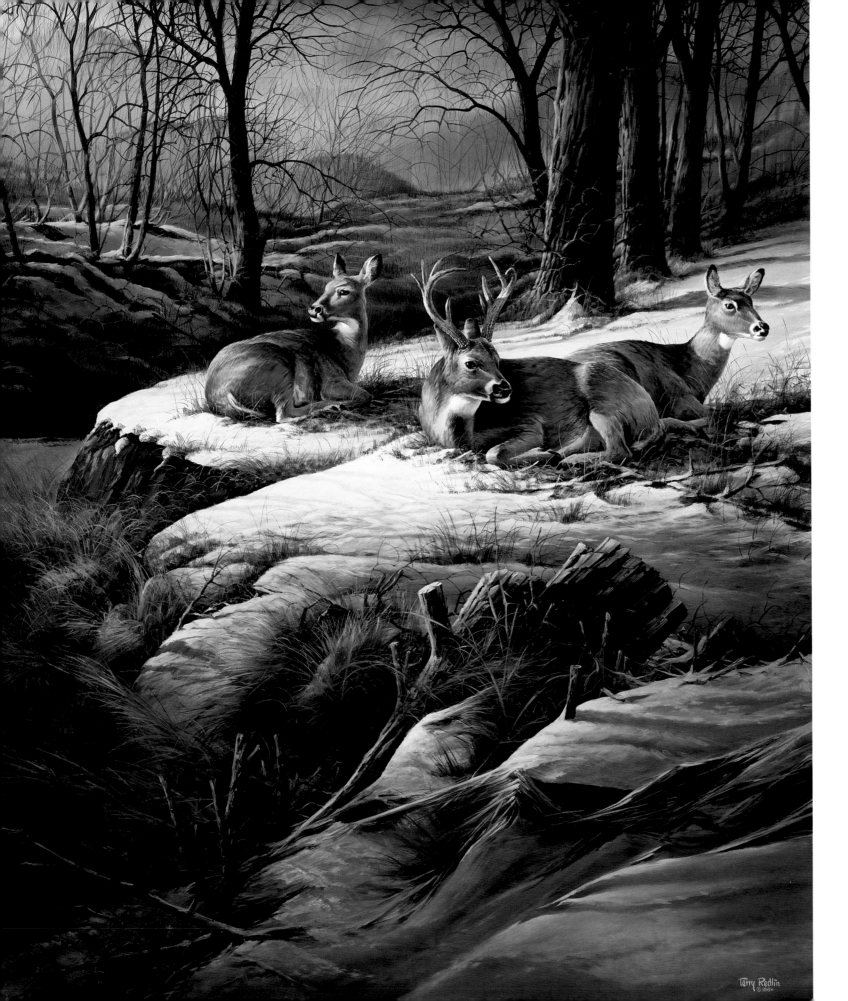

Sunny Afternoon

The deer have found an ideal location to spend a few peaceful hours. The exposed grass offers some protection from the wet snow, the warm sun is unobstructed, the river bottom is nearby and there is no sign of man's presence. They will rest for awhile more, then move on in their continuing quest for browse.

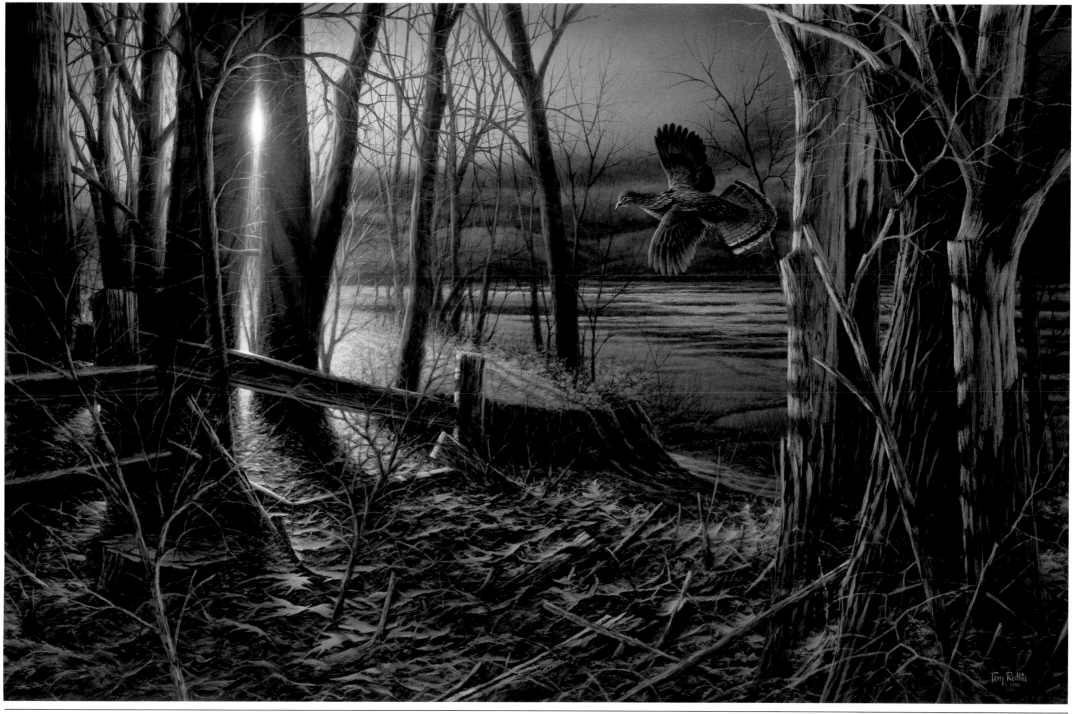

Sunlit Trail

As the setting sun splits the trees in a blaze of light, the ruffed grouse glides to a resting place. We note that both the grouse and nature have begun to reclaim the area from man. The overgrown trail and broken split rail fence leading to the lake tell us that at one time this was also man's favorite haunt.

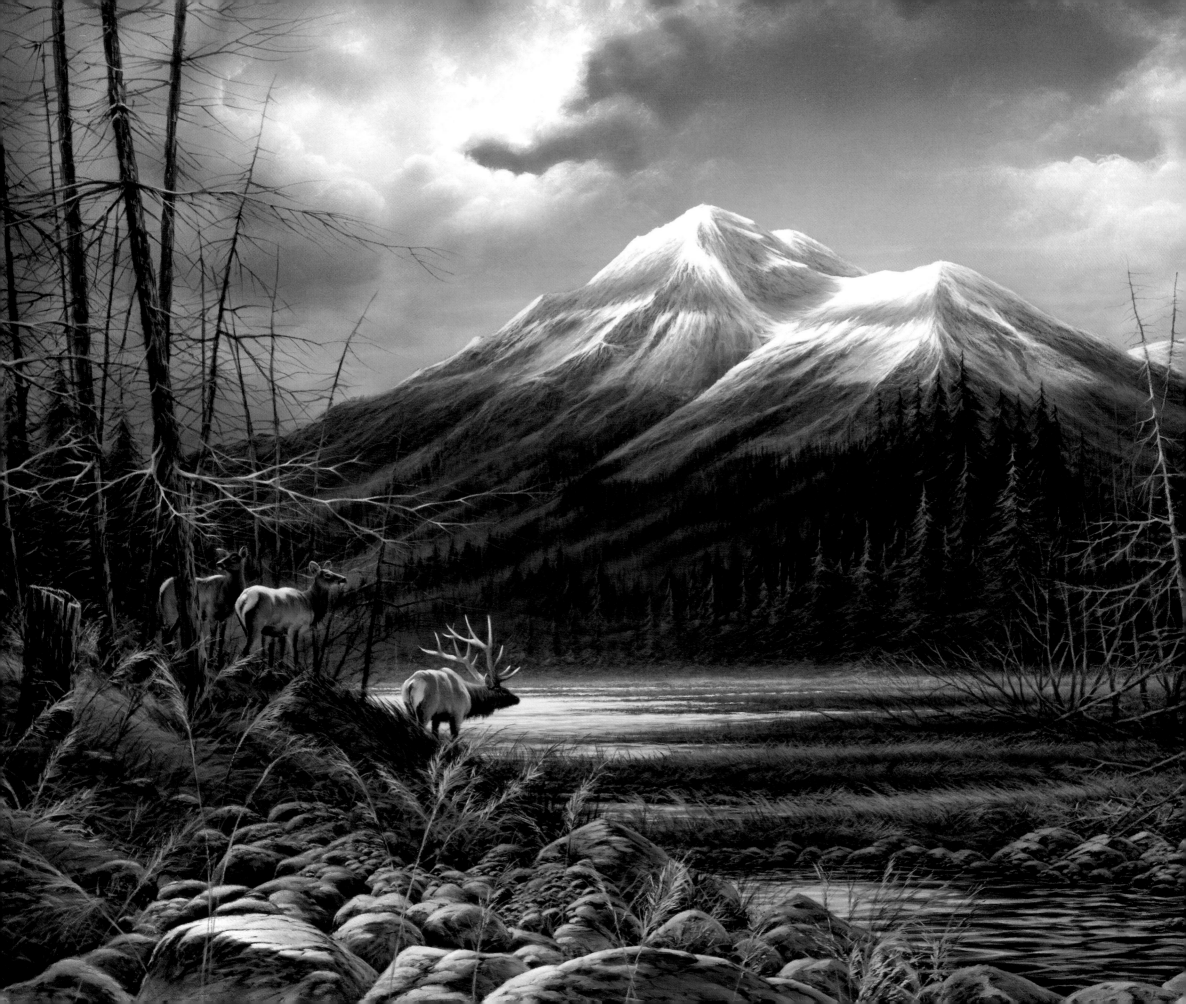

The Master's Domain

Within a landscape of majestic proportions three elk pause, silently surveying their wilderness domain. We can easily imagine that only Indians, mountainmen and wildlife have ever traversed its secluded and pristine beauty.

But these possibilities become insignificant in the presence of the mountain. Mute and seemingly eternal, it conveys to the surrounding terrain a sense of both beauty and supreme power.

As we contemplate this scene we come to realize that man can best appreciate nature, and that its forces are beyond our understanding or ultimate control.

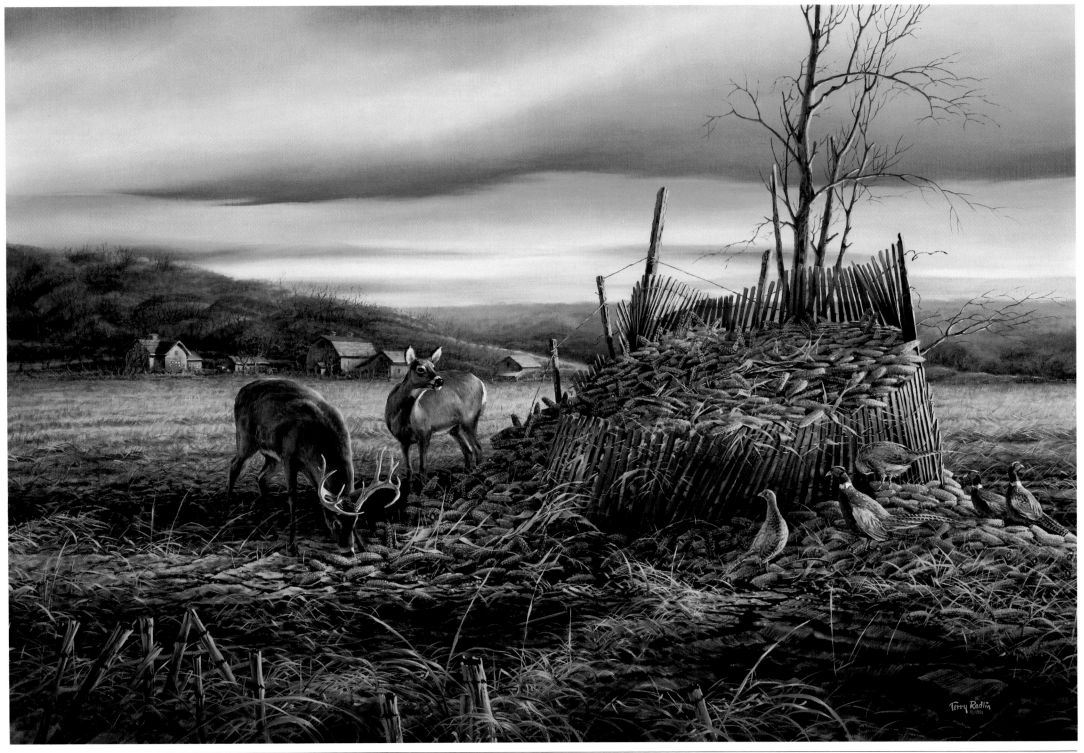

The setting for this unique encounter was witnessed by a friend of the artist on a quiet fall afternoon. Both the pheasants and the white-tailed deer have discovered the faulty make-shift corn crib. They keep a wary eye on one another, but apparently feel any potential trouble is secondary for as long as the corn holds out.

Sharing the Bounty

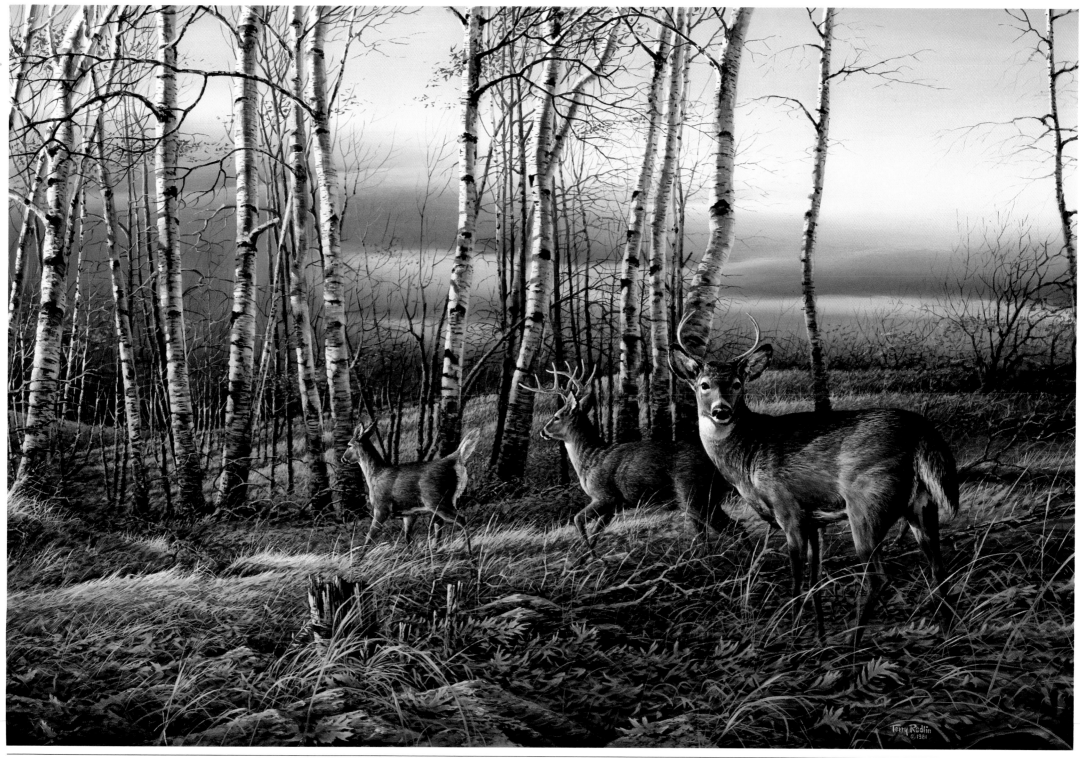

The Birch Line

After many years of bow hunting the artist has seen this occur several times. Portrayed is a typical reaction as the young buck, overwhelmed by curiosity, has stopped. The older buck and doe sense the same presence, but are wise enough not to hesitate as they move quickly away toward the birch line and distant brush.

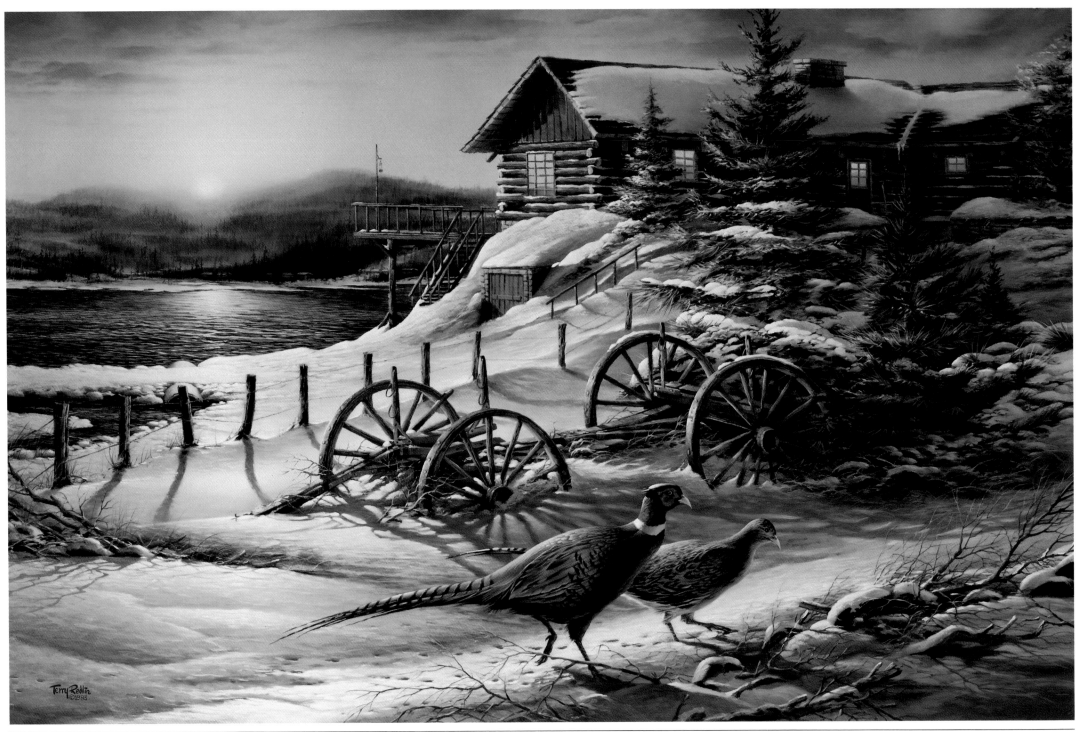

An early winter snow has covered the ground, but melted as it fell into the still open lake. The cabin owners have shoveled their walk and driveway and no longer use the warm weather balcony. The pheasants, unlike their neighbors, require neither path nor amenities to live on the land and meet their elemental needs.

Peaceful Evening

Seed Hunters The pheasants blend into the grass and shadows as they search for food, while at the house smoke suggests the farm family will not wait long for their meal.

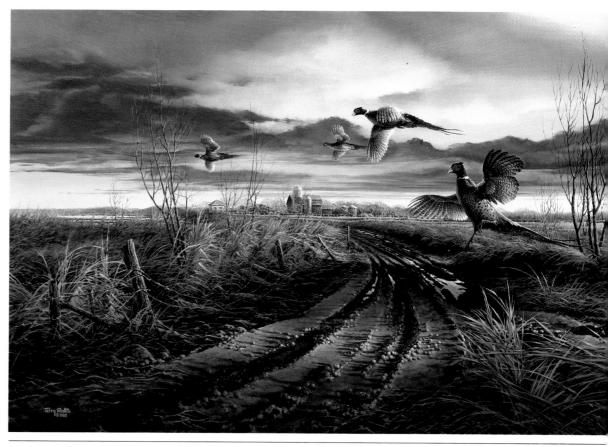

Country Road The shower has passed, the skies are beginning to clear and the ring-necked pheasants are out scouting for their evening meal. They will settle in around this old back country road which, until dry, will carry no disruptive traffic.

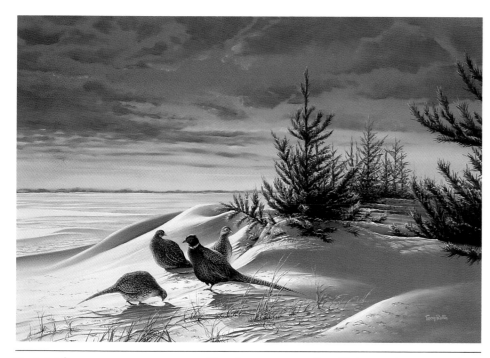

Quiet Afternoon The pheasants are all puffed up to keep warm in the late afternoon sun. With the shelterbelt protecting their backs from the northwest winds, and open fields to their front, they feel safe and secure.

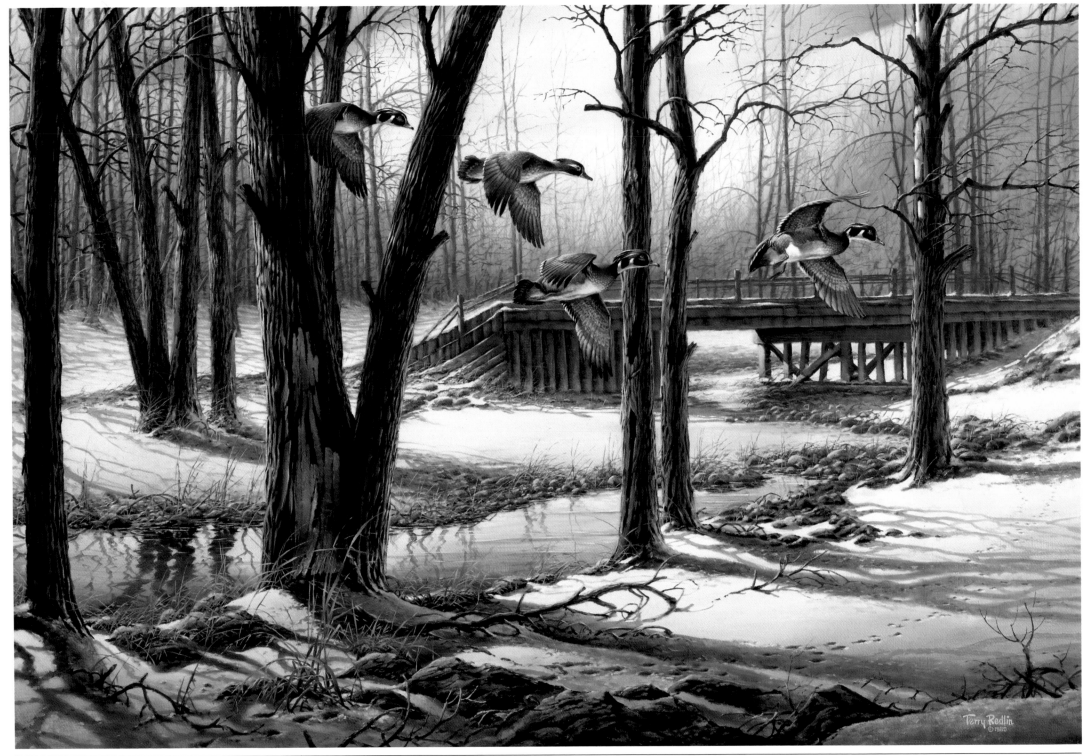

The area around this old wood piled bridge and scenic hill country was explored by the artist on a field trip one April morning. A late season snow had just fallen and as he walked not only wood ducks, but also mallards, teal and geese were flushed from their resting places. In a special sense the artist felt the woods on this bright morning had "come alive."

April Snow

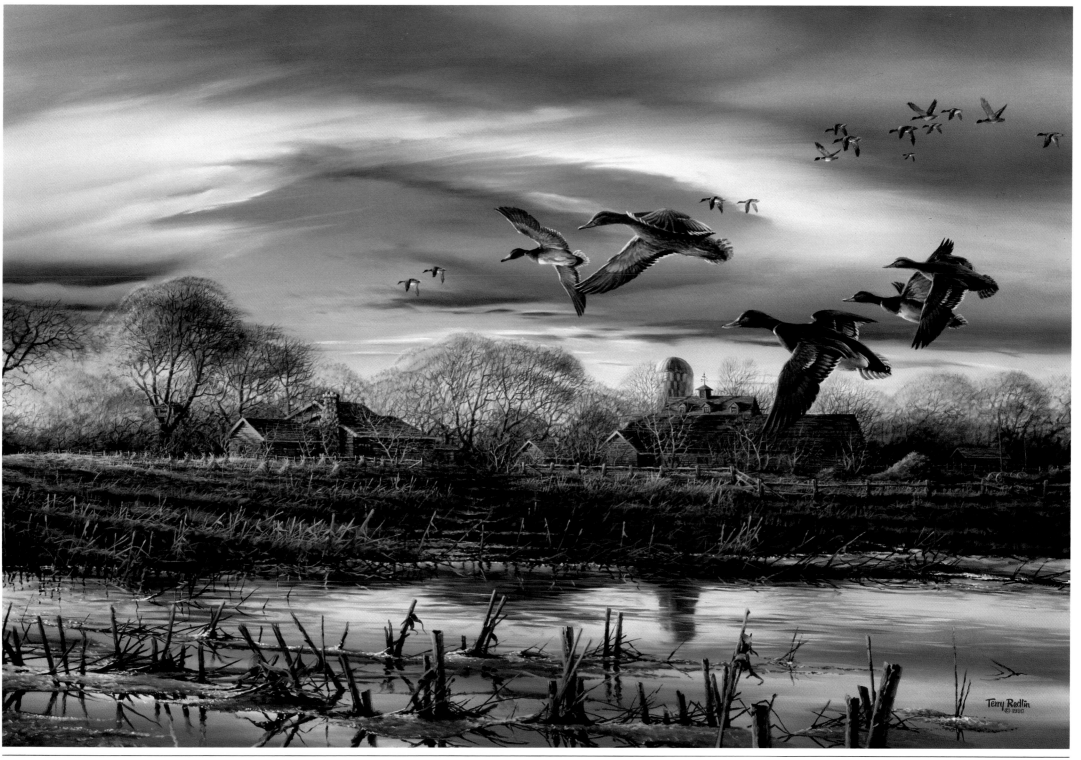

Spring Thaw

The melted snow has formed a pond in the corn field and will no doubt delay spring plowing. The farmer, however, will wait patiently in his comfortable home. His children, we surmise, are also anxious for warmer weather to re-occupy their tree house. This musing is of little concern to the mallards who require only a simple resting place before continuing their journey north.

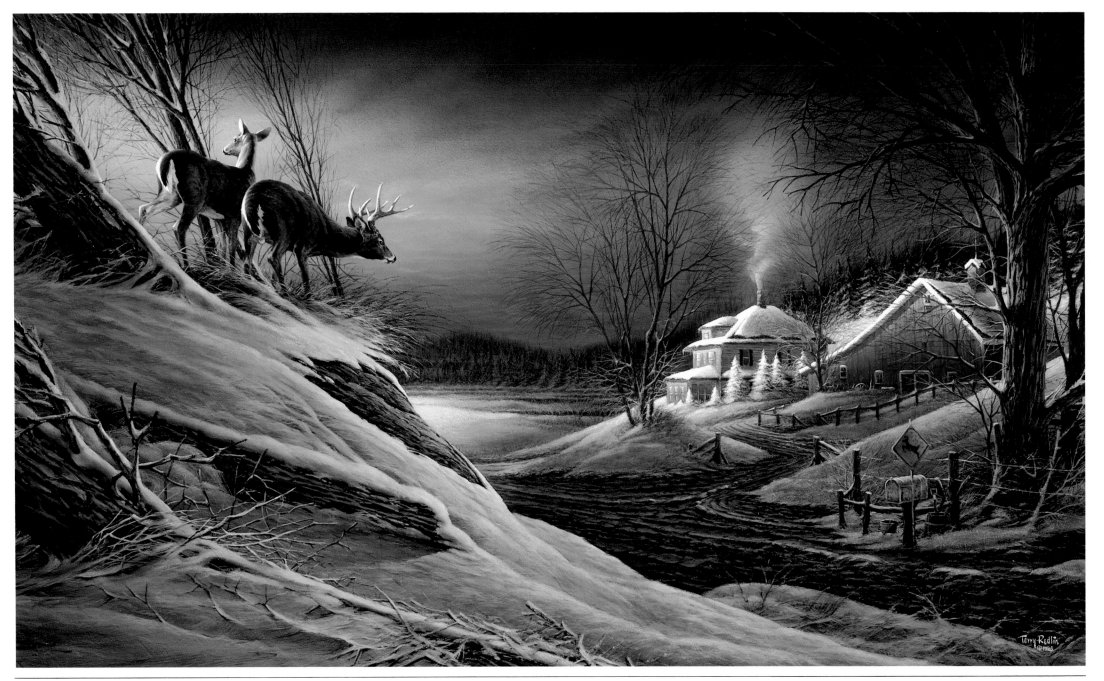

Both deer and man have apparently agreed that this particular spot is a good crossing place. But the deer have learned to be cautious before accepting even such official approval. They hesitate, carefully scanning the road as any prudent pedestrian. We can expect that when our gaze is momentarily diverted they will quicky descend and, if we look again, the hillside will be empty.

Deer Crossing

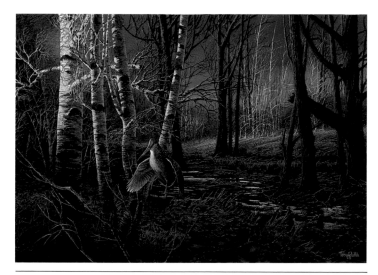

The Loner

The soft, muddy bottom of this deep woods depression is an ideal location for the woodcock. Only the sunlight striking its golden breast violates its near perfect camouflage.

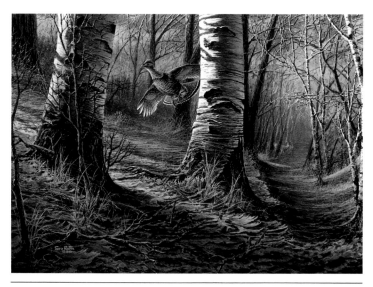

Intruders

The grouse has been startled by unexpected visitors. The deer, appearing at the far end of the trail, are not a threat and will peacefully go about their normal activities.

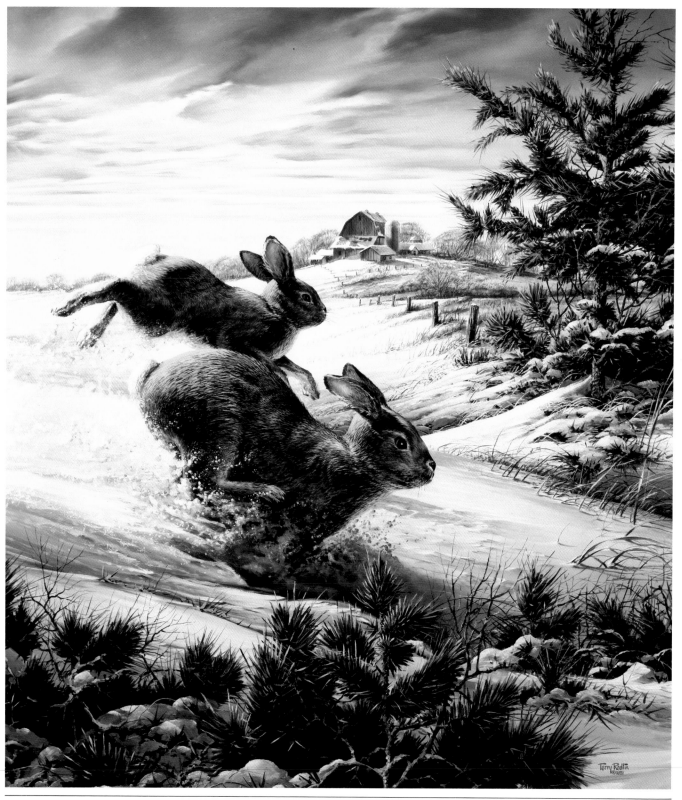

Hightailing

In high gear and heading for cover in the nearby brush, this pair of cottontail rabbits would be only a blur to the casual observer. This familiar animal received its name from the fluffy, white underside of its tail which is apparent as these rabbits scamper away.

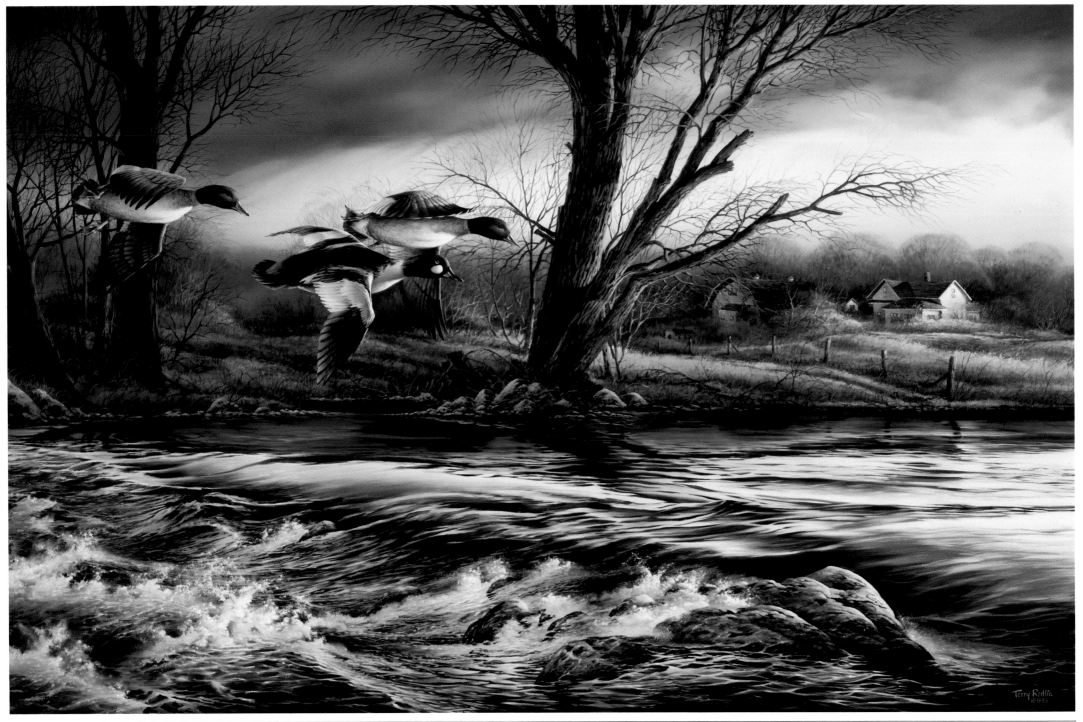

Three goldeneyes skim the river surface and head upstream looking for quieter water. These birds are commonly known as "whistlers" because of the loud, high pitch of their wings in flight. Here the artist treats us to a vivid contrast of color and movement. The horizontal center of warm browns and oranges is essentially static. Cool blues and greys frame this center, and the rushing water and straining goldeneyes quickly bring the viewer into the scene's focus of high action.

Rushing Rapids

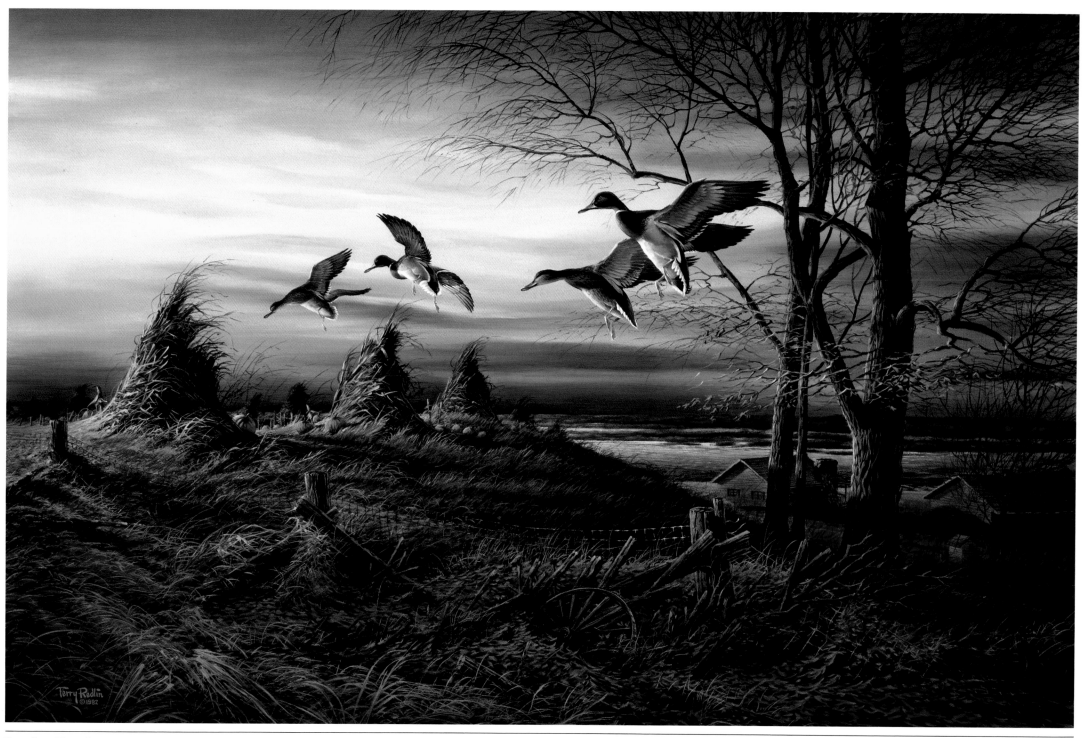

October Evening

In this image we are invited to relive a romantic range of experiences. Below the hill we see the deserted hunting lodge, and in the distance a wide expanse of water and marsh. In the foreground, partially buried, is a discarded wagon wheel that once carried someone's now forgotten dreams. The silhouetted shocks are surrounded by pumpkins waiting to become part of some home's Halloween festivities. The mallards, ignorant of such human activities, are interested only in the corn to satisfy today's hunger.

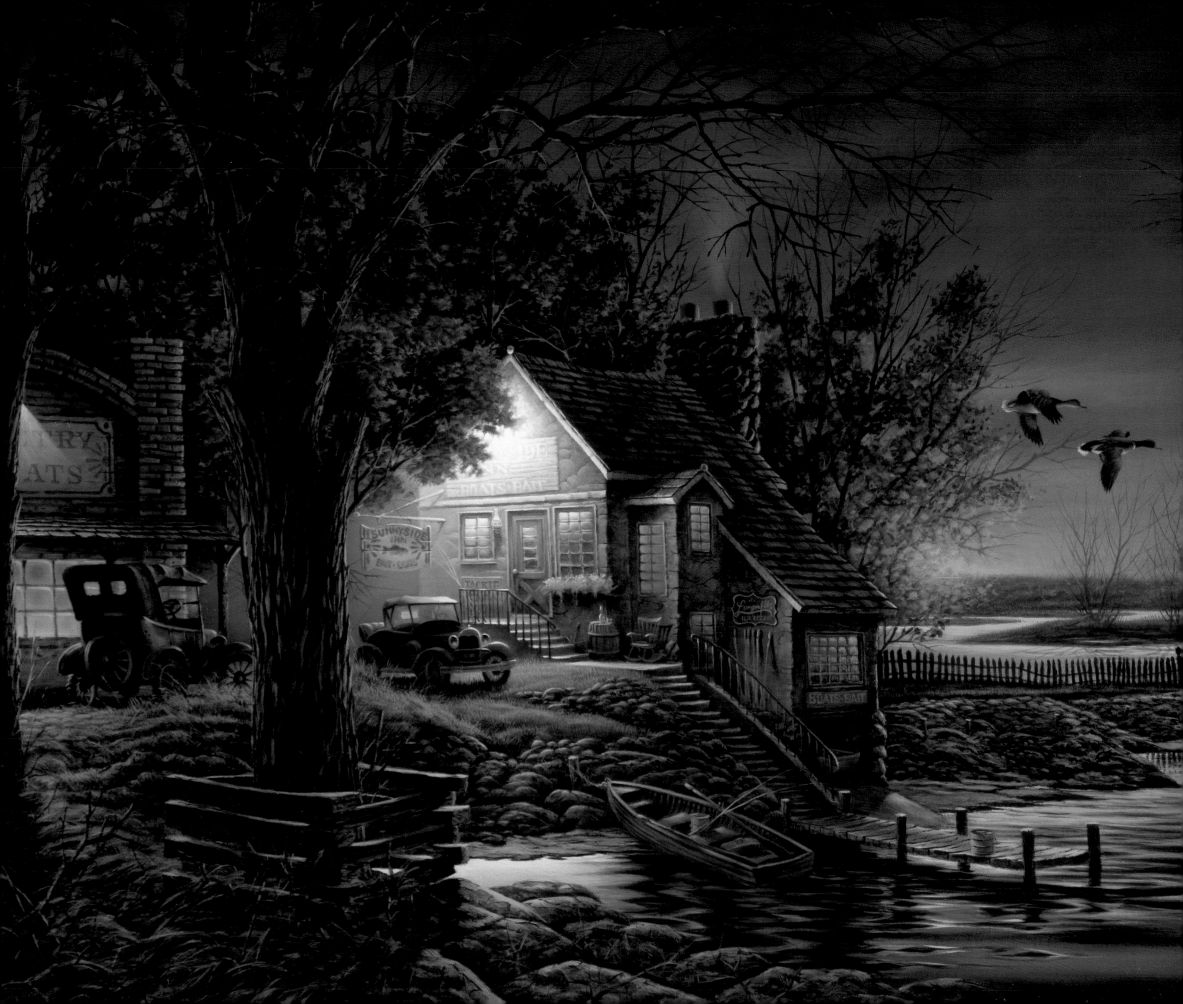

Terry Redlin
©1986

That Special Time

For Terry Redlin this painting holds warm memories of childhood when an uncle would take him fishing to many new and, to his young eyes, exotic places.

This romantic rending is a composite of all those long ago fishing excursions. The older touring car and sporty roadster with rumble seat dates the scene as sometime in the 1930's. The Sunnyside Inn was an actual resort near the artist's hometown in eastern South Dakota.

The time is early evening, the mallards are coming in, and our fishing party is the first one off the lake. They have disappeared inside, probably for a bite to eat or refreshments before heading home.

Chances are the young man asked his uncle for some Langenfeld ice cream, a popular brand in the upper-midwest during this period. The artist's wife was a member of this Langenfeld family, and the authentic ice cream sign is one of the personal touches we sometimes find in Terry Redlin's paintings.

Such reveries allow us, with only a slight effort, to disassociate ourselves from the present and join with the artist as he remembers a special time of his life.

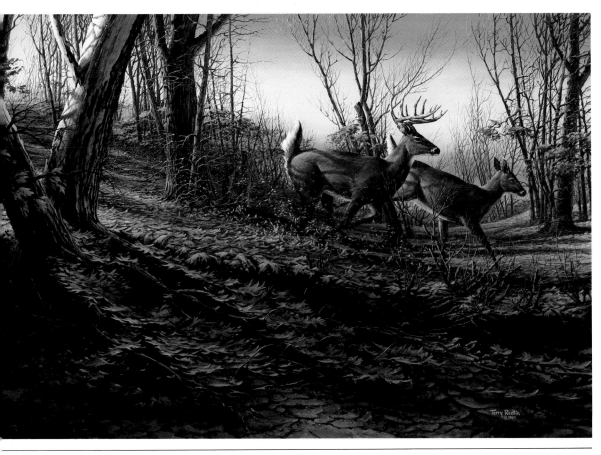

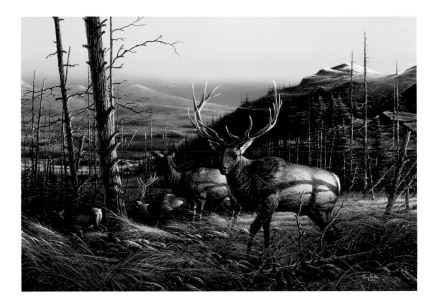

The elk herd is keenly aware of the occupied line shack cabin below. Moving quietly, they give it wide berth and make their way through a dead fall area in the foothills.

Passing Through

With their "flags up", a pair of white-tailed deer are moving fast across a washout area. This late fall setting, with its dead trees and exposed, leaf filled roots, was an Outdoor Life cover.

Autumn Run

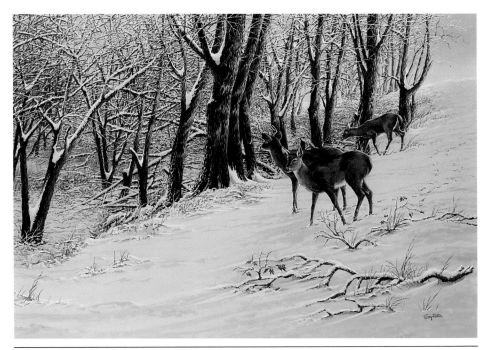

It is early morning, the deer have finished their night feeding and are ready to bed down. Always cautious, they carefully pick their way through the new snow and back to the draw.

Back from the Fields

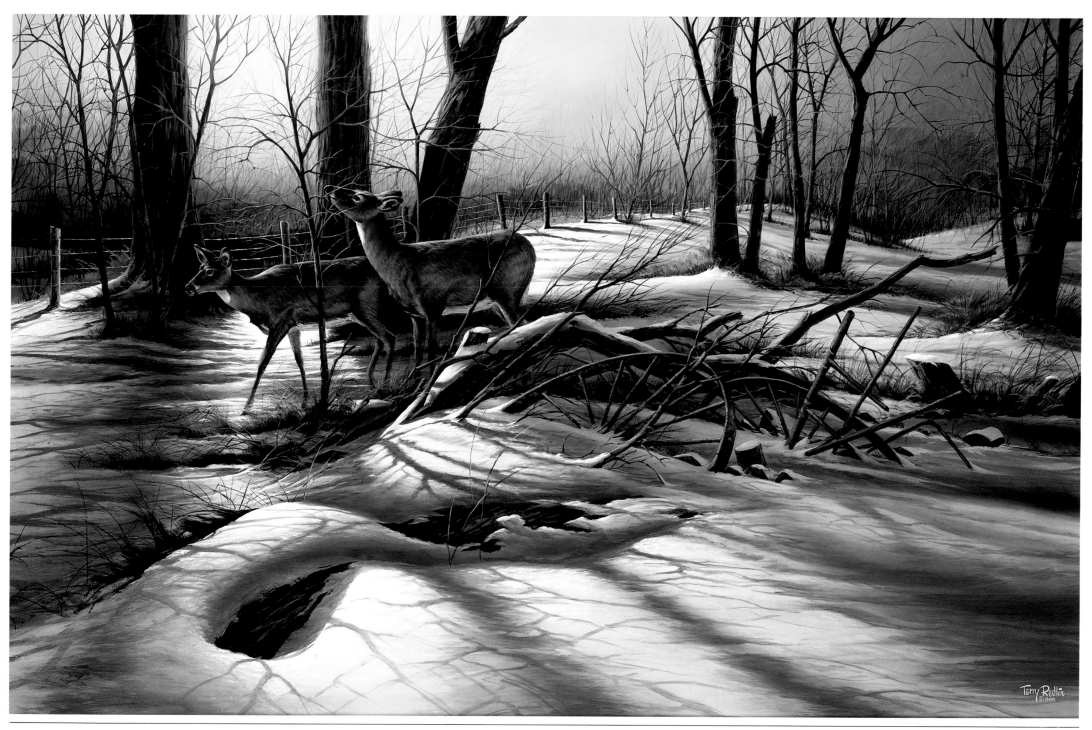

Browsing

In this peaceful setting we clearly see what have become hallmarks of the artist's work. The sun has slipped below the horizon, filling the sky with warm light and casting its reflected glow over the snow. The wildlife are content in their own world, busy searching for the day's nourishment. However, the barbed wire fence and half covered wheel remind us that man, and his unpredictable behavior, is not far away.

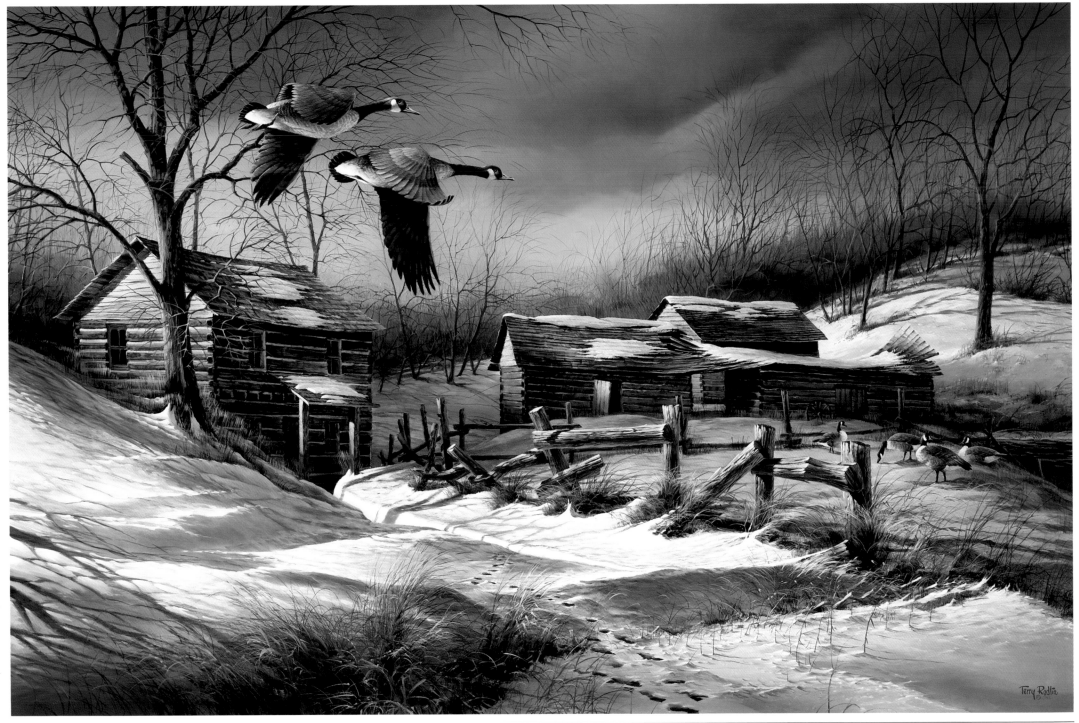

Tucked comfortably into a protected woodland valley, and with water almost at the front door, this seemed an ideal place for the early homesteader to settle. But he has moved on, and the log buildings and fence line have begun to show their age. However, the location's advantages remained, and the Canada geese return to visit year after year.

Winter Windbreak

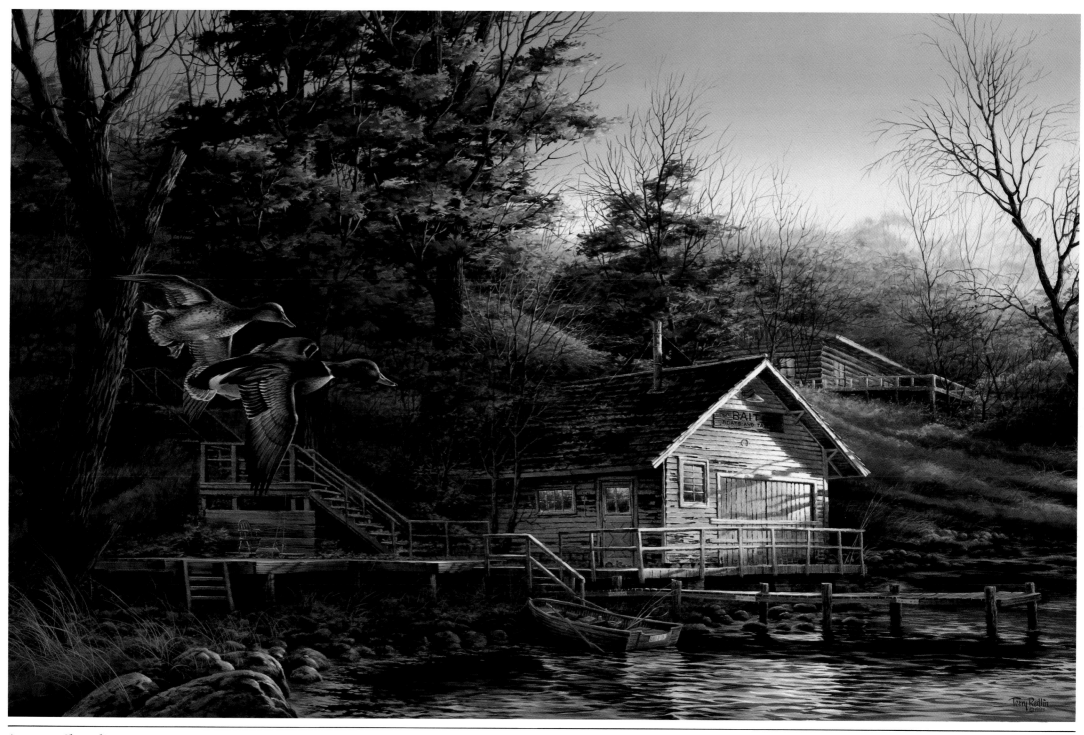

Autumn Shoreline

The bait shop is closed for the season, but someone is preparing to make one final attempt to catch the big one. Perhaps the waiting boat and gear is for the shop owner who, after a summer of catering to others, is finally taking his turn. The mallards, too, are enjoying the quiet, blissfully unaware that a different type of season will soon begin.

Coming Home

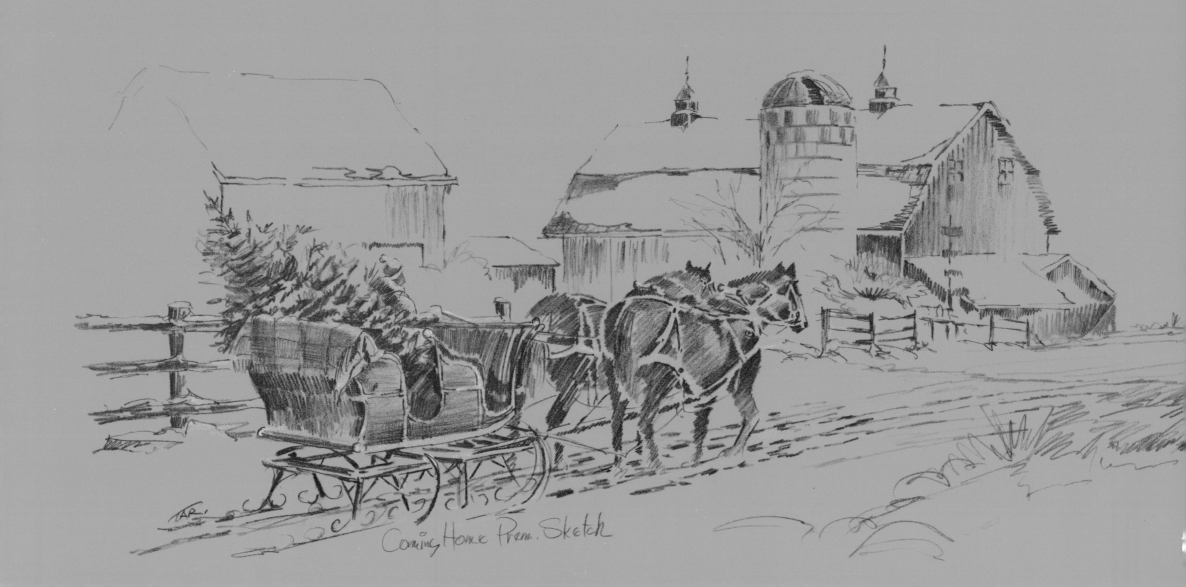

Coming Home Prem. Sketch

In the world inhabited by lovers of nature and her creatures, Terry Redlin holds a pre-eminent position as a wildlife artist. He is one of the pioneers in the modern wildlife art movement that began in the mid-1970's, quickly gained widespread popularity, and continues today unabated.

It was an exciting time as wildlife art came out of the sportsman's den and into the living rooms and the boardrooms of America.

This explosion of interest in wildlife art had many complex roots. It developed from a deep need to rediscover a heritage that had been neglected. It was a popular revolt against the art establishment and its self-serving norms. It was a subconscious desire to restore symbols so basic to so many Americans. And it was a romantic longing for a return to simpler verities.

Terry Redlin was in the front ranks as the role of wildlife art in our society was re-examined. And his art, like that of the movement itself, changed and matured.

If chronologically reviewed the body of his work over this period would show a shifting of style, mood and subject emphasis. We would see that he intuitively understood how refusal to change becomes stagnation, how openness to experimentation offers the possibility of progress.

So, too, our own experiences disclose how traditions are constantly tested as we explore new paths and patterns. Terry Redlin's life as an artist reflects this reality as the paintings on the following pages attest.

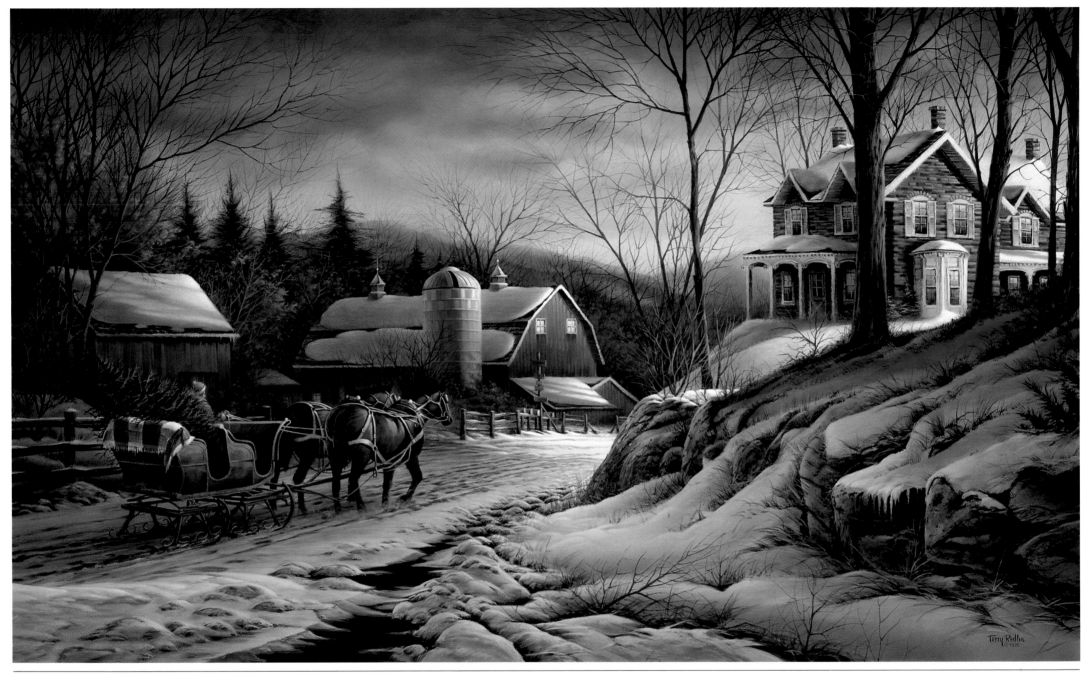

In this nostalgic scene coming home becomes both a place and a feeling. It speaks to us of a tradition we share, if not in actual fact, then in the values it represents. The Christmas tree has been cut from just down the road. We can imagine the fresh smells of baking bread in the kitchen. The farm house will soon be alive with the joyful sounds of children from two generations. And the pole signs in front of the barn tell us there are other farms nearby where similar preparations are underway.

Coming Home

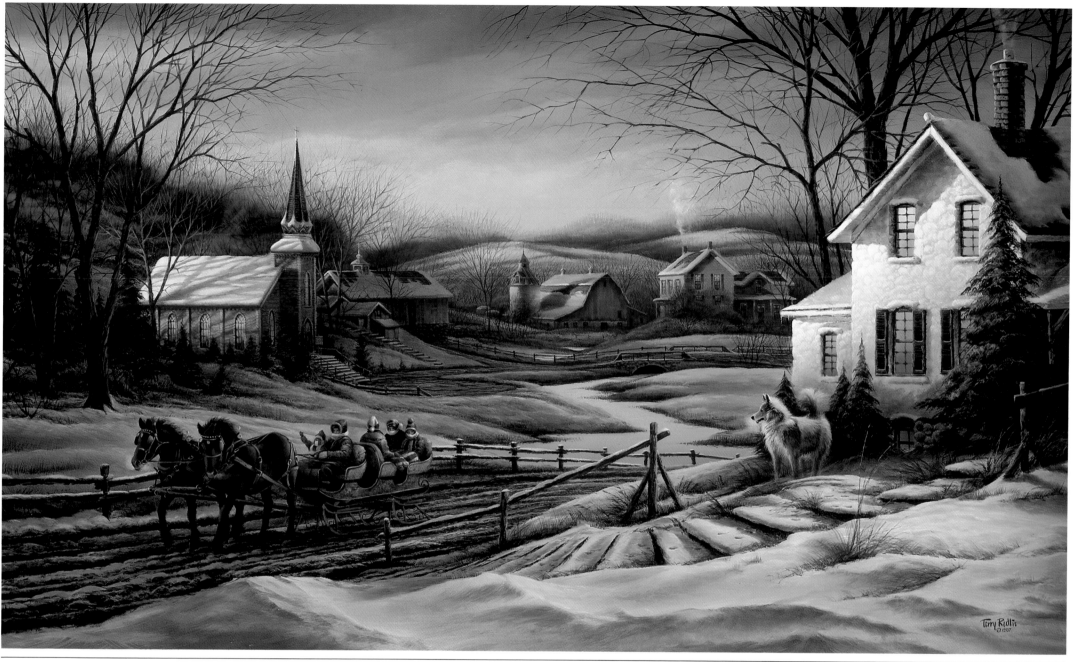

Together for the Season

The family has returned to the small crossroads town for the holiday season, and Dad has hitched up the sleigh and horses for a late afternoon ride. The departed sun is casting a warm glow over the sky and river surface, but the bundled passengers and horse's breath tell us the winter air is cold and crisp. For this homecoming excursion only the farm dog has been left behind. He is an important part of this rural family, but the sleigh is crowded and someone must watch the house.

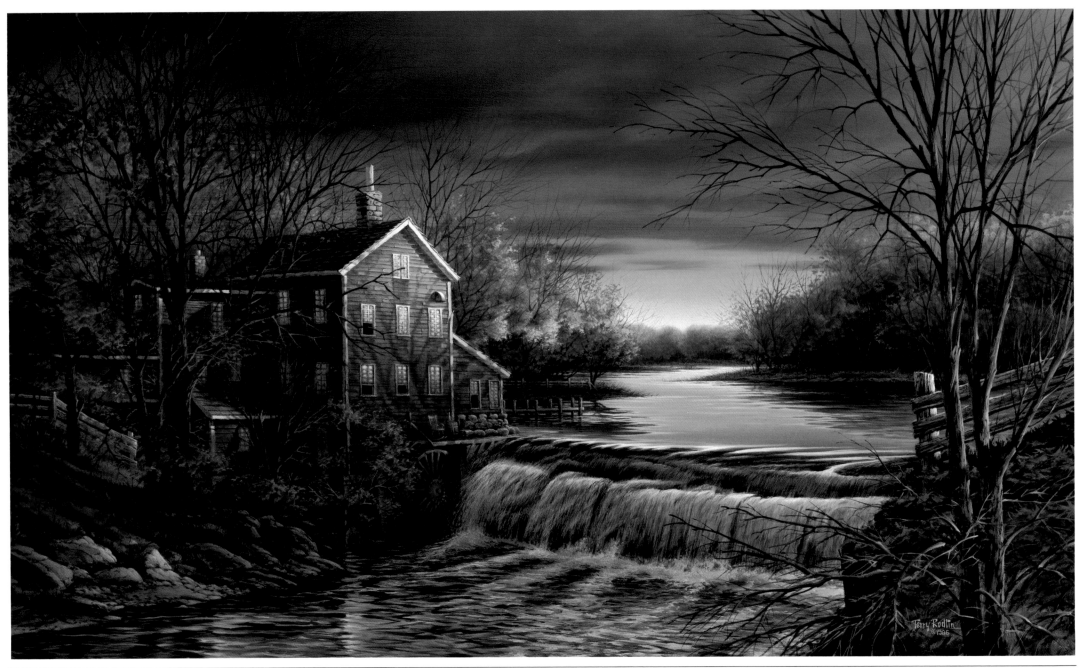

The old mill pond is an important symbol to many Americans. Its calm presence represents a less hurried time when life's ambitions were in proper perspective. Such a reordering of priorities is evident on this peaceful autumn afternoon. The mill owner has built a viewing platform overlooking the pond and, recognizing the moving water's healing power, often sits in the rocking chair listening to its soothing sounds.

Autumn Afternoon

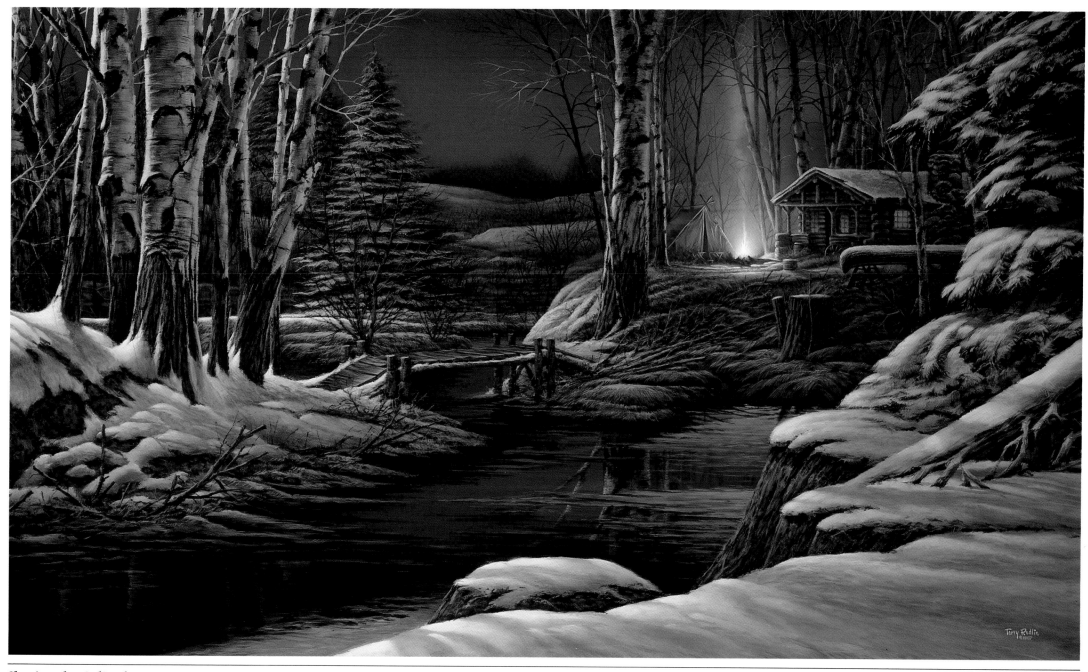

Sharing the Solitude

In this idyllic scene the artist invites us to share, along with the cabin inhabitants and their camping visitors, one of those rare nights in the deep woods. The high moon has momentarily broken out from the clouds, turning the snowy landscape to bright day. The surrounding silence provides, for those of contemplative nature, a perfect setting for the primitive message contained in the flickering campfire.

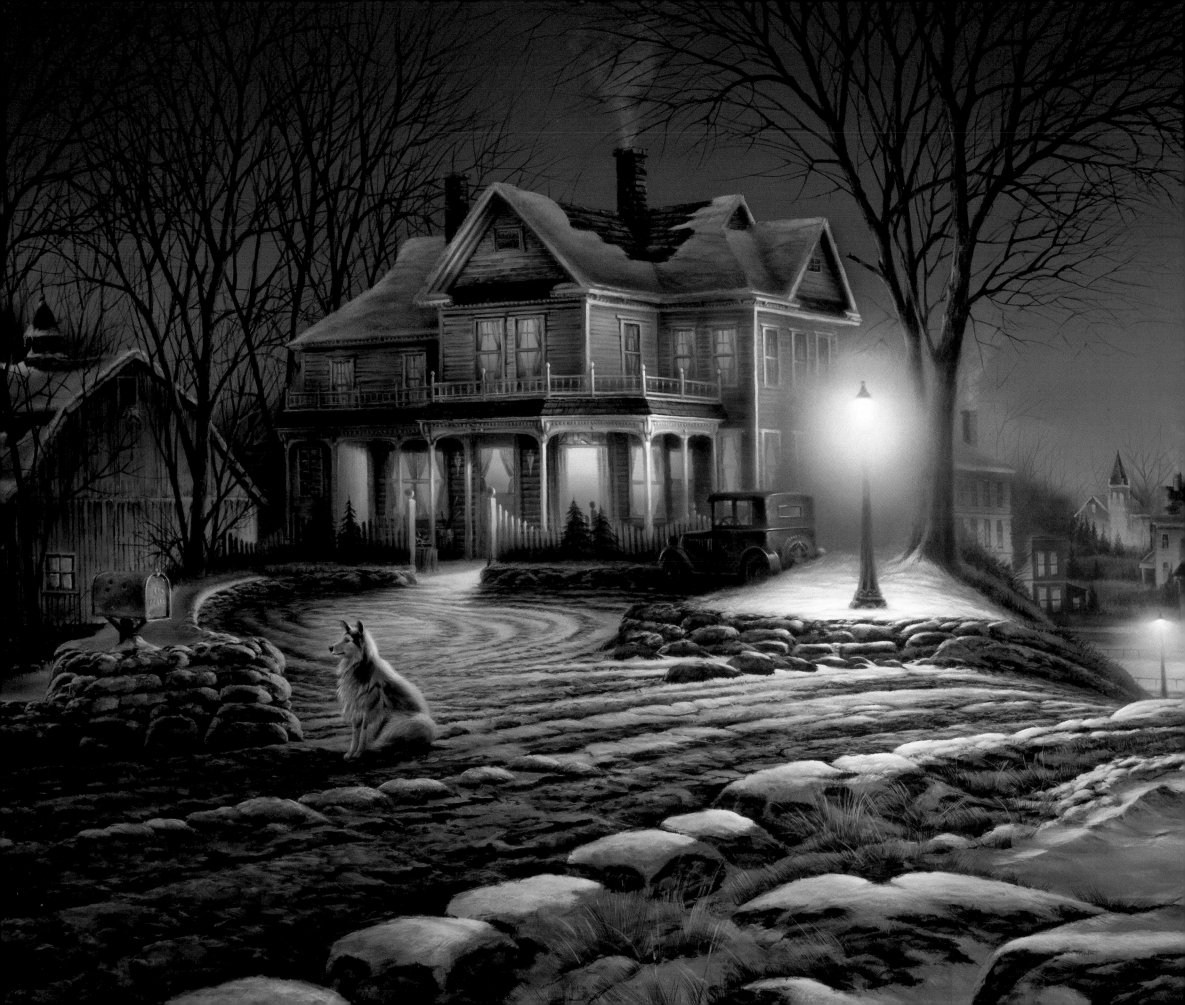

Terry Redlin
© 1987

Lights of Home

In many ways small towns are alike. One of the most common similarities is the big house on the hill. On the highest point of land lives the town's banker, doctor, pioneer land owner or other prominent person. And often this residence is an active social center for the community.

Such a story is recounted in this painting, a familiar remembrance from the artist's small town background.

All the lights in the big house have been turned on, a sign of welcome for arriving guests. The dog knows from experience that when this happens company is expected, and he waits on the road with anticipation.

Below the big house we see other familiar small town sights—the square, the church and, barely visible behind the house, the school building.

The romantic spell of this cold and hazy evening is intensified by the glowing lights, and we can be readily transported back to an era when one took the time to get to know their neighbors.

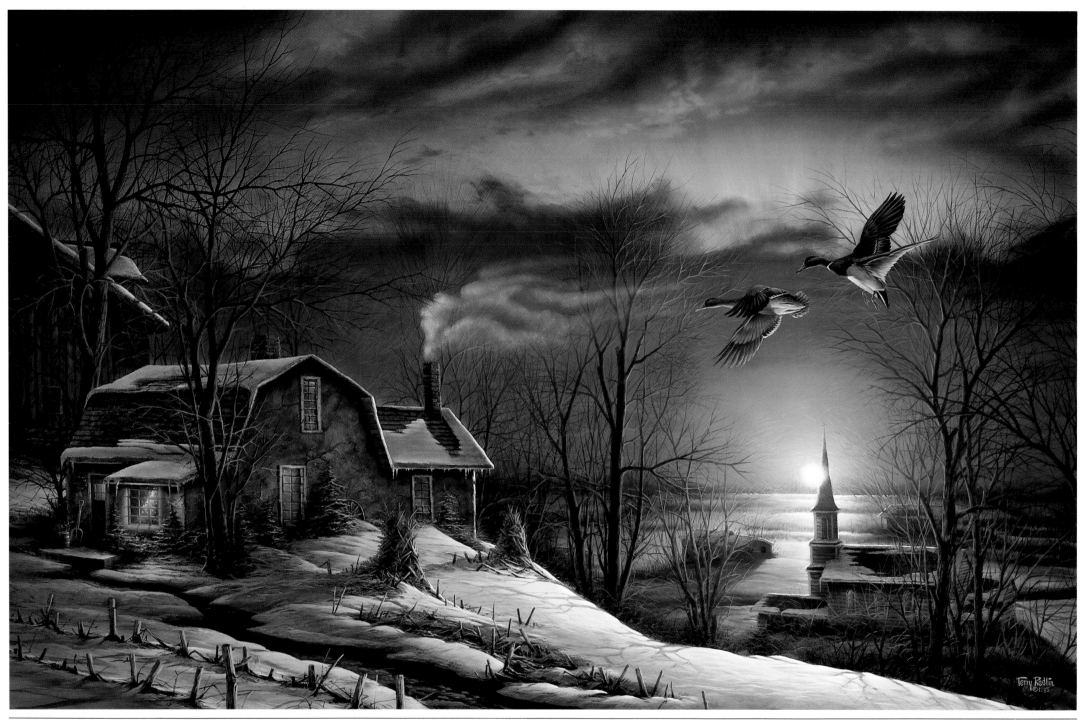

The spirit of sharing is beautifully extended to the world of nature in this holiday scene. To help wildlife survive winter the farmer has temptingly placed two corn shocks at the open side of his house. A welcoming wreath hangs near the door for human visitors. And a Christmas tree warmly beckons in the window as two late-leaving mallards glide down for a needed meal.

Sharing Season I

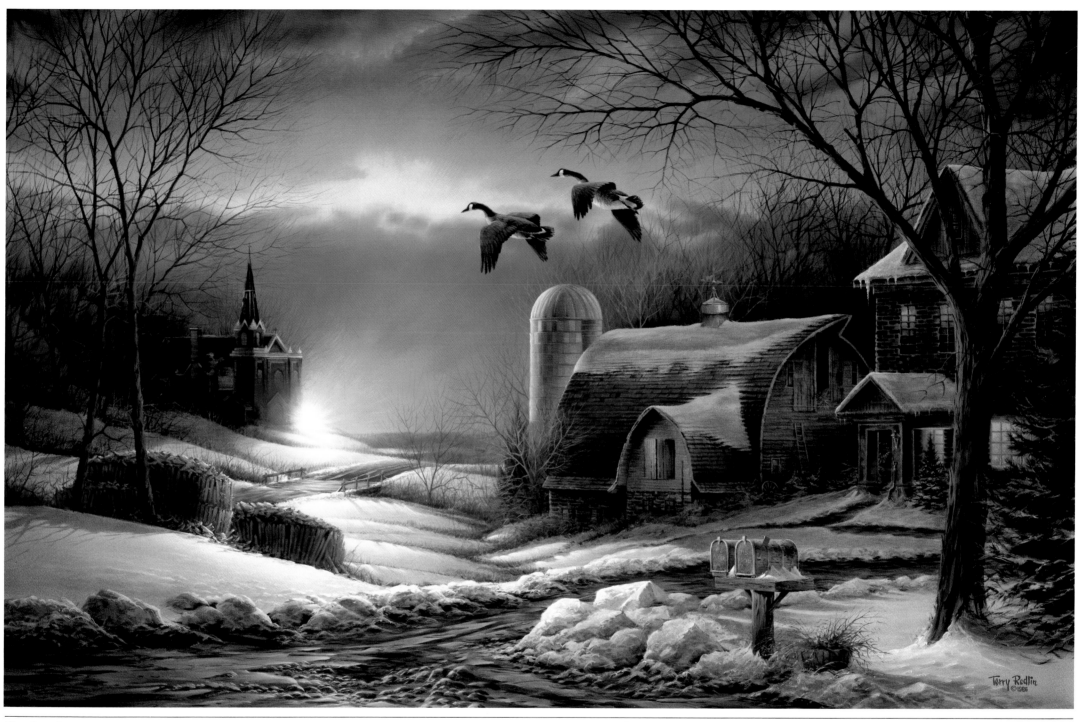

Sharing Season II

This painting, a companion to the image on the opposite page, celebrates the same sharing impulse that is so often apparent in rural areas. We note the wreath and shovel by the front door, the distant church, and this time the corn in bountiful supply in two open cribs. A warm and friendly mood permeates the scene as a pair of Canada geese stop by to share in this holiday atmosphere.

Listing of Titles

Western and Alaska Field Trip Studies

Terry Redlin constantly returns to the outdoors for inspiration, to study animal anatomy and to renew his understanding of their behavior. The individual drawings made on such field trips may remain just that, small masterpieces in their own right. Or they may become starting points for complete compositions. These drawings, from a recent trip to the western states and Alaska, give us a possible hint at the content of future paintings.

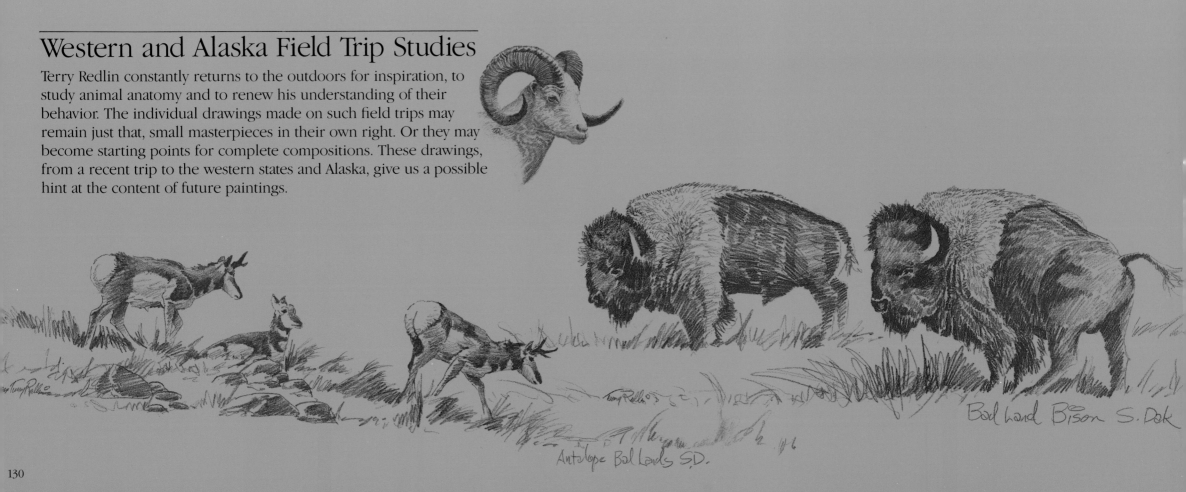

Antelope Bad Lands S.D.

Bad Land Bison S. Dak.

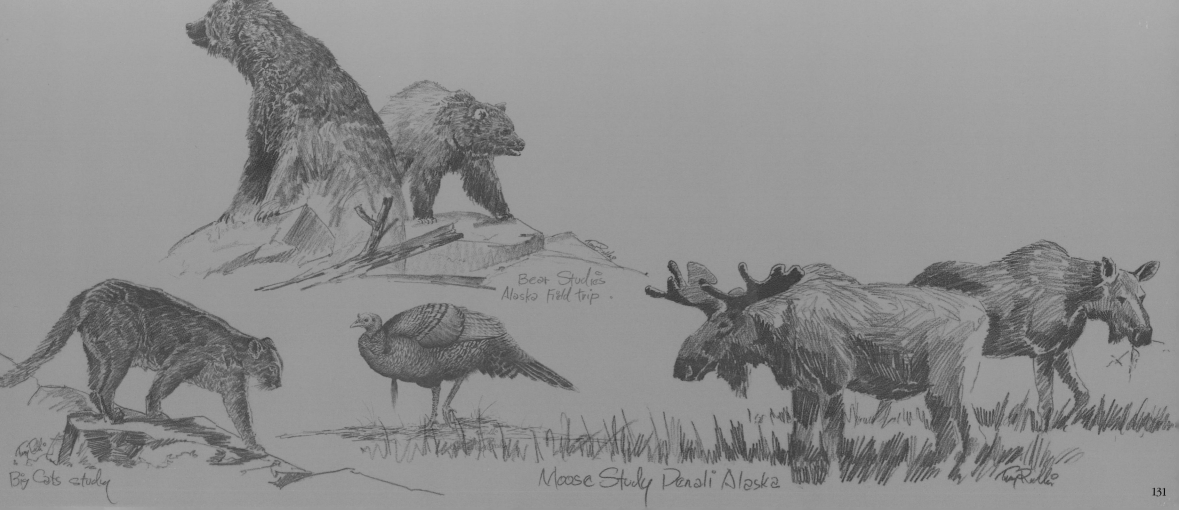

Bear Studies
Alaska Field trip.

Big Cats study

Moose Study Denali Alaska

A special part of Terry Redlin's being is connected with Camp Courage, a facility in Minnesota that assists the disabled to live full and constructive lives. Each year he donates the use of his art to illustrate their fund-raising Christmas cards, and participates in other supportive activities. This drawing reminds us that the outdoors is a healing place, big enough and open enough to accept all people.

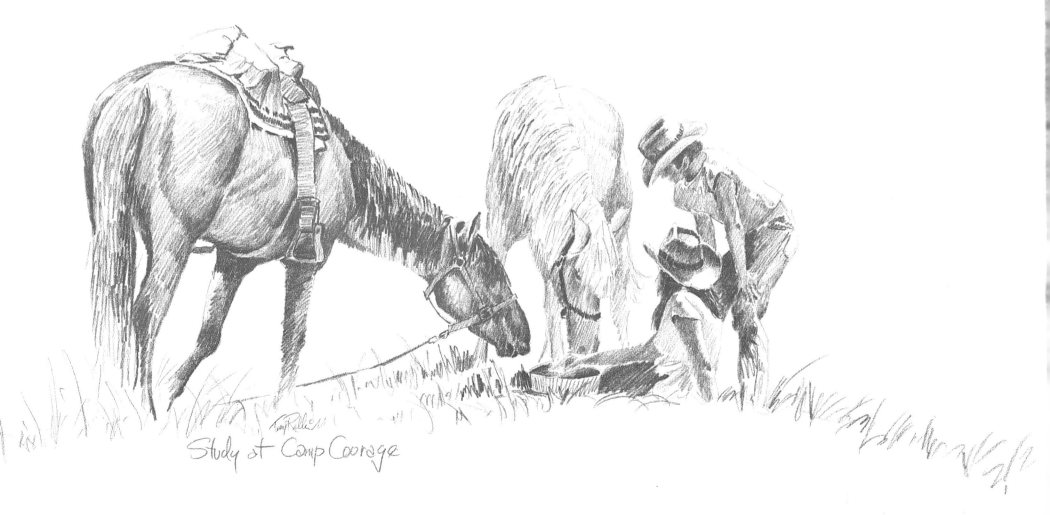

Study at Camp Courage